florescence
the world's most beautiful flowers

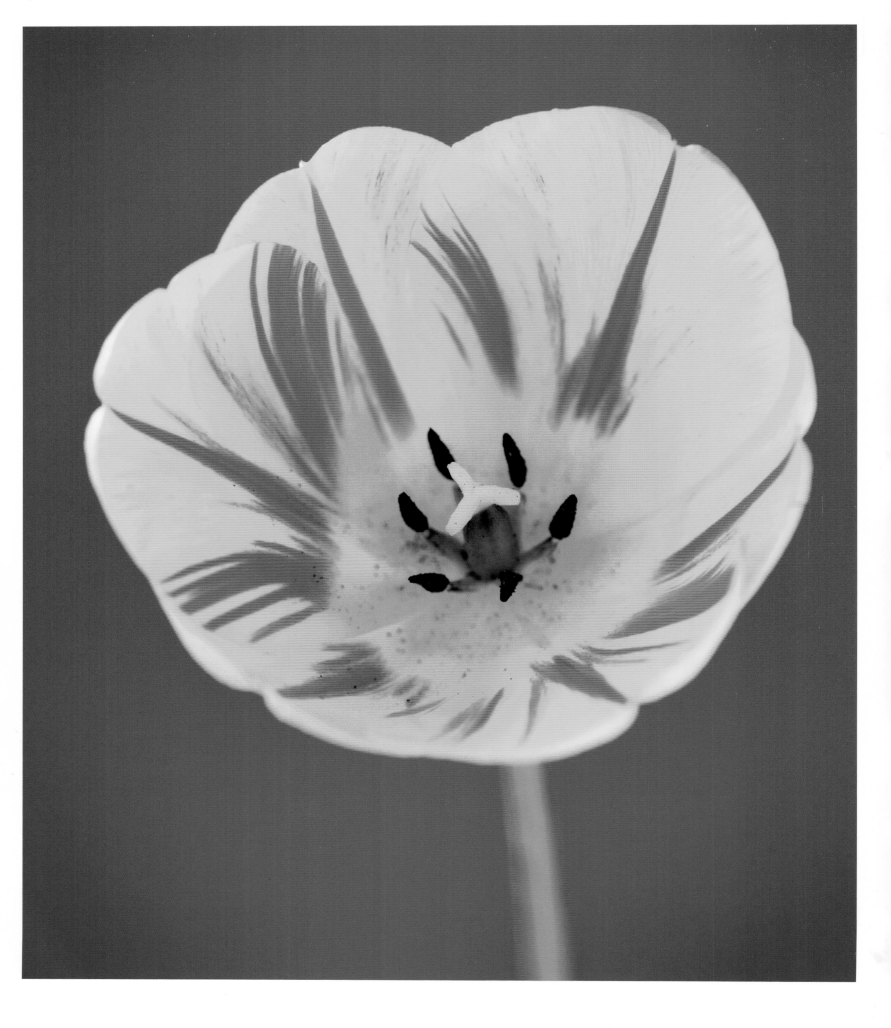

florescence
the world's most beautiful flowers

Clive Nichols

Noël Kingsbury

MERRELL
LONDON · NEW YORK

For Hazel and Robert

Preface

Clive Nichols

One of the most delightful things about a garden', wrote the novelist and gardening enthusiast W.E. Johns, 'is the anticipation it provides.' Perhaps the most keenly anticipated event of the gardener's year is florescence, when delicate buds on lovingly tended plants open to transform the garden with their gorgeous colours.

This book is a celebration of that brief, wonderful period. It explores the extraordinarily rich variety of flowers available for us to cultivate and enjoy. But more than that, it is a celebration of each flower's unique personality. Those who know my work will be aware that I think of these images as 'plant portraits'. For me, this means approaching each flower as an individual, in the same way that a portrait photographer approaches a sitter.

Photographers who work with flowers often talk about them in terms of colour, texture and form. However, discussing flowers purely in those terms implies that they are inanimate objects, and overlooks the fact that they are living, growing things. Each flower has its own distinct characteristics and personality, and that is what I try to convey in my photographs. For example, some – dahlias, for instance – are tough and bulky, while others – such as crocuses – are very delicate and fragile.

I am often asked how I create my flower photographs. For me, simplicity is the key. First, I select the flower I want to photograph. This is not as simple as it sounds, and it is one of the most crucial aspects of a shoot. I buy a lot of the flowers I use from specialist nurseries, which are marvellous places for finding extraordinary plants. I spend a lot of time there, looking carefully at the plants that fascinate me before choosing which to photograph. I buy others from garden centres. I also grow some rarer specimens specially, in my own garden.

As anyone who has tried flower photography will know, not all flowers are photogenic. When choosing, I look for an individual that has its own special and unique character. Finding that perfect specimen is very exciting, and I immediately begin to visualize how I will interpret those unique characteristics creatively in an image. At its best, photographing flowers is a joyful experience, and I sometimes get so excited by my work that I sing while I'm doing it!

Although I often shoot outside in my work as a garden photographer, the vast majority of the flower images in this book were shot indoors, either in my house or in greenhouses. This kind of environment gives me complete control over the photograph. It is essential to have perfectly still conditions, as these photographs can be ruined by the tiniest breath of wind.

I always shoot using natural light, sometimes bounced off reflectors; never flash or artificial light. The quality of natural light is also important, and I prefer to work with soft, diffused light (see p. 188). I also use a variety of coloured backdrops, which can radically alter the mood of a photograph and the way a flower is represented. Then I explore the flower with my camera. I might start by photographing a whole flower, then focus on particular areas, such as the stamen or the edge of a petal. I use a macro lens, which allows me to go very close, even filling the frame with quite a small area of the flower. Like a portrait photographer shooting a model, I often find that one shot evolves into others. I vary the depth of field to isolate different parts of a flower, and the more I explore, the more interesting it becomes.

Sometimes a flower is particularly striking from the side, or above, or underneath. Occasionally I emphasize small details, such as the tiny hairs on the back of the star-shaped flowers of borage (see pp. 54–55). In this particular case, the back is almost more interesting than the front. I experiment with different angles, move the flower, twist it round and try new approaches from higher or lower viewpoints. I can easily spend an hour photographing just one specimen, and if I get four good shots from a day's work, I'm happy.

Sometimes one shoot is not enough. I occasionally photograph flowers at different stages of their life cycle, as their character can change totally. For example, one of the flowers in this book is a peony, *Paeonia lactiflora* 'Sarah Bernhardt' (opposite and pp. 178–79). I grew it myself and was able to shoot it at different times. At first it forms a tight ball with lots of overlapping petals. When it opens, it becomes an incredible, blowsy creature with petals resembling layers of artfully arranged material in an elaborate dress.

I keep my photographic technique to a minimum, as I want the flower's character to take centre stage. I believe that if you over-complicate the image there is too much information for the eye to take in. These are simple subjects shot in a very simple way, and that is what makes them strong and bold.

Although flowers have an extraordinarily wide range of characteristics, one thing they all have in common is transience. For me, part of the joy of photographing them is capturing the beauty of an individual specimen at a certain time, and preserving it long after that flower has gone. One of my central aims in this book is to draw attention to how amazing flowers are when really studied in detail. It is a fascinating miniature world that most people never see. I hope readers get as much enjoyment from looking at the photographs as I have had from making them.

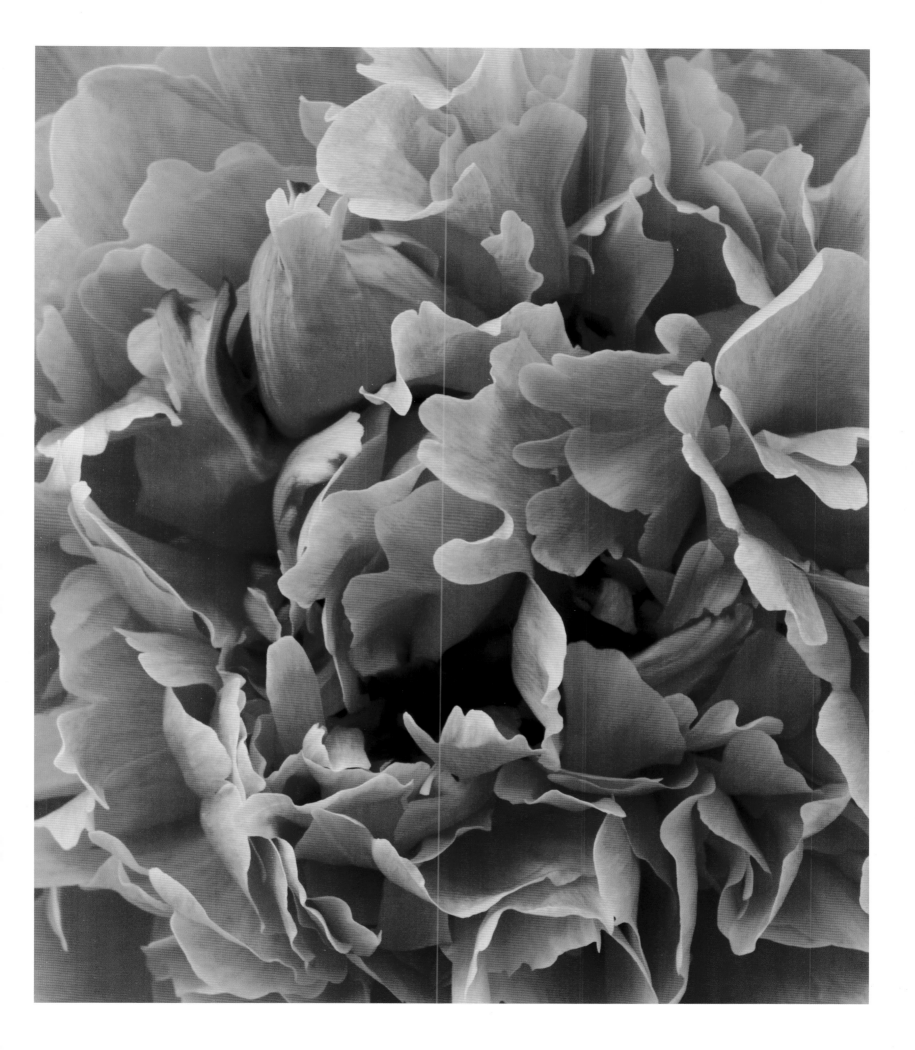

Introduction

Noël Kingsbury

Clive Nichols's flower portraits leave the viewer in no doubt about the passion he feels for his subject, a passion that has led to a deep understanding, both of the plants and of the people who grow them. He has been one of the UK's foremost photographers of gardens and plants since the early 1990s, when garden photography started to emerge as a distinct discipline, illustrating a growing number of magazines and books. Gardening has always been the British national passion, but in the late 1980s and early 1990s British gardeners began to export their expertise. The development of cheaper high-quality photographic reproduction and the growth of consumer lifestyle publishing resulted in a flood of books built on the flair and knowledge of gardeners and designers who had turned their hands to writing. Thanks to the size of the market for English-language books, such names as Penelope Hobhouse, Rosemary Verey and Roy Strong became internationally known. Two photographers in particular, Jerry Harpur and Andrew Lawson, established garden photography as an art form in its own right; Clive Nichols got his reputation up and running very soon afterwards.

There was nothing in Clive's childhood to suggest his future career. Born in 1962 in Grantham, Lincolnshire, he started photography during his degree in Human Geography, worked for three years as a chef in an Italian restaurant, then turned to travel journalism. He found it difficult to make a living, and, casting around for gaps in the market to exploit, realized there was little good garden photography. 'I knew absolutely nothing about plants and gardens', he recalls; 'In fact, I hated gardening when I was young. My father tried to interest me, but he didn't have any luck.' The first place he ever photographed was the National Arboretum at Westonbirt in Gloucestershire: 'I loved the trees.'

Clive was simply the right person in the right place at the right time. 'From my first publication in 1988 my career got going fairly quickly', he recalls. 'Within five years of starting I was making a pretty good living. I got into all the quality consumer magazines: *Homes & Gardens*, *House & Garden*, *Country Living*, *Gardens Illustrated*, *Garden Design*.' Travelling and working outside were all part of the appeal for him, and he began to sell to foreign magazines, as well as the 'more upmarket British ones', which also covered good overseas gardens.

During the course of his career, Clive has done all the photography for some fourteen books, including two on colour: one with the leading American garden writer Tom Fischer (*The Gardener's Colour Palette*, 2010); the other with Nori and Sandra Pope, the Canadian couple who created what was for a period (1988–2005) one of the most acclaimed gardens in the United Kingdom, Hadspen in Somerset (*Colour by Design*, 1998). Clive has also undertaken one of the greatest challenges for a photographer – explaining his craft – in *The Art of Flower & Garden Photography* (2007). Having had two children (aged sixteen and eighteen at the time of writing), he has put his parental experience into two books aimed at gardening parents: *Great Gardens for Kids* (2002) and *How Does Your Garden Grow?* (2005), both with Clare Matthews.

Creative people do not have a good reputation for being tidy or organized, but Clive's sense of order is key both to his success running a business and to his photographic style. His office is among the neatest of any garden professional I have met. In that respect, he has been greatly helped by his wife, Jane, who has a reputation as a very efficient businesswoman. He likes order: it and composition 'are natural to me; a sense of order gives me a style that is clean and simple'. Among the first gardens he shot were Wollerton Old Hall in Shropshire, Sir Roy Strong's The Laskett in Herefordshire, and Versailles,

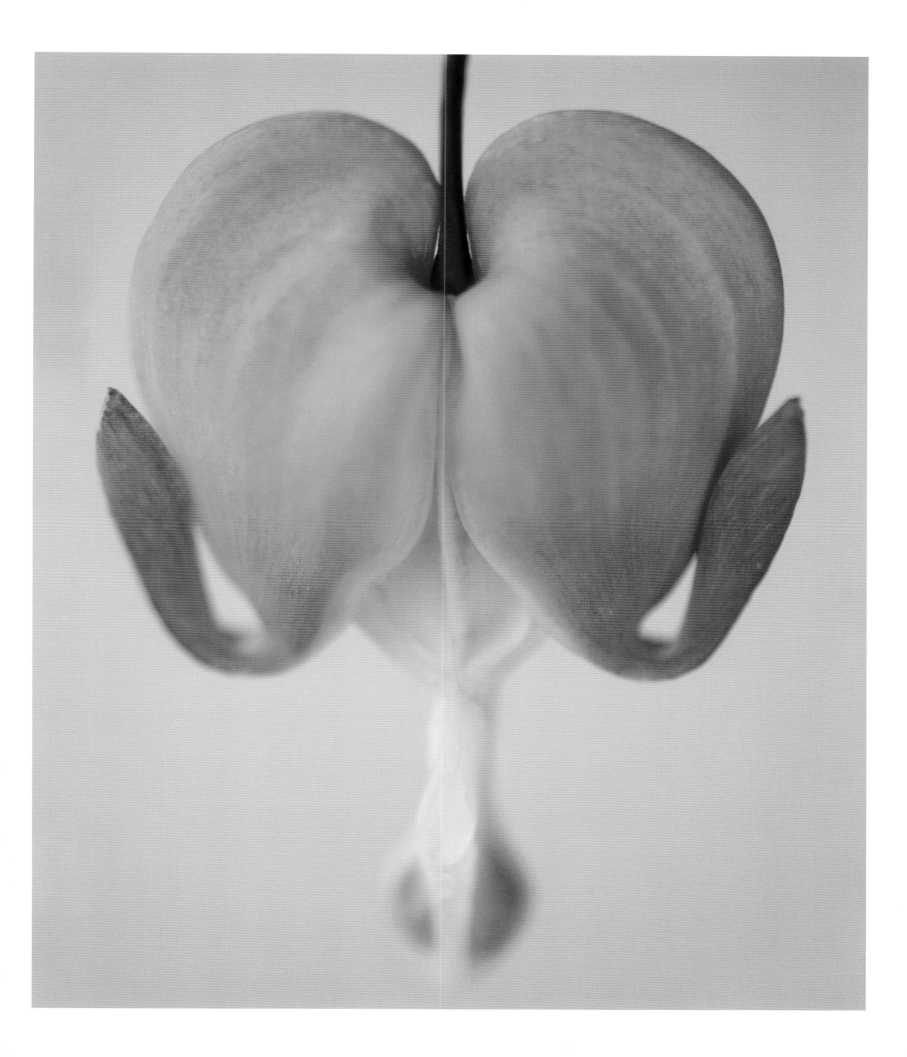

near Paris – all of them gardens with good structure. He is fond of strong bones in gardens, and has recently been photographing French gardens, especially in the south, responding to their structure. 'I don't get on well with cottage gardens,' he says; 'they're too busy.' He prefers to photograph early and late in the year, when there are few distractions and the light is better.

Early in our discussion we talked about how we are both easily bored, and how English gardens are all too often unadventurous. Clive believes gardeners are always trying to copy one another: 'It's odd how we feel a historical pressure to make a particular kind of garden. I like places that really try to be different.' Among these more radical gardens he lists The Old Zoo, Lancashire (a formal, contemporary garden, which incorporates a collection of sculpture); Througham Court (a Gloucestershire garden on scientific themes); and La Bambouseraie (the oldest bamboo collection in France). Another favourite that is a real mould-breaker is Lady Farm in Somerset, where the owner, Judy Pearce, has been inspired by a variety of different places to create a contemporary garden that fits perfectly into its surroundings of rolling green hills.

'I nearly always manage to get into the gardens I want to,' says Clive. 'Finding good gardens is about networking, word-of-mouth contacts and being charming, and of course it's much easier when you have a reputation.' He recalls the friendships that have built up: 'I used to love visiting Hadspen and seeing the Popes. I loved their sense of humour. I always enjoy seeing John and Lesley Jenkins at Wollerton Old Hall; and Gina Price at Pettifers is near my studio: it's a lovely garden and she lets me cut plants for work, which is great.'

Mainau, a garden on an island in Lake Constance, in south-western Germany, is a place Clive particularly loves, for its feeling of being a world apart. His favourite garden, though, has to be Keukenhof, a park in The Netherlands, famous for its displays of spring bulbs. 'It really is the best garden. The smell of all those bulbs is fantastic. You cannot be depressed there – it's the most inspiring place I have ever been to.' He is not uncritical of Keukenhof, however: 'A few years ago I went around it as part of a Floriade event [an international gardening exhibition held every ten years in The Netherlands], and I had a go at them because everything was the same as it had been ten years before. Jacqueline van der Kloet [a garden designer who has made a career from designing public plantings with bulbs] was part of that group, so I like to think that they might have listened to what I said. Since then they have become much more colour-coordinated, and I know Jacqueline has been involved.'

Garden photography involves turning the zoom ring on the camera a lot, going from a wide angle, to capture the sweep of the landscape, to close-ups of individual plants. Over time Clive has developed a particular feel for the close-up, exploring the beauty of the plant as an art object, and it was this interest that led to this book: 'I've been working on it for three years. I usually pick the perfect specimen flower and take it indoors, so I can control the light; you can't manipulate the light outside. Indoor work is new to me, though.'

Clive likes growing plants that he can pick at a stage of perfection, such as poppies: 'I sometimes get a passion about particular flowers, although I always come back to tulips, which I've always loved – they're flowers with good structure – and dahlias.' He describes a 'constant trawl' through nurseries and gardens. 'In particular, in this book, I want to show that you can get amazing plants from nurseries. There are so many dedicated people: such plantsmen as Hugh Nunn at Harvington Hellebores in Worcestershire, Graham Gough at Marchants Hardy Plants in Sussex, David Austin for roses

and Raymond Evison for clematis. The whole process of producing different varieties fascinates me, and I love to photograph different versions of a plant. I feel as if I have hardly begun with orchids: they're enthralling.'

Clive has always 'had a thing' about colour, but his views have changed: 'I used to love really strong colours, but now I am a lot more subtle (partly through doing this book), making backgrounds tune in with the flower, rather than clash.' He is convinced that he has made a successful career in flower photography through being good with colour. 'I really don't like non-colour-coordinated borders – the sweet-shop look.'

Many of Clive's subjects could be called cult plants: species that are not conventionally beautiful or colourful, but which have intricate markings in brown, fawn and cream. These genera – arisaemas, paphiopedilums, fritillaries – tend to attract enthusiast growers with an obsessive streak. 'I'm drawn to the unusual, things people don't normally see', he says. 'I approach flowers as though they are people; in particular, I like flowers with personalities, such as arisaemas, which look like someone's head from the back.'

An obvious question concerns Clive's own garden. The answer is that he does have one, and it is rather a nice one, although he confesses to being 'a bit of a fair-weather gardener'. His garden plays a role in his work: 'I like to design stuff to photograph, putting together hardscape and plant combinations to be photogenic, then photograph it to death.'

Around 500 square metres (5400 sq. ft) in size, and enclosed by walls of warm Oxfordshire stone, the Nichols family garden was once a cowyard,

part of a large complex of farm buildings. One wall is painted dark red. 'I love painted walls in the garden', Clive says. 'People do it abroad, but not in the UK.' The planting is mostly of low herbaceous perennials and grasses, all carefully colour-schemed. 'I want flowers that pick up the colours of the stone,' he explains, 'so there are no yellows or whites.' Grasses include the delightfully feathery *Stipa tenuissima* and a couple of magnificent *Ampelodesmos mauritanica*, a tall species (2.5 metres/8 ft) that forms bulky clumps but with very airy seed heads on wand-like stems. Clive's favourite perennials include the dark-red *Pulsatilla vulgaris* var. *rubra*, the violet–blue *Salvia nemorosa* 'Caradonna' and the soft pale-pink *Astrantia* 'Roma'.

An important question for any photographer these days is how they have handled the change to digital photography. Clive left it later than many of his colleagues: 'I switched in 2006', he says. 'I was dead against it at first; people didn't know how to process digital files properly, and I actually nearly gave up … but over the last few years there have been big improvements, including a hugely increased ability to control colour; it's a software improvement.' Looking back, he says that 'with film you were stuck with what you shot, but digital gives you greater control of the finished product. It does take a lot of post-production work, but you can tweak the picture to get the effect you want, and it is possible to get colours much closer to what they should be.' One great advantage is that 'it is possible to shoot at much lower light levels, so you are not so dependent on artificial light if you are working indoors; you can register the shadow details of natural lighting.' This book, then, represents a master in his field working with a new technology that is finally coming of age.

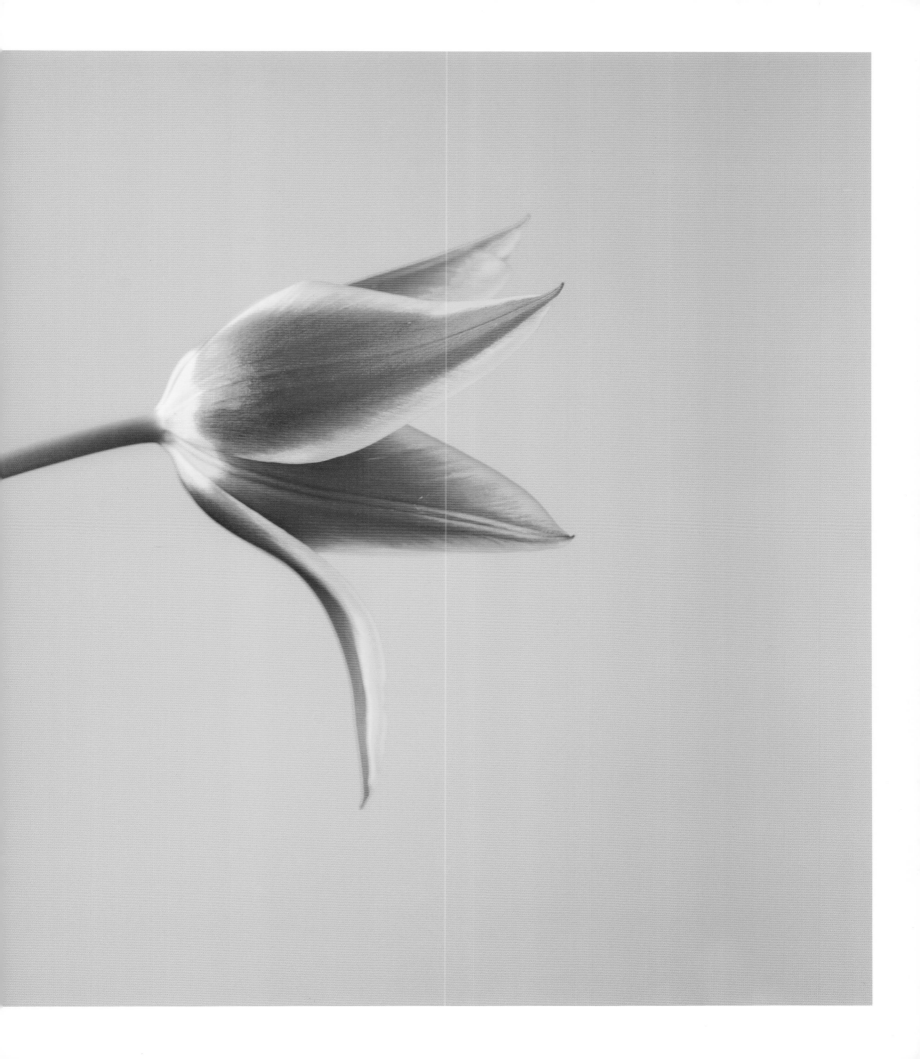

Allium 'Globemaster'

Not long ago, the idea of growing onions or garlic as ornamental plants would have been seen as odd, to say the least. A few species had for some time been grown in gardens by aficionados of bulbous plants, but it was only during the 1990s that designers and other creators of fashion in the garden world began to pay them serious attention and raise their profile with the gardening public.

Of the many members of the genus *Allium*, it is the so-called 'drumstick' kinds that have seized the gardening imagination. There is nothing like them in the plant world: their almost spherical heads packed with hundreds of tiny flowers atop tall, straight stems come with little foliage, the strap-like leaves at the base often hidden by surrounding plants. Their colours, which vary from pink to deep mauve, are almost a sideshow, for it is the simple, elegant and exceptional form that has proved so popular.

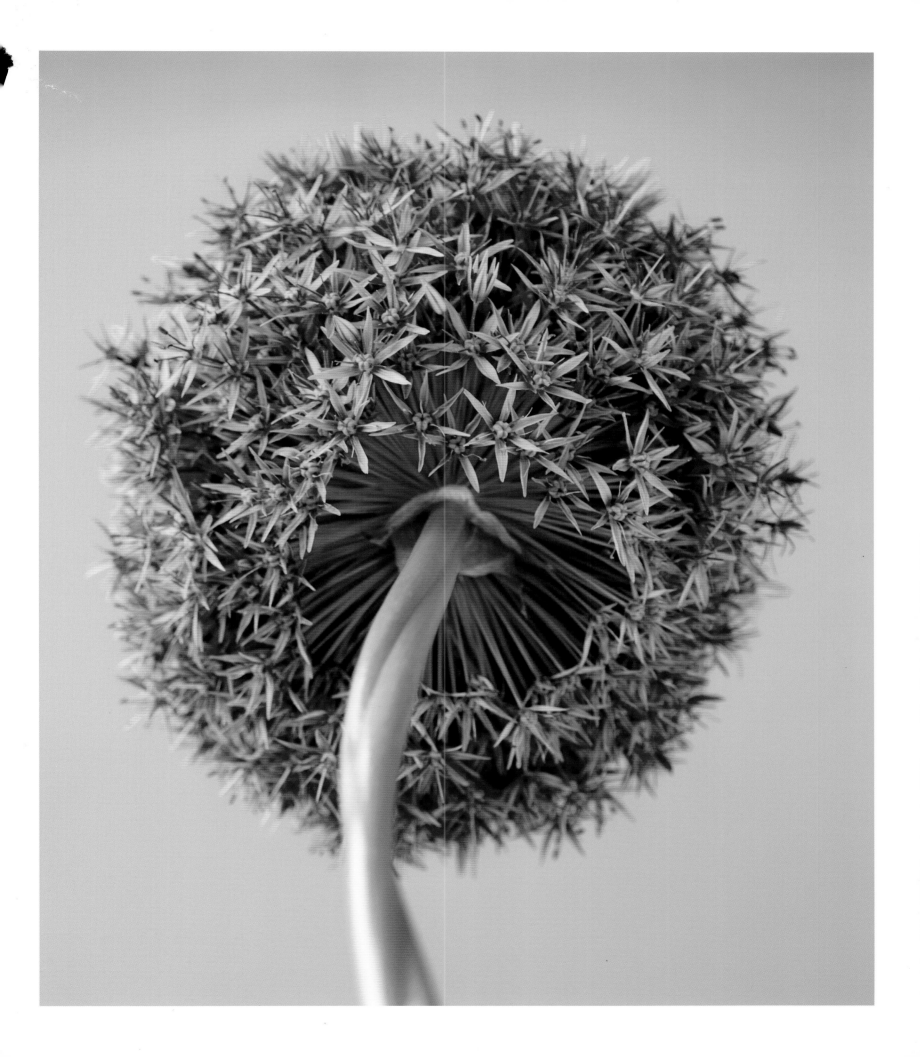

Adonis multiflora 'Sandanzaki'

Adonis was at the centre of a number of the so-called 'mystery cults' of the ancient world, a male figure of death and rebirth, worshipped largely by women, including those of Sappho's circle on Lesbos. It is the ideal name, then, for a genus that includes several of the first species to flower after the cold winters of Central Europe and Asia. In Japan, *Adonis multiflora* appears to be an ancestor of a range of selections that have been raised over the last two centuries; they are popular as cult plants, grown and exhibited by aficionados who especially covet forms with anemone- or peony-shaped flowers. The plant played a central role in the celebration of the Japanese Spring Festival (New Year, until the adoption of the western Gregorian calendar in 1873); the festival is still celebrated informally, and *Adonis* plants are still used to decorate household shrines.

Tulipa 'Spring Green'

The green-streaked, goblet-shaped blooms of
'Spring Green' are beloved of florists, who value
them for their long life, their tall, straight stems
and their fresh, unusual colouring. As the name
suggests, viridiflora tulips (of which this is one)
all have a touch of green somewhere in the
flower's make-up: some are exotic, candy-
striped combinations of ivory, green, pink and
red; others, such as this one, are elegant in
their simplicity. Viridiflora, or 'viriscent', tulips
were first described by Clusius (Charles de
l'Écluse, 1526–1609), a Flemish doctor and key
botanist of the time, in his book *Rariorum
plantarum historia*, published in Antwerp in 1601.

It is some centuries now since prized tulips
were grown one to a bed, surrounded by bare
soil, the better to be admired. Viridiflora tulips
are valuable as cooler elements in schemes that
include the hotter ends of the colour spectrum.

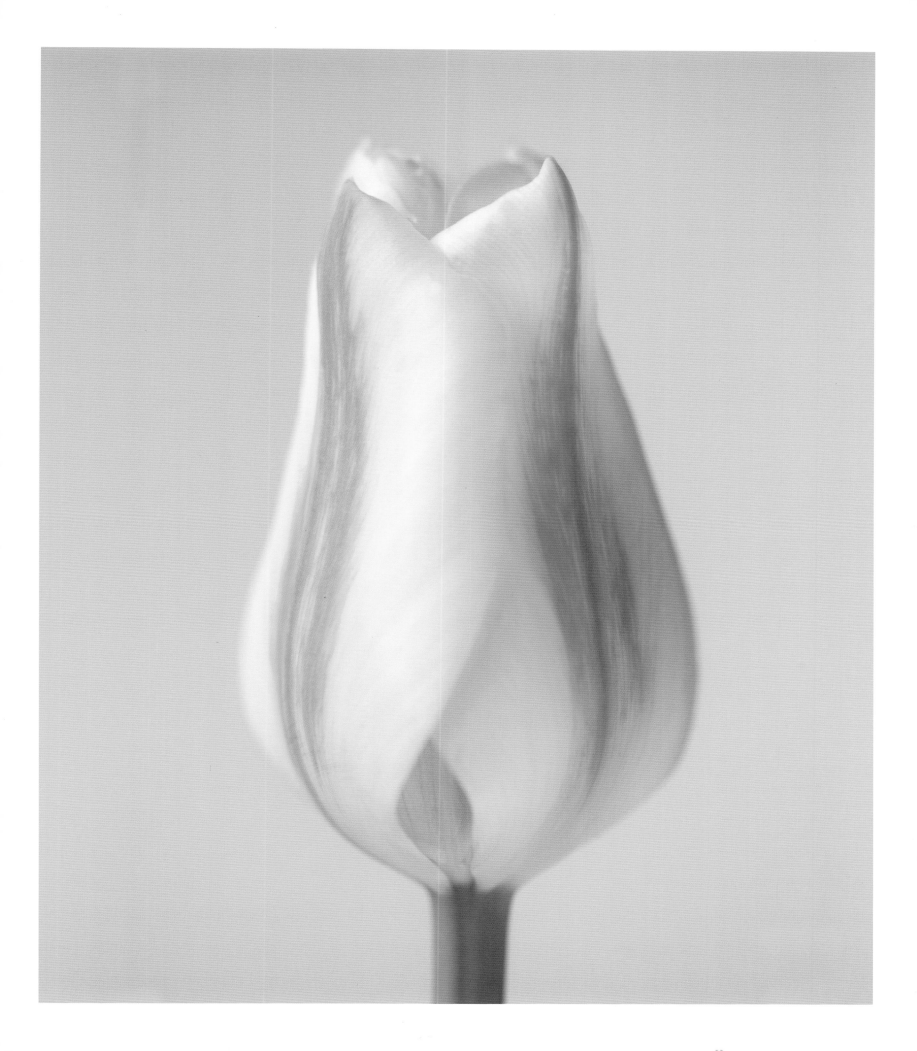

Muscari armeniacum 'Valerie Finnis'

Grape hyacinths are spring-flowering bulbs named for the hyacinth-like shape of the flower head and the rounded form of the tiny individual flowers. The flowers have an odd habit of squeaking when they are rubbed together. Mostly short, at around 20 centimetres (8 in.) tall, and nearly all blue, *Muscari* are not spectacular or commercially important enough to attract large-scale breeding programmes; named cultivars are usually the result of a dedicated grower or enthusiast picking out an exceptional plant from a flower bed or seed tray.

Muscari are blue in the way that most blue flowers are: not blue at all, but purple or mauve, because the colour is a mixture of two primary pigments, blue and red. Mutations in which the blue is missing produce a slightly washed-out pink flower, but if the red is absent the result is one of the most exquisite powder blues to be seen anywhere in the plant kingdom. 'Valerie Finnis' is the best known of the small number of varieties with this colour.

The plant is named after a well-known personality in the British garden scene, Valerie Finnis (1924–2006), who discovered it in a batch of seedlings. She trained as a gardener in the days when few women did, at Waterperry Horticultural School for Women in Oxfordshire, and stayed there as a teacher, also becoming a successful photographer of plants and gardens and an internationally famous lecturer. Unlike most garden photographers, she rarely shot gardens without people; her archives are now one of the most valuable sources of photographs of the United Kingdom's most famous garden personalities – often shown in their gardening tweeds, getting their hands dirty.

Valerie's passion was for alpines and small plants compatible with them, such as varieties of *Muscari*. It is difficult to know whether her biggest interest was in plants or in people, since she seemed to know everyone in the garden world. Those of us who started out in the nursery trade have fond memories of her visiting Royal Horticultural Society flower shows, encouraging and advising us; her iconoclastic sense of humour and theatre was never far away. This little grape hyacinth is the perfect way to remember her – vivid but modest.

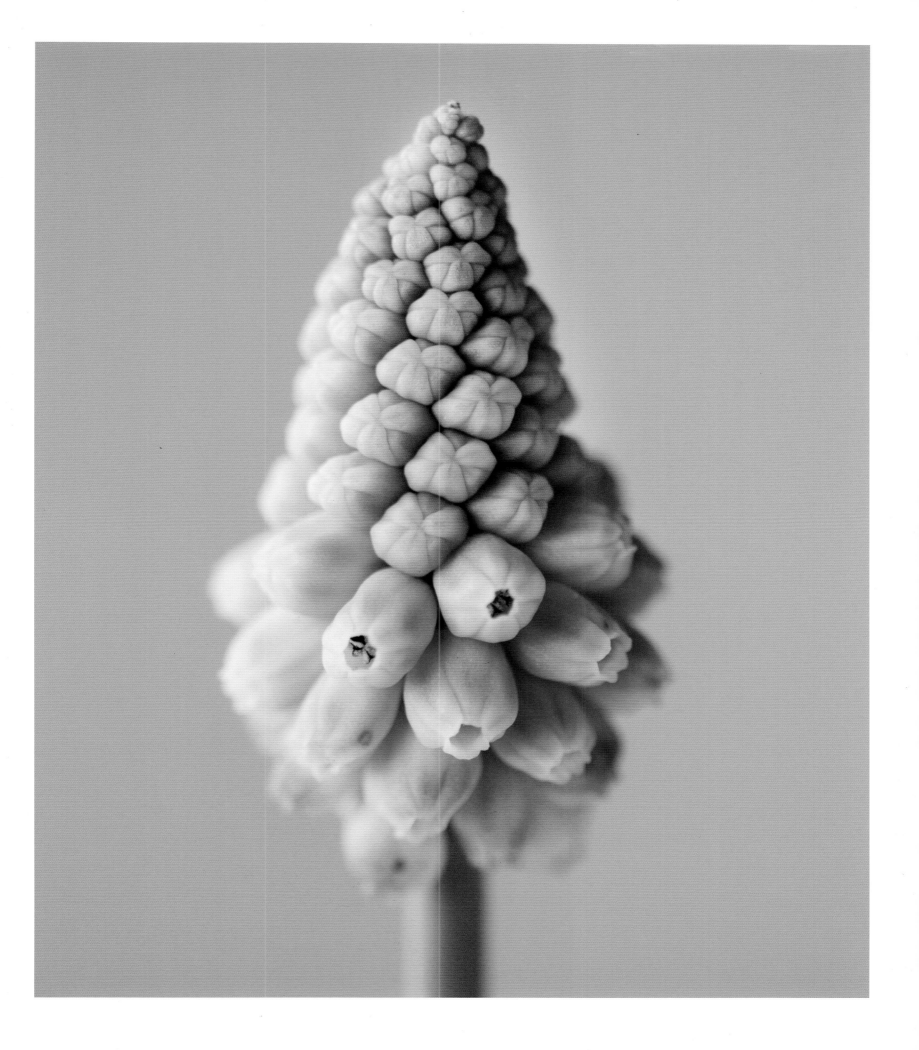

x *Doritaenopsis* cultivar

Plant species can be made to cross (hybridize) with one another, and it is on this basis that much of our garden flora has been made, but they do not usually cross between genera (the group represented by the first part of a Latin name). Orchids, however, are different, and show an extraordinary readiness to hybridize across boundaries that would be insurmountable in other plants. Gardeners sometimes refer to plants that cross easily as 'promiscuous', usually pronounced with a rather prurient smack of the lips, and by these standards orchids are positively orgiastic.

x *Doritaenopsis* is a cross between *Doritis* and *Phalaenopsis* (see pp. 162–63); both genera are South-east Asian rainforest species, and the hybrid makes an excellent and easy houseplant. Its name is logical and easy, but what happens when crosses are made between multiple genera? A wholly new name has to be invented, and the results are becoming ridiculous, the following being some recent examples: *Nornahamamotoara*, *Georgeblackara*, *Yonezawaara* and *Charlieara*.

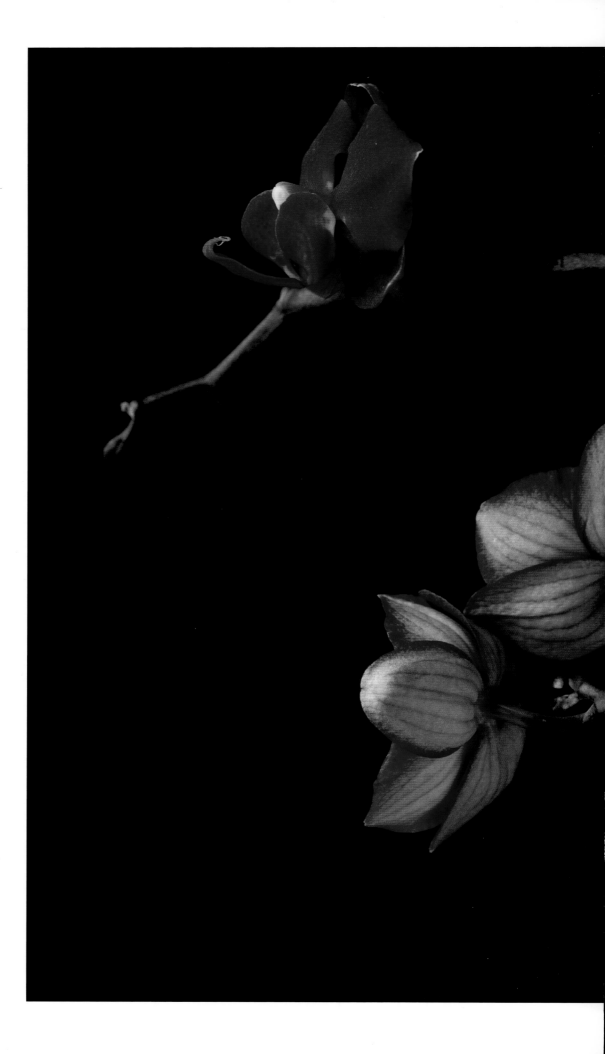

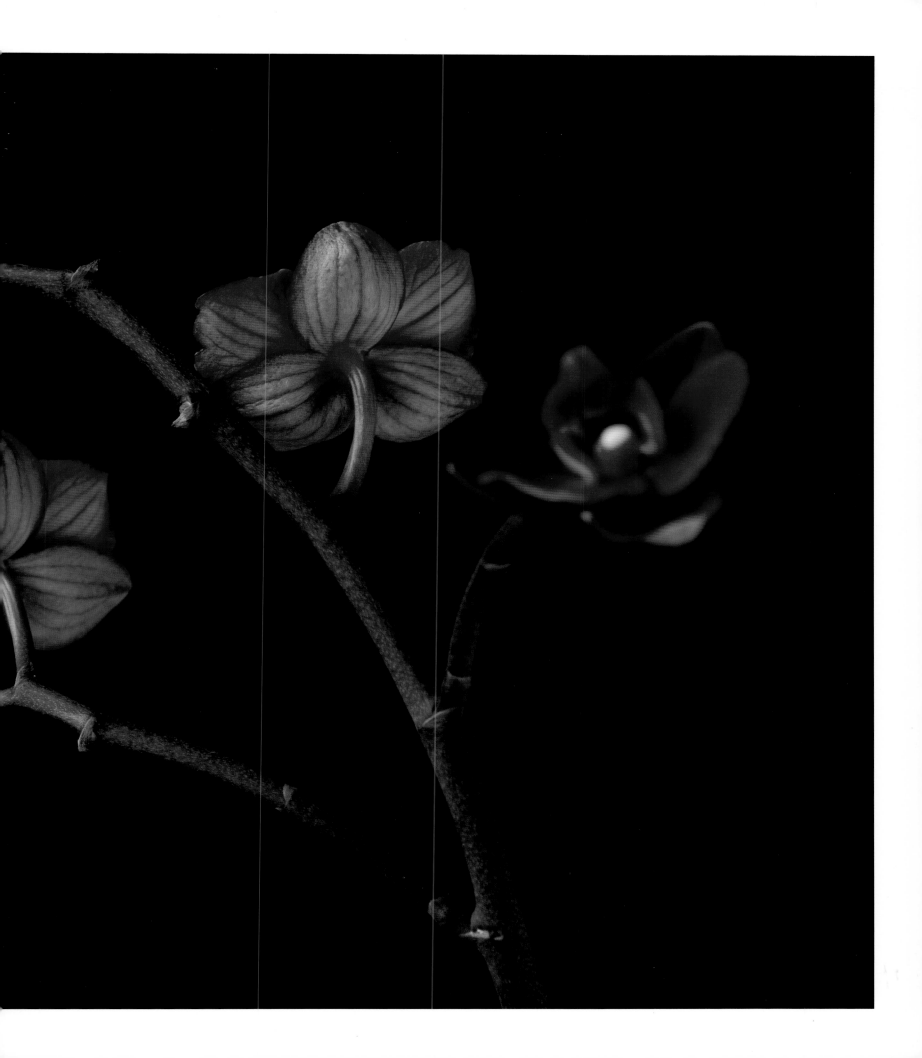

Ranunculus asiaticus

It is ironic that the Dutch – with their wet fields, often recently claimed from sea or marsh – should have become such successful purveyors of *Ranunculus* and tulips. Both came from the Middle East, and both like a period of summer dormancy with no competition from other plants. How much more logical it was that southern California, with a climate far closer to that of *Ranunculus*'s homeland, should become a major producer. In the 1920s a father-and-son team, Frank and Edwin Frazee, began to grow the plants near Highway 101 in Carlsbad, north of San Diego. Alongside freesias and gladiolus, the ranunculus made a spectacular impression when the fields were in flower. 'If I had one penny for every picture that has been taken of those fields, I'd be a rich man', Edwin Frazee is reported to have said. He and his family did well enough, for the fields are still a local tourist attraction.

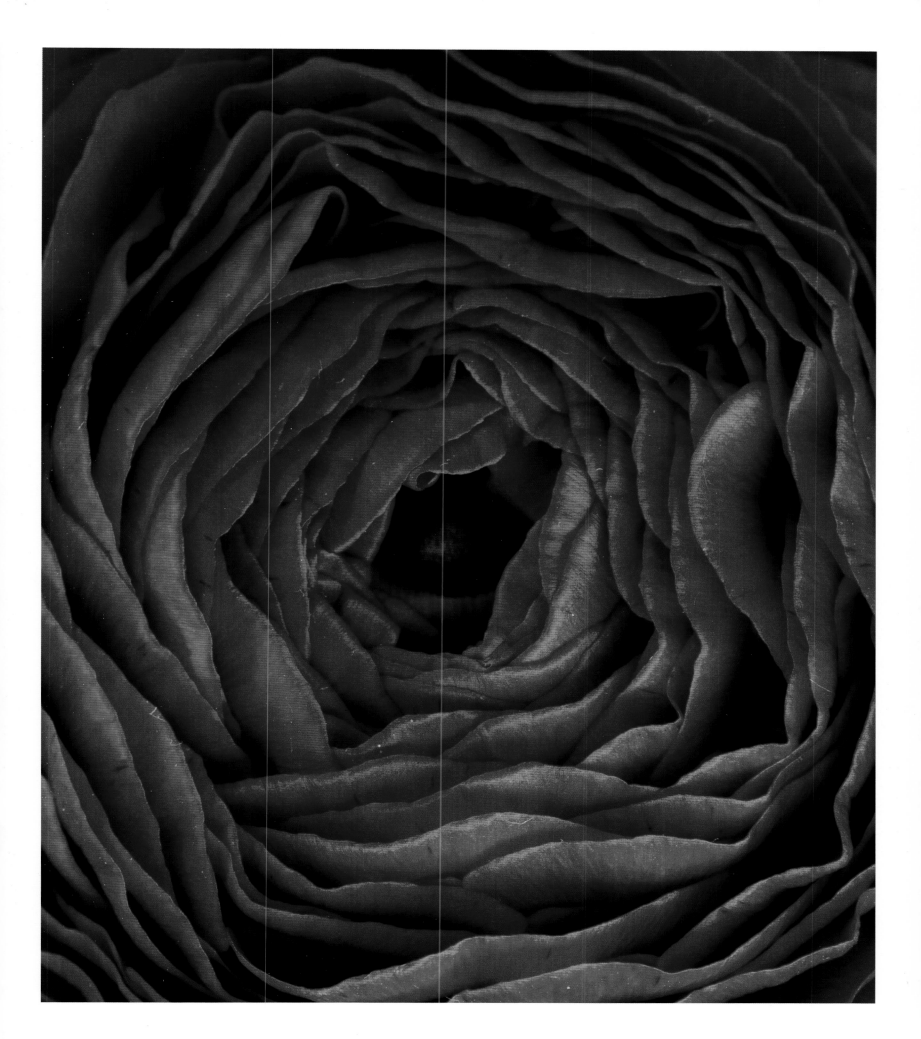

Nerine bowdenii

As the wind and rain of autumn herald a time
of year when there will be little colour in the
garden, a sudden flash of pink may surprise
those unfamiliar with nerines. A genus of some
thirty species, all from South Africa, the hardy
Nerine bowdenii is most frequently seen growing
at the base of house walls. Nerines are among
those plants that seem to flower best when
ignored, and when growing in what seem to be
less-than-perfect conditions. Clearly not minding
the poor, rubble-filled soil so often found
around building foundations, the plants benefit
from the heat radiated by stone and brick.

The flowers usually precede the leaves, which
grow over the winter to die back in the summer.
This life cycle is typical of plants that grow in
Mediterranean-type habitats (with hot, dry
summers and cool, wet winters), enabling
them to avoid drought by taking advantage
of the mild winters and long, cool springs of
maritime climates.

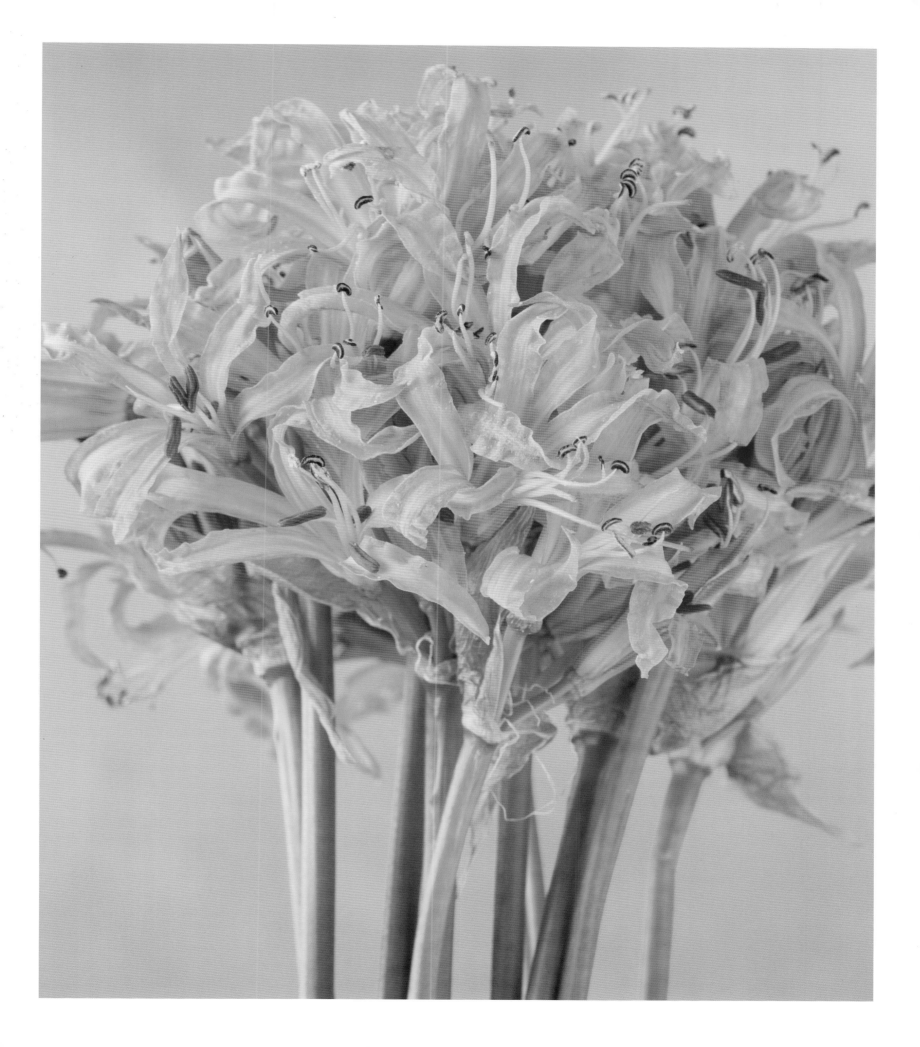

Crocus 'Blue Pearl'

Crocus chrysanthus 'Snow Bunting' (page 36)

Crocus chrysanthus 'Zwanenburg Bronze' (page 37)

In many parts of central and southern Europe, as soon as the snow melts, the crocuses appear and cover the woodland floor with their tiny blooms. This natural flower carpet has been emulated in many parks and gardens, where crocuses are the ideal bulb to follow the first snowdrops. While they always look good close up – and of course one has to stoop in order to appreciate the very fine lines or gradations in hue that often add much to the colour – crocuses are best appreciated en masse. Since they are easily integrated into grass, for their foliage does not remain long to get in the way of mowing, they can be spectacular when naturalized in lawns.

A particularly good example of crocus choreography is in Copenhagen, in the gardens of Rosenborg Castle, where a vast area of perfectly level lawn in front of the Renaissance building is one of the city's most important public spaces. Spring sees a display of crocuses covering an area 160 x 11 metres (525 x 36 ft), arranged in rectangular blocks of different colours, from white to deep purple. The effect is of an abstract painting, but with a shimmer produced by the individual flowers. The lawn was planted in 1968 with 200,000 bulbs in a collaboration between the royal garden staff and landscape architects Ingwer Ingwersen and Erna Sonne Friis.

As is the case with many Mediterranean plants, crocuses were highly regarded by the ancient Greeks and Romans. One species (*Crocus sativus*) is the source of the spice saffron; others were used as dyes, producing a rich colour similar to that of the most highly regarded dye of all, imperial purple. The crocus was supposedly the result of the Roman god Mercury turning a companion, whom he had accidentally killed in a game of discus, into a flower. Even today, graves in parts of Greece are planted with crocuses, for the flower has traditionally been a symbol of hope in much of Europe.

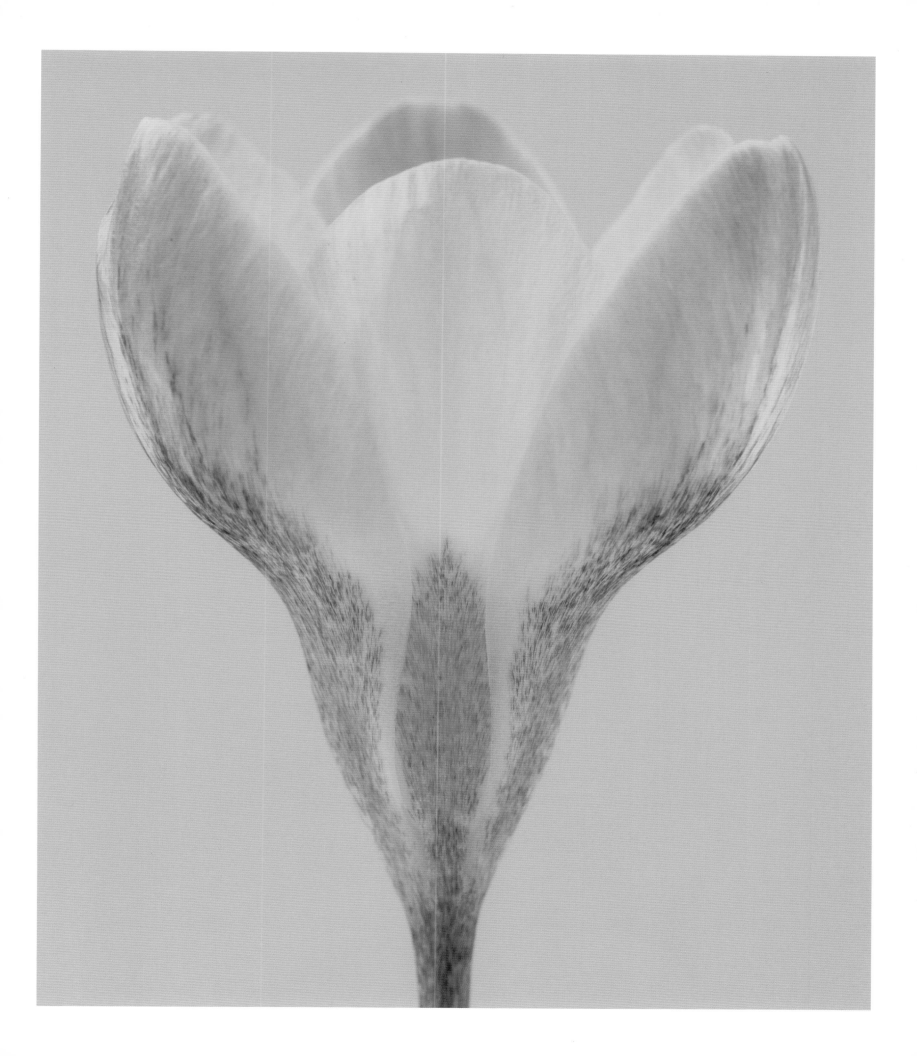

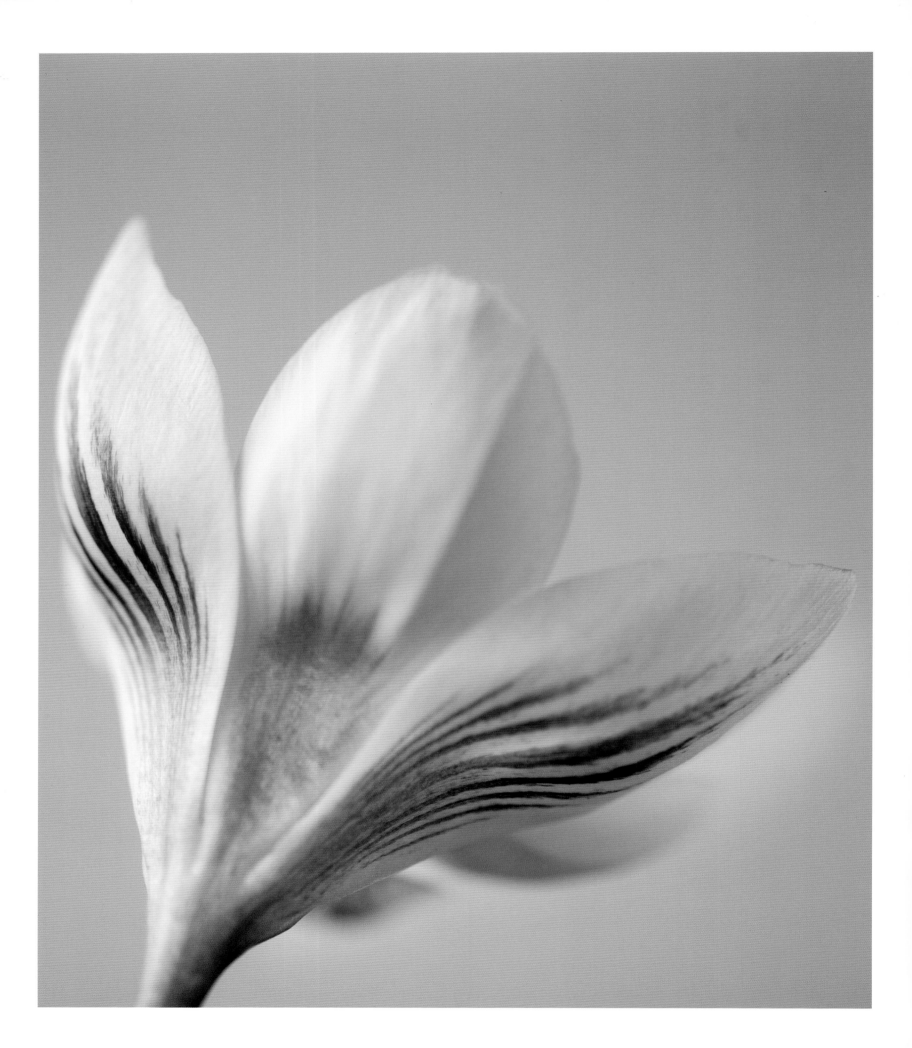

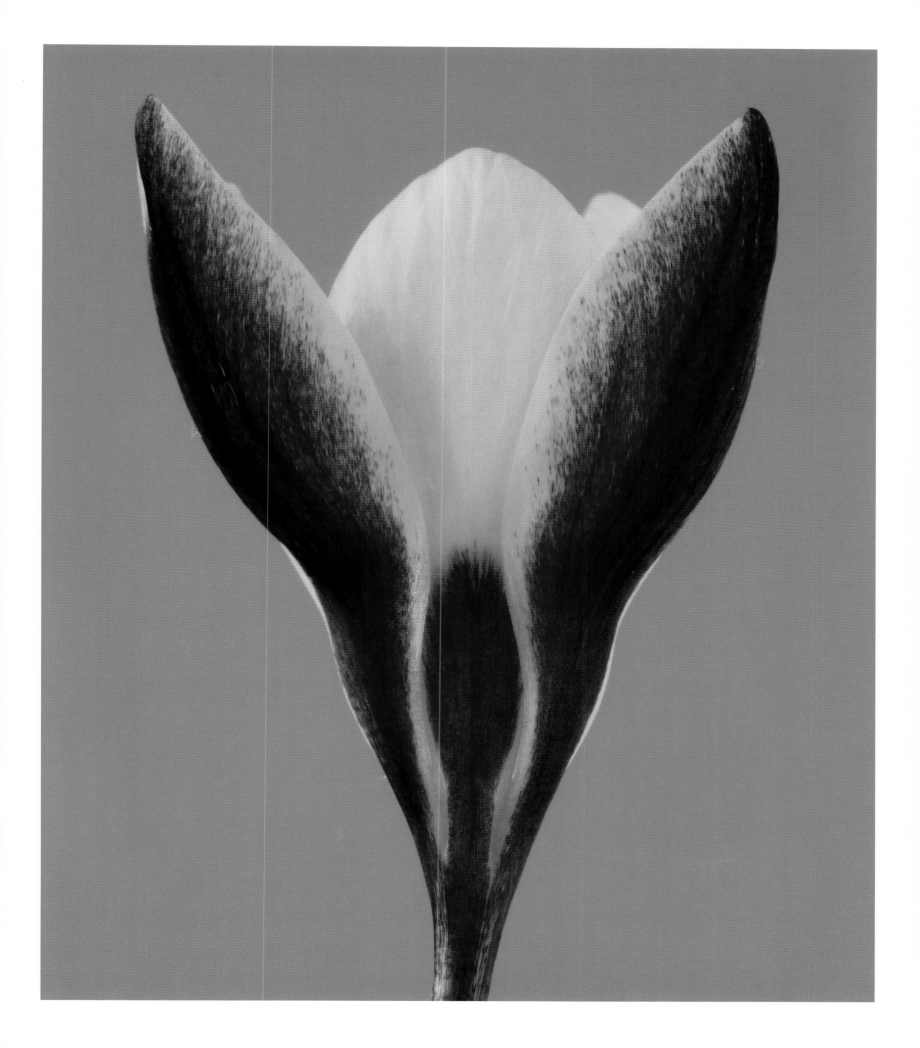

Hydrangea macrophylla 'Renate Steiniger'

'Mophead' hydrangeas are undeniably highly
artificial plants, dependent on humans for
their propagation and continued existence.
'Natural' hydrangeas have flower heads of tiny
fertile flowers surrounded by a ring of large,
conspicuous infertile flowers; the so-called
'lacecap' hydrangeas still maintain this form
of flower. Mopheads, however, are nearly all
infertile, so whereas the lacecap is a delicate
geisha, graceful but still in possession of her
fertility and sexuality, the mophead is essentially
showy but barren, a camp and posturing eunuch.

The decadent mophead has always been popular.
Not only do many love its blowsiness and great
size, but also it is relatively easy to grow, and
unlike many popular shrubs does not become
too large, flourishing even in a container. The
flowers are also remarkably long-lasting: if cut
just before they die, they can be dried, turning
deep, dark and rather mysterious shades.

'Renate Steiniger' is a 'blue' hydrangea; the
inverted commas are necessary because
sometimes it is pink. Confused? It is one of
several hydrangeas that illustrate the principle
of hyperaccumulation. This is when plants take
up significant amounts of metals from the soil,
although not necessarily because they need
them. It is a useful characteristic to us when
the metal concerned is toxic, since such plants
can be used in bioremediation, cleaning soils as
they grow. In acid soils, hydrangeas accumulate
aluminium, which results in flowers coloured by
pigments of a spectacular icy blue. In neutral or
alkaline soils, however, the aluminium remains
insoluble and the plants cannot absorb it, and
so the pigments are pink.

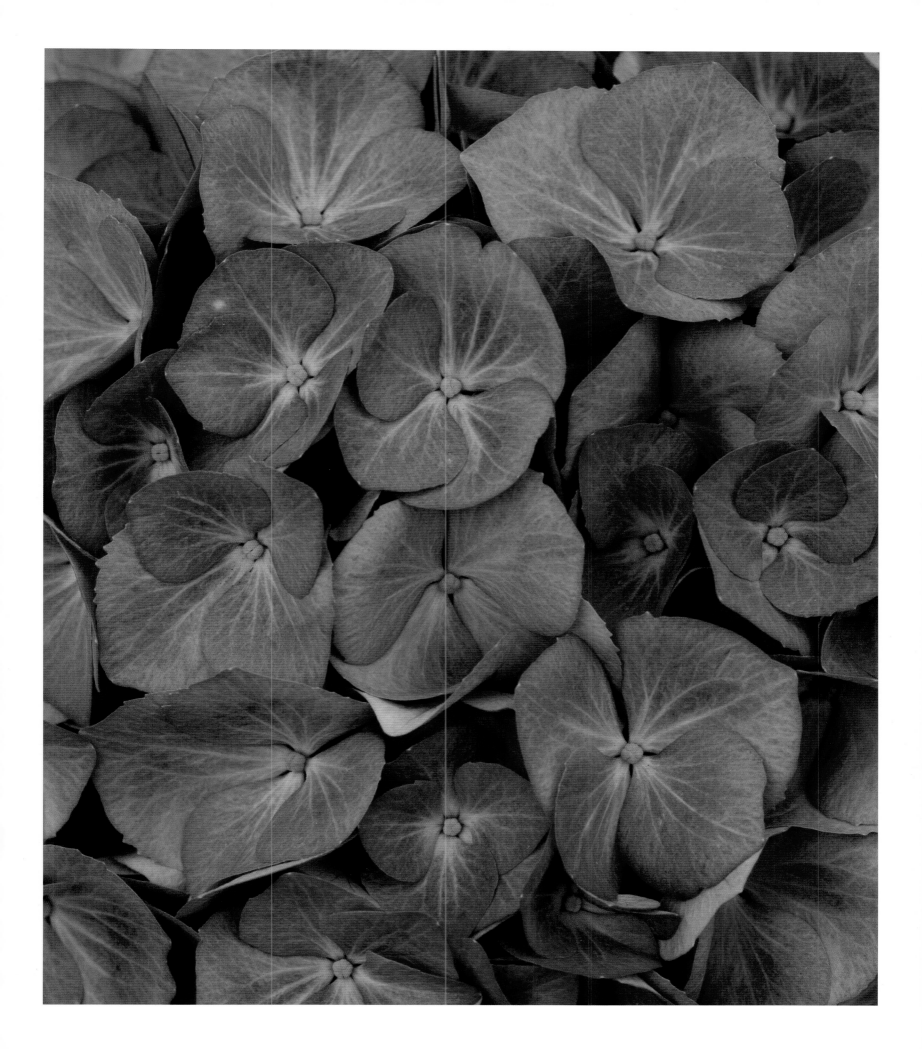

Hepatica nobilis

The Latin name *Hepatica* refers to this plant's former use as a treatment for liver problems, based on the medieval Doctrine of Signatures, which stated that if something looked like an organ of the body, it could be used for treating that organ. Another example was 'lungwort', members of the genus *Pulmonaria*, which have spotty leaves that resemble lungs.

The most widely distributed of a small genus of spring-flowering woodland plants closely related to anemones, this species has a regional form, *H. nobilis* var. *japonica*, from which have been selected cultivars that are currently among the most expensive plants in the world. Some sell in Japan for the equivalent of thousands of pounds. Of all the many plants that are the object of gardening cults in that country, this is probably the highest in status. It is certainly the most jewel-like.

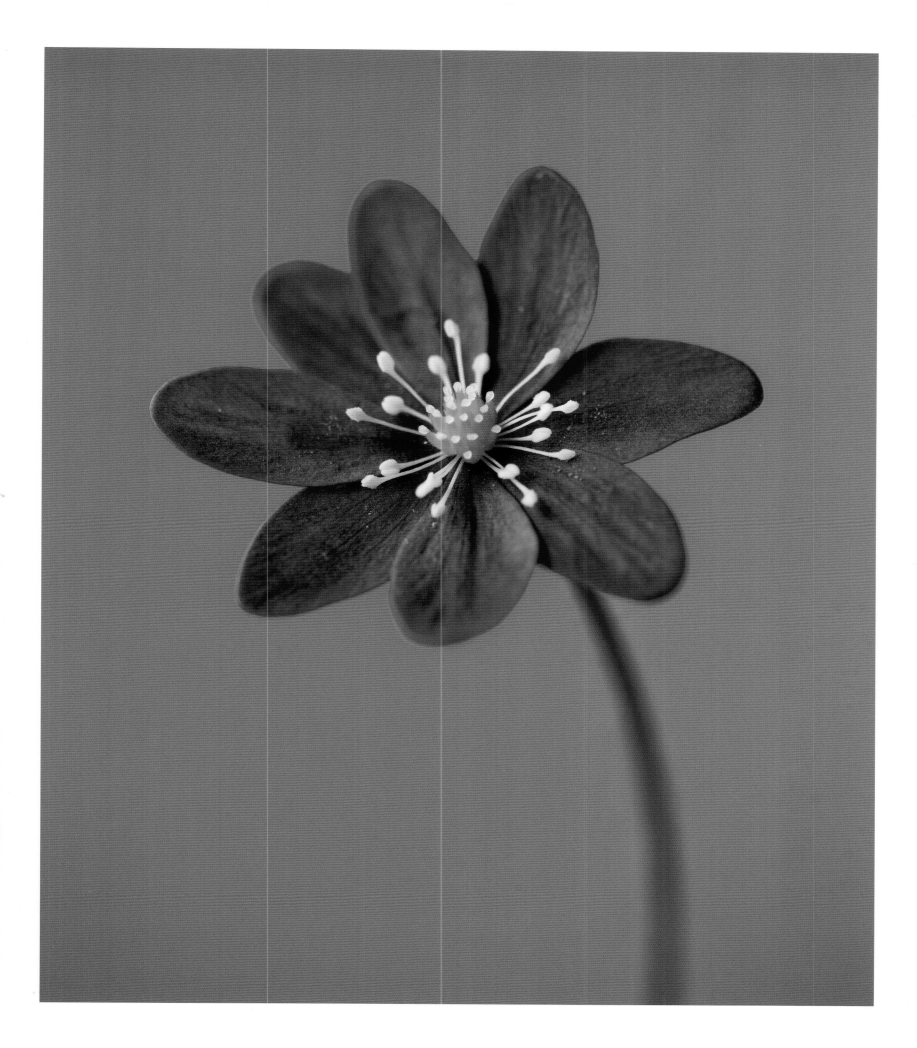

Astrantia 'Roma'

'What are you growing that for? It looks like a weed.' That is the kind of remark most people would have directed at growers of astrantias in the days when, to be worth having, a plant had to be bright and cheerful. Common to woodland-edge habitats in Central Europe, astrantias are quiet and subtle, lush of leaf and pale of flower. Despite appearances, they are members of the *Apiaceae*, or *Umbelliferae*, family, which includes cow parsley, hogweed, Queen Anne's Lace, fennel and others with many tiny flowers packed into radiating, plate-like heads.

The rise of the astrantia began in the 1960s, when gardeners began to look more carefully at plants they had previously ignored. Astrantias are the quintessential 'new perennial': subtle, unusual of form, robust and low-maintenance. In the beginning there were only *Astrantia major* and a few less easy-to-grow related species. A sub-species with more prominent outer bracts, *involucrata*, added a frisson of difference. Then odd colour forms began turning up. The plant is so common in the wild that it was easy to collect seed from anything that looked a bit different. 'Roma' was picked out of a batch of seedlings by the Dutch garden designer and nurseryman Piet Oudolf, and launched in 2000. For many years Oudolf has worked with a local farmer to trial plants on a large scale. Thousands of seedlings are planted out and a very few selected for further development, the rest being ploughed in at the end of the season. The development of good new varieties often depends on this kind of rigour.

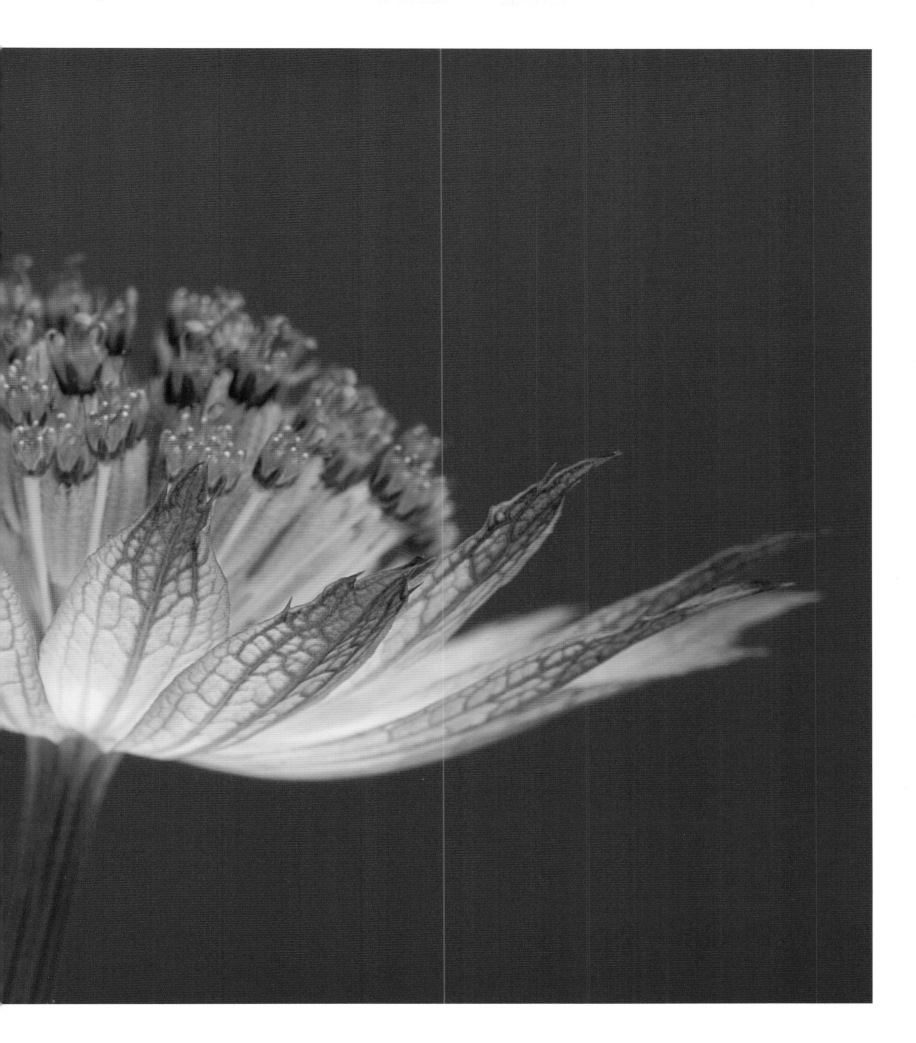

Rosa 'Darcey Bussell'

In 1955 the Englishman Graham Stuart Thomas (1909–2003) published *The Old Shrub Roses*, and embarked on a mission to rescue varieties in danger of extinction – mostly those bred in the nineteenth and early twentieth centuries. The 'old roses' then began a long climb to popularity, at first through rich trendsetters, many associated with the British aristocracy (for whom nostalgia is second nature). That many of these roses were poor garden plants, flowered only once a year and were available in a small range of colours limited their popularity.

Then David Austin (born 1926) arrived on the scene. In 1963 he had hit upon the idea of crossing old roses with modern ones. Starting his own company, David Austin Roses, in 1969, he began to produce 'English roses' to combine the best characteristics of old and new. 'Darcey Bussell', released in 2006, is one of the few real reds the company has produced (reds are particularly difficult for breeders to get right). It is named after the highly acclaimed ballerina, who was appointed principal at the Royal Ballet in London at the age of just twenty.

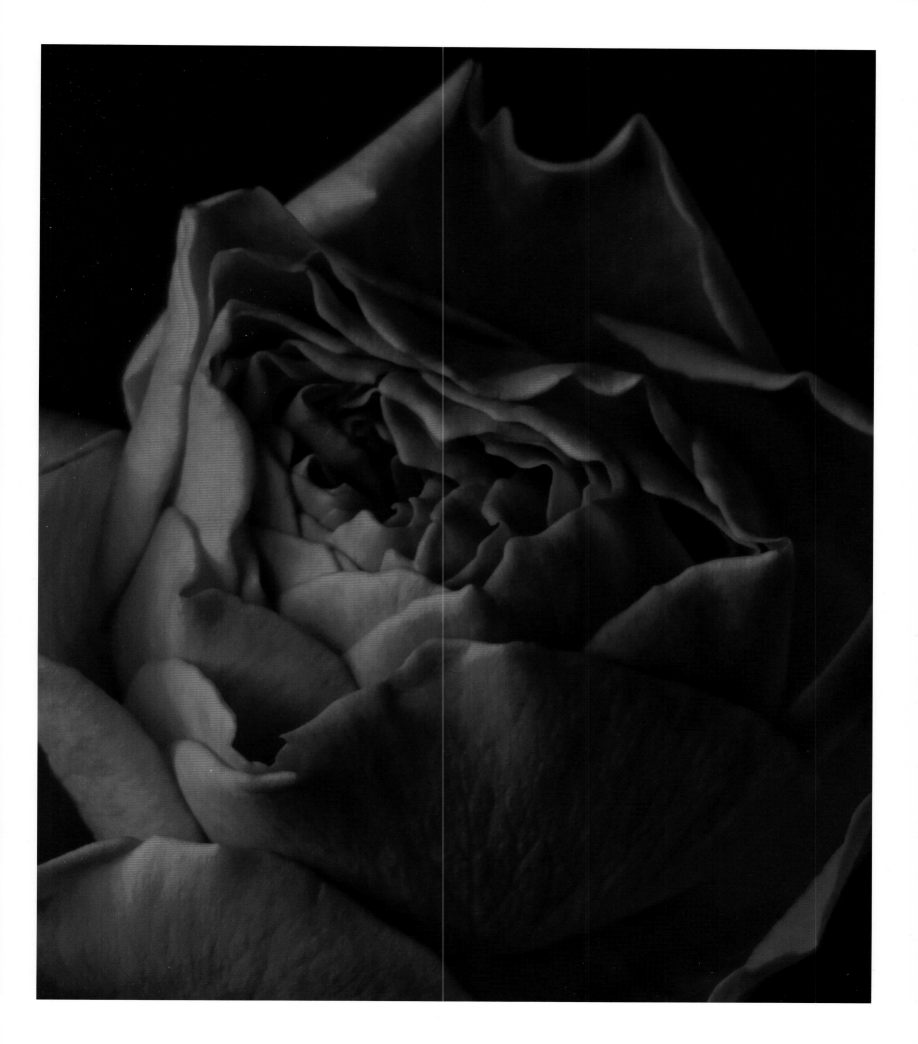

Iris 'Harmony'

Iris danfordiae (overleaf)

At the end of winter, everyone – not just gardeners – wants to see a sign of spring. Plants are needed that respond quickly to the change in the season, and perform dramatically. The plants to do that the most effectively are often those from extreme Continental climates, where spring is a brief interlude between the bitter cold of winter and the heat of summer. Such plants do not always make long-lived garden plants, however (see pp. 112–13).

Professional plant-hunter Jim Archibald knows *Iris danfordiae* in the wild, where it grows very high up in the dry, scrubby steppe of Turkey. 'It is much smaller,' he says, 'a more intense yellow … utterly, utterly different from the cheap clones sold in garden centres.' Nevertheless, few of us would complain about the rich yellow of this diminutive and cheerful spring flower.

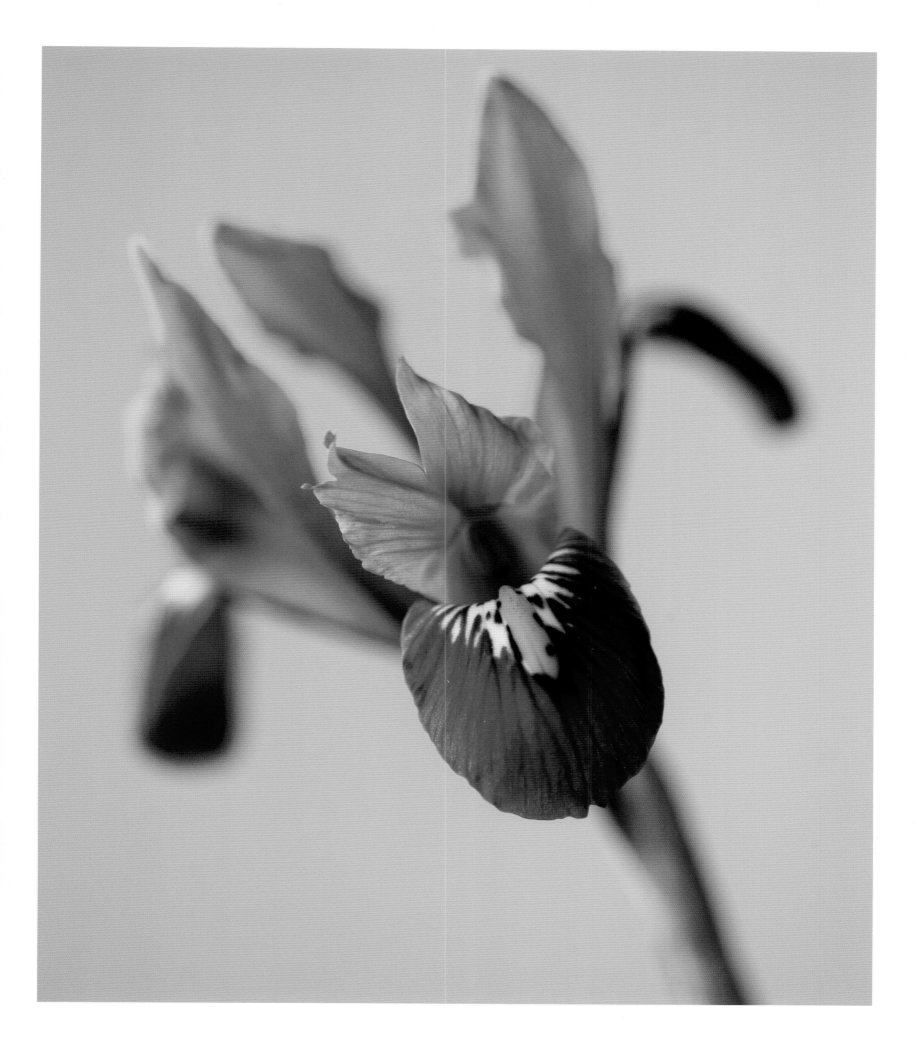

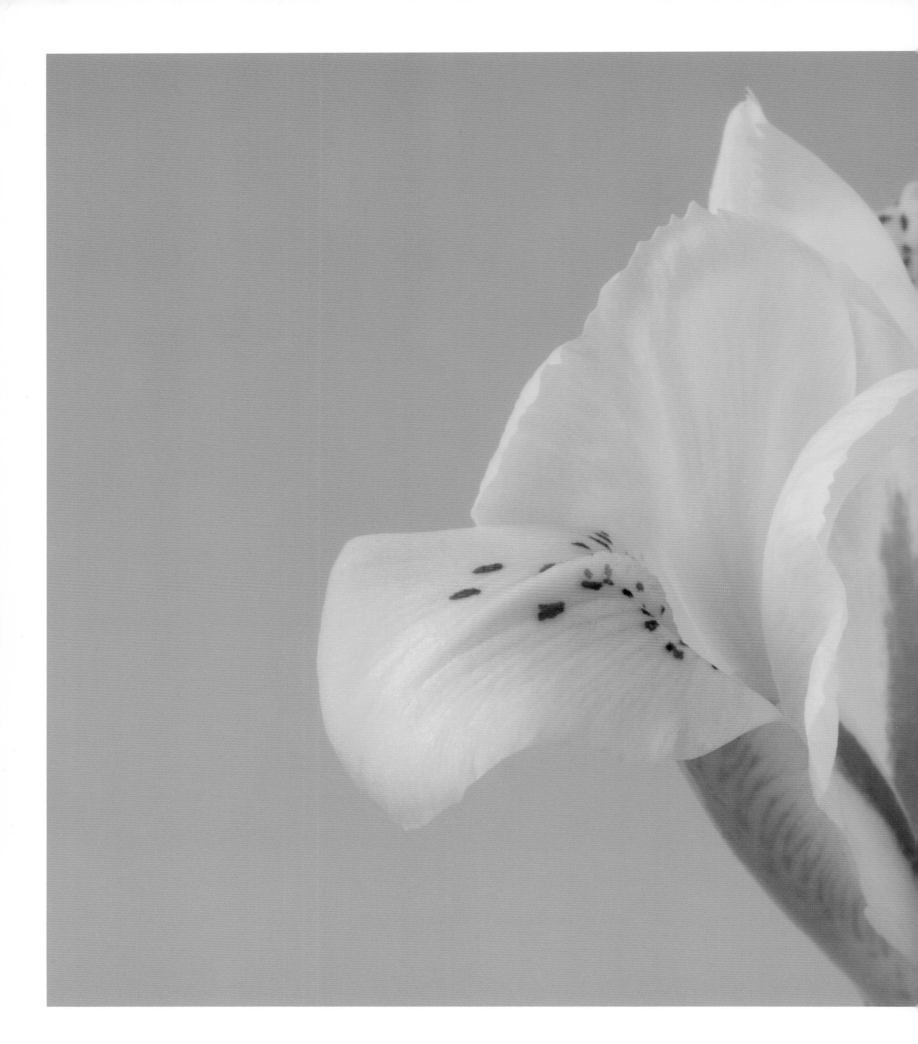

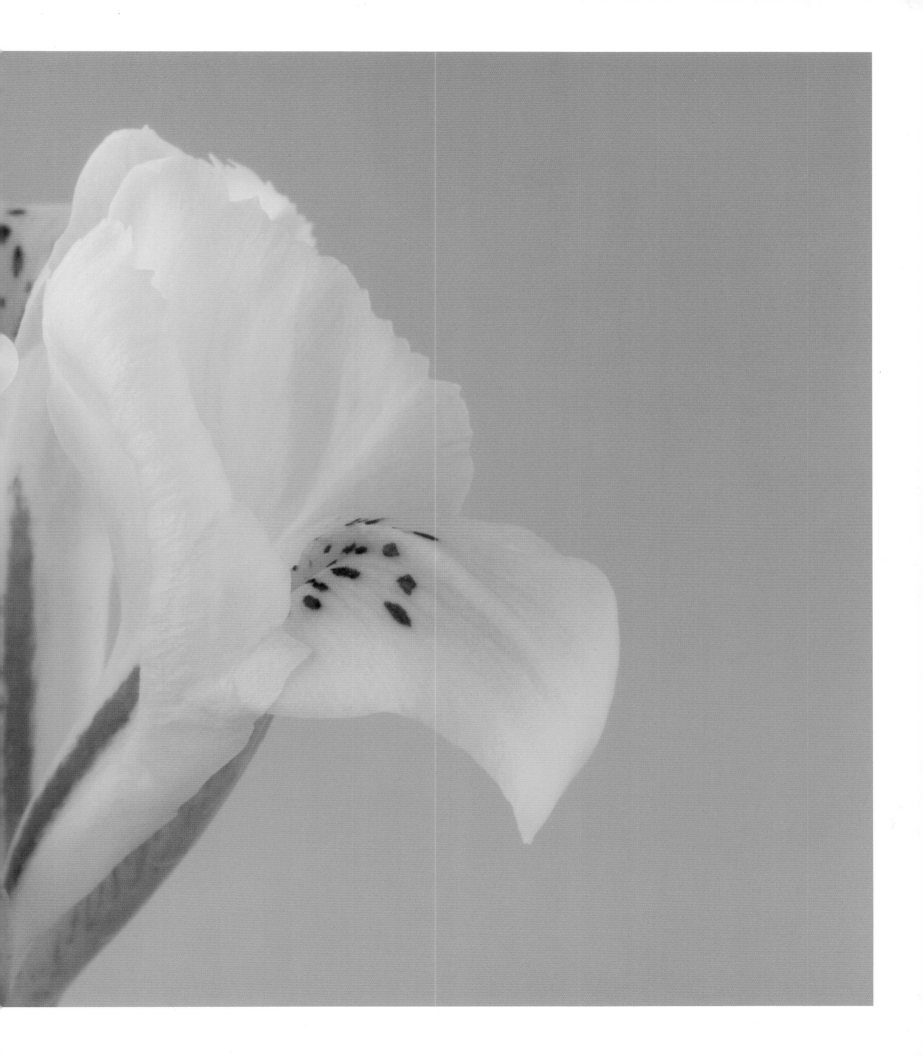

Trillium sulcatum

Trilliums are one of those groups of plants that have a mystique about them. They are not common in gardens, and people who grow them successfully are regarded with a certain amount of awe by other gardeners. 'They are not difficult,' I was told by a leading commercial grower, 'but they are fussy, and slow.' Trilliums make no big impact in the garden. Instead, they add something special and rather dignified to shady corners – the presence of a plant that looks very different from anything else. The name 'trillium' indicates that the plant's parts tend to come in threes: the leaves are in threes, and so are the petals and other components of the flower, although the stamens are six. This particular species is from the eastern United States, the home of most of the more attractive and more easily grown species. Its flowers enthral, but its foliage is good, too: big and majestic.

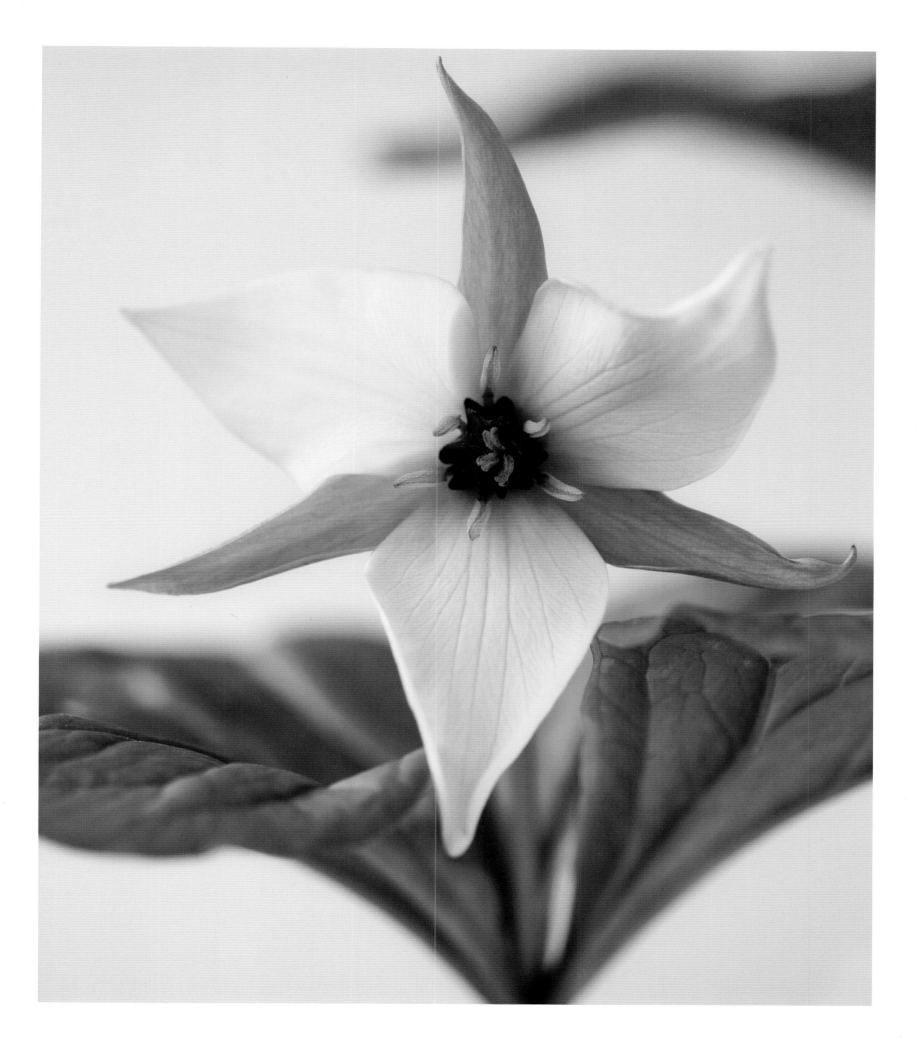

Magnolia campbellii 'Darjeeling' x *cylindrica*

Tree magnolias are some of the most
magnificent of hardy plants, all the more
so for flowering early in the year, before the
leaves appear. The flowers are large, up to
15 centimetres (6 in.) across, and extraordinarily
thick in texture. Magnolias are among the most
primitive of flowering plants, possibly dating
back to the Cretaceous era, when they would
have been seen by the last of the dinosaurs.
They first appeared before bees, and the size
and robust texture of the flower might have
evolved to cope with the rough-and-ready ways
of the crawling beetles that are thought to have
pollinated them. Most species are now extinct.
The survivors come from an area with a long
history of relative climatic stability – the forests
of south-west China and the neighbouring areas
on the other side of the Himalayas – where
many ancient plant species survive, the best-
known being gingko (*Gingko biloba*) and the
Dawn redwood (*Metasequoia glyptostroboides*).

Borago officinalis

The exquisite blue flowers of borage are intoxicating if grown en masse, although the individual plant is coarse and shaggy, and – if allowed to self-seed – can soon become a weed. The plant has traditionally been used in drinks, as John Gerard (1545–1611/12), the great English herbalist of the Renaissance, noted: 'The leaves and floures of Borrage put into wine make men and women glad and merry, driving away all sadnesse, dulnesse and melancholie.' There may have been some truth in that, as herbalists in the late twentieth century began to promote borage for the treatment of depression, particularly if it was associated with the menopause. Medical evidence is not yet forthcoming, but the sight of a field of borage is enough to lift anyone's spirits. The plant has shown potential as a green manure, as its taproot lifts nutrients from deep in the soil, and the flowers are adored by bees, so the future may hold more of this cheering sight.

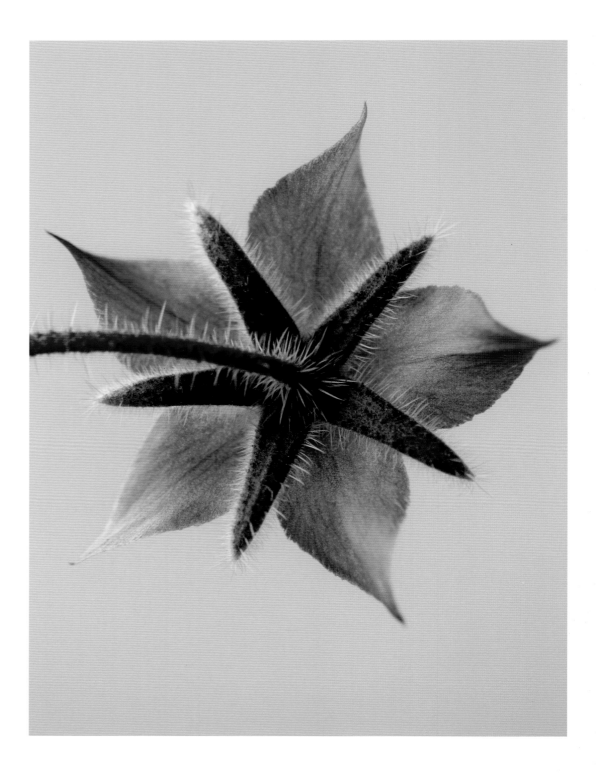

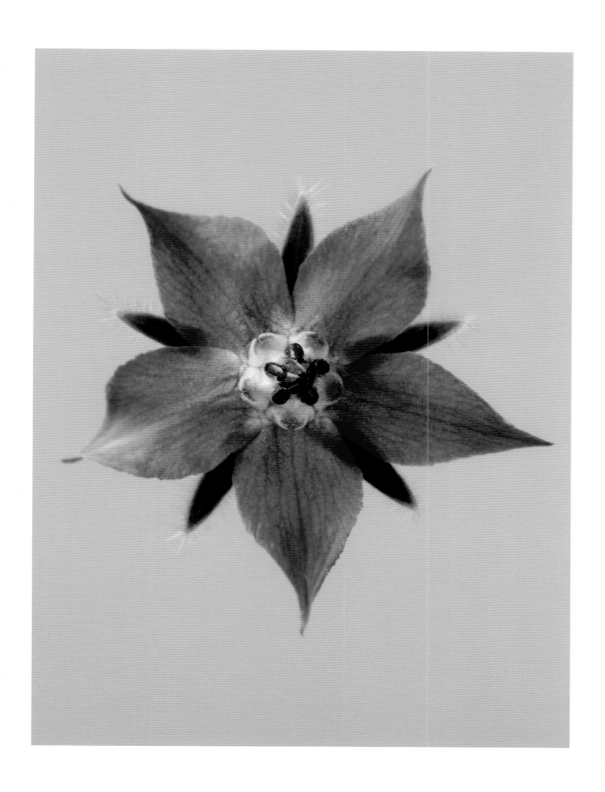

Cyclamen persicum

The fate of most cyclamen sold in garden centres, florists' shops and market stalls is ignominious – 99.9 per cent are surely dead within the year. Cyclamen can, however, be long-lived; if cared for from year to year they can grow steadily and flower ever more spectacularly, even if they are somewhat erratic and never as tidy as the plants that emerge fresh from the nursery greenhouses every autumn.

Descended from a species found wild in the eastern Mediterranean region, commercial cyclamen were first bred in the mid-nineteenth century by French, British and German growers, who tried to produce large plants with flowers in as wide a range of colours as possible. The development of 'Giganteum' in 1870 by a British grower was a breakthrough, and nurseries all over Europe adopted the plant for use in breeding. Current trends, however, are for smaller, more delicate-looking plants, many of which are produced by returning to the wild species for new genetic material.

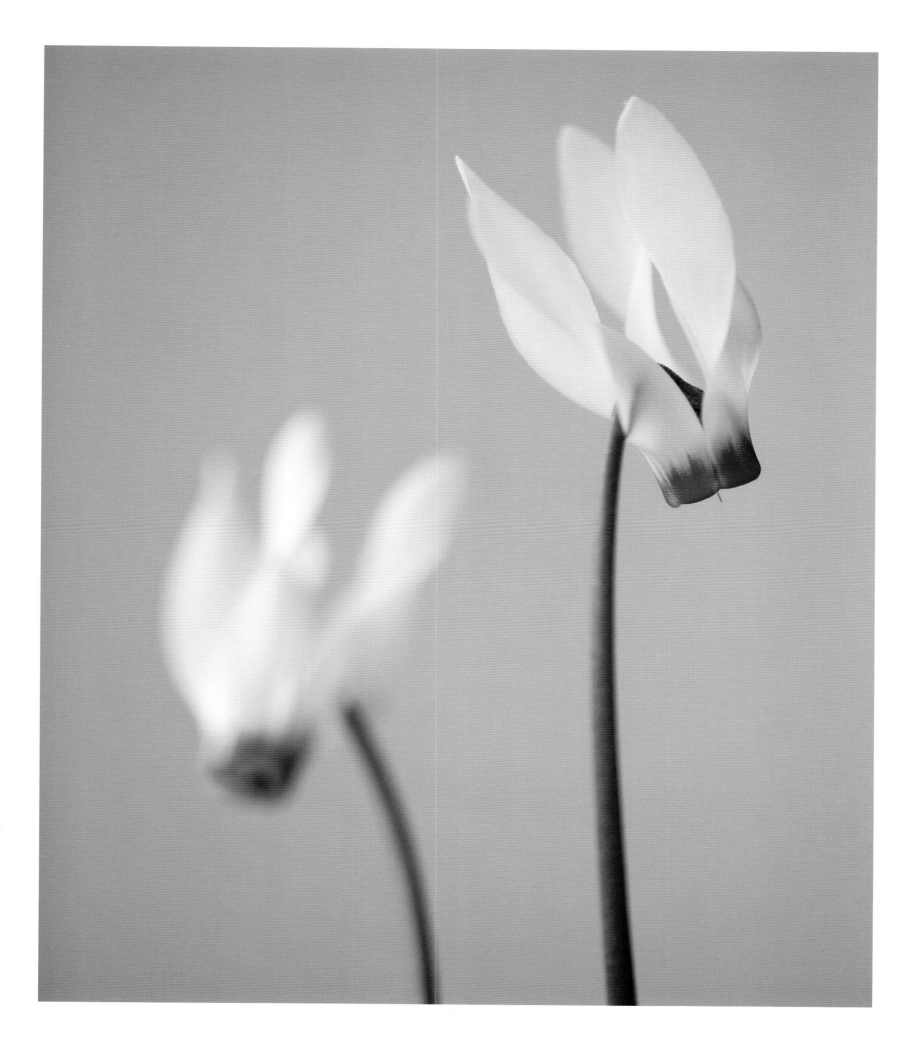

Helleborus x *hybridus* 'Harvington Double Chocolate'
Helleborus x *hybridus* Ashwood Garden hybrids (overleaf)

If there is one fashionable plant as the twenty-first century begins, it is the hellebore. These murky flowers, which would be ignored if they bloomed in June, are very welcome to gardeners in temperate zones when they appear in late winter. Their mysterious greys, pinks and maroons carry a sophisticated cachet, and their foliage – more or less evergreen, and rather magnificent – gives gardeners an extra reason for growing them. In nature they are woodland plants from south-eastern Europe: there, even in the shade of trees, summers can be hot and certainly dry, so the plants have evolved to do most of their growing from late winter to early summer, and then, if necessary, become dormant.

Hellebores have been around for some time, but for many years little breeding was done. One keen grower of them in England, Helen Ballard, produced some wonderful plants over a period of thirty years, but nurserymen made the mistake of propagating them by division, a very slow process, resulting in some of the most expensive herbaceous plants of all. It was not realized for some time that seed-grown plants can be almost as successful. Hellebore breeding was boosted during the 1980s and 1990s, when there was a flurry of plant- and seed-collecting before war broke out in the Balkans. Good new varieties are now probably growing on top of landmines.

The relative ease of breeding hellebores has led several nurseries to start breeding programmes. Some prefer spots and splashes, others favour doubles, others aim to perfect yellows or reds, while yet others concentrate on the fine foliage. Because the plants are seed-grown, they will never be exactly like their parents, and this element of chance makes growing them just that little bit more exciting.

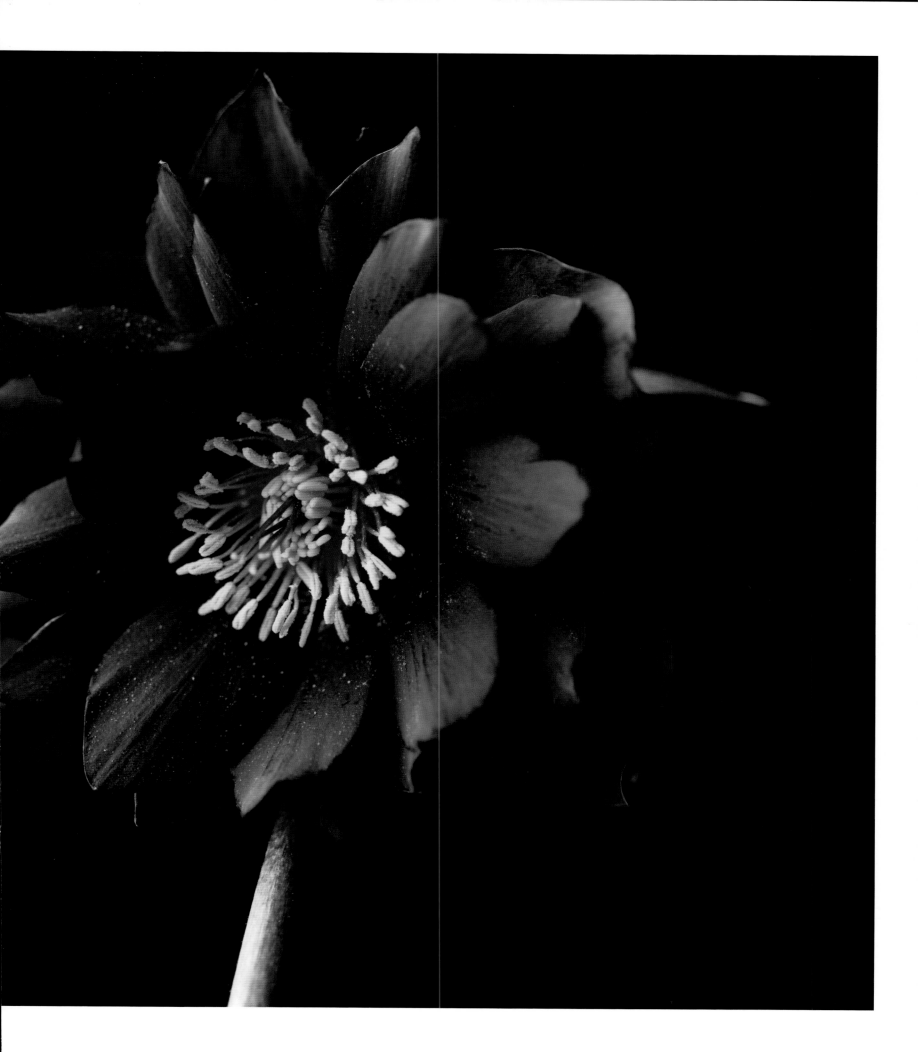

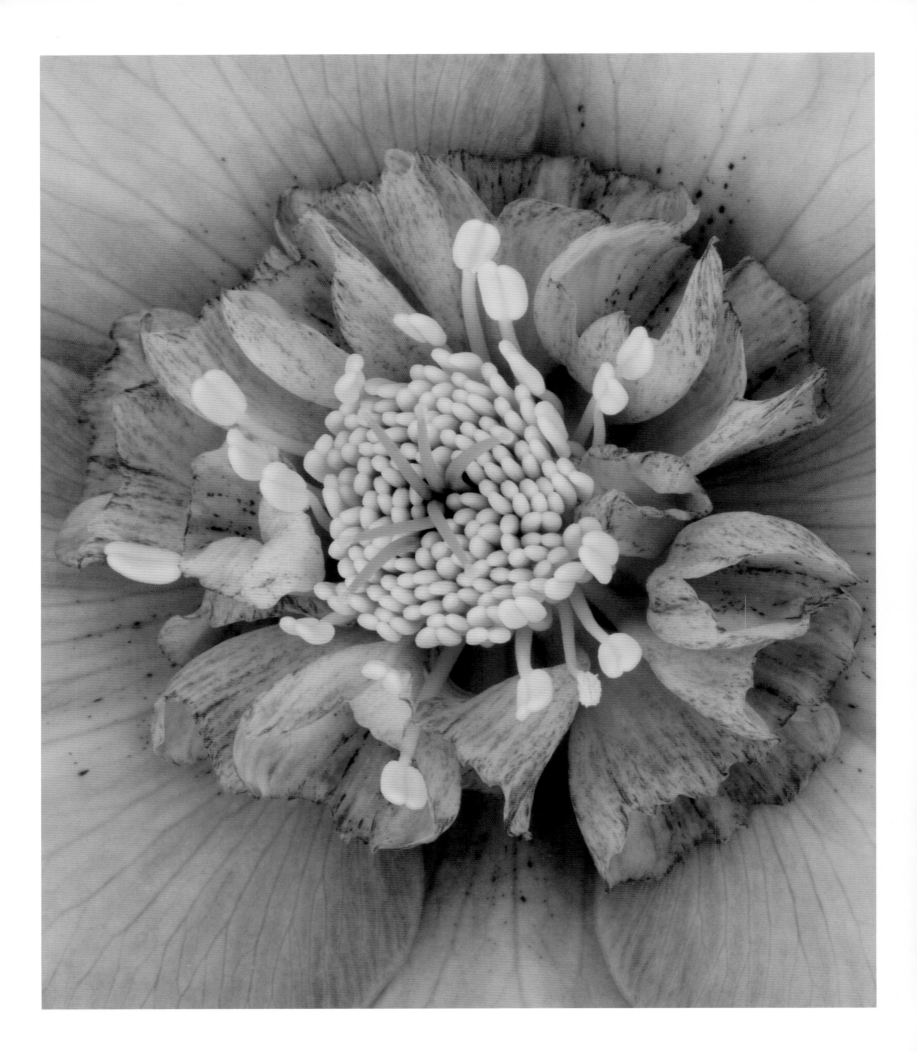

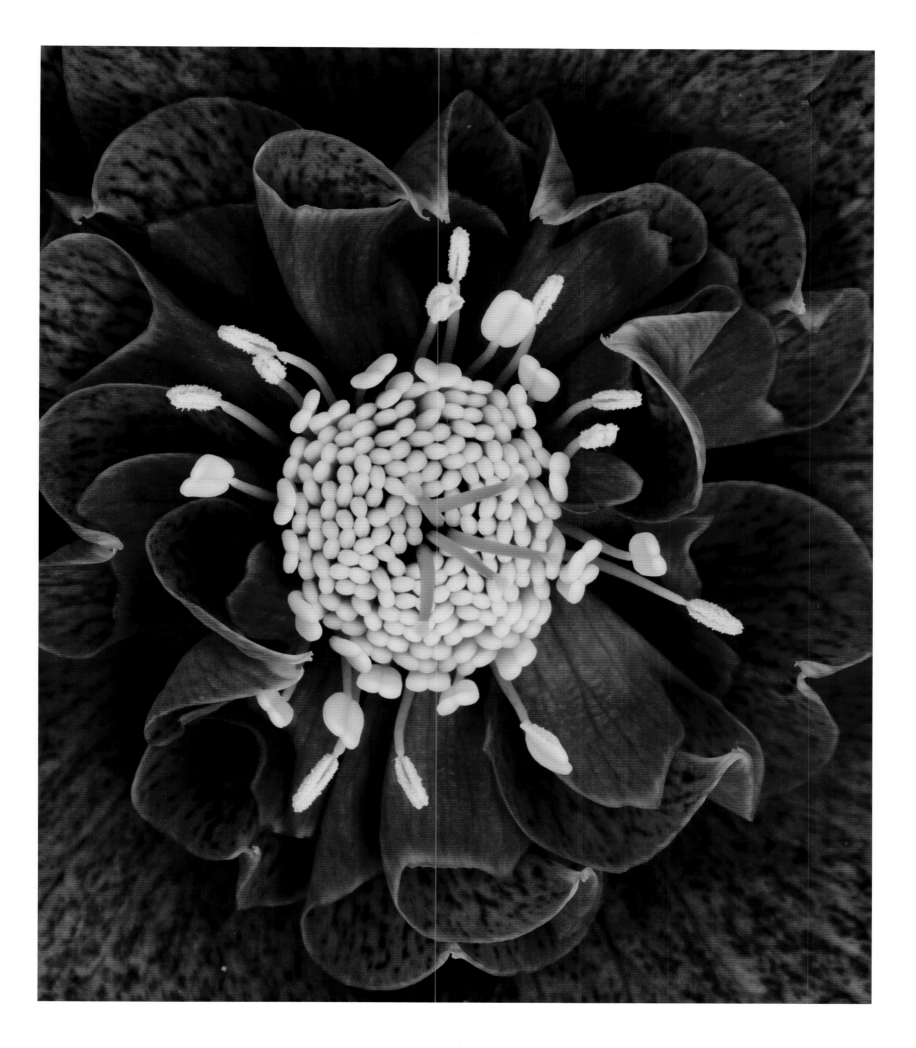

Rudbeckia 'Golden Jubilee'

Black-eyed susans are deservedly popular perennials. They flower in late summer and early autumn, and – unlike so many of their relatives – are short enough to fit into any garden, especially those belonging to people who feel intimidated by the height of so many late-flowering perennials of North American origin. Such plants are tall because of a struggle for survival in the hot, moist summers: the taller the plant, the more light it will get and the more it can overshadow the competition. So why are some *Rudbeckia* species so usefully short (about 60 centimetres/24 in.)? The answer is that they do not enter the competition, but avoid it by living in places unsuitable for taller species: woodland edges, poor sandy soils and unstable habitats, such as gravel bars on rivers. These are niches that are easily exploited by a species that puts its energy into producing seed instead of growing tall; it can spread itself far and wide when its habitat becomes unsuitable for further growth.

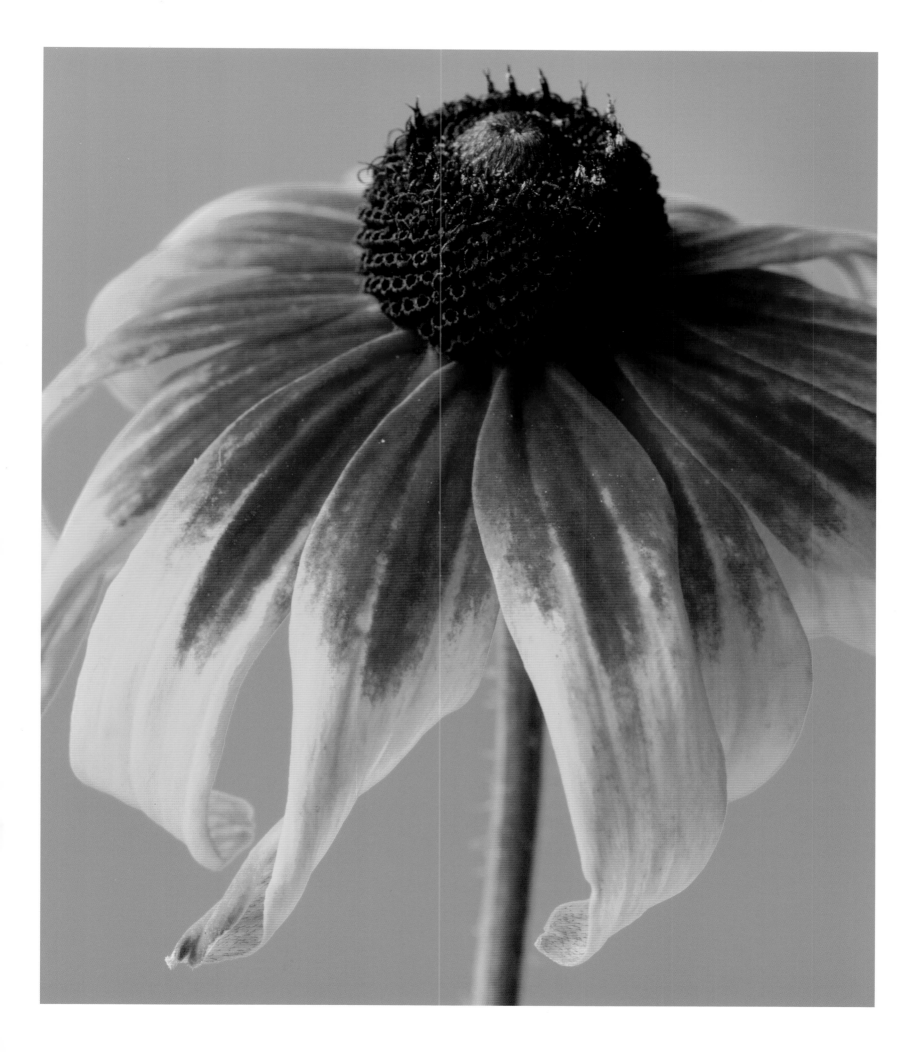

Echinops ritro 'Veitch's Blue'

The common name for *Echinops*, 'globe thistle', describes it precisely: the flower and seed heads are perfect globes, and the leaves indeed spiny and coarse. Given the reputation of thistles, however, one wonders how many people have been put off by the name. Often seen in the deeper reaches of the big herbaceous borders without which no traditional English garden is complete, these rather magnificent plants impress early in the season with their large, roughly divided leaves.

Echinops is the kind of plant the breeder finds hard to improve, and so there are few named varieties. This one commemorates one of the most important British nurseries of the nineteenth century: Veitch's. Established in 1808 by John Veitch (1752–1839), the nursery was at the forefront of plant-hunting, sponsoring collectors to sweep the globe for new plant varieties. Once established and trialled at the nurseries (one in Exeter and one in London), good varieties would be selected or crosses made and named. By 1914 the nursery had introduced some 1280 plants into cultivation, of which most were greenhouse plants.

E. ritro 'Veitch's Blue' is a good example of a cultivar that is little different from its parent plant. The blue is clearer than that of a straight *E. ritro*, but not dramatically different. The flower's hardiness and reliability are now regarded as vital for good garden plants, but were not so important in the nursery's heyday, when the wealthy could afford armies of gardeners to tend, propagate and protect for the winter. The decline of Veitch's after the First World War, which cut a swathe through the nation's gardeners and the greenhouses and walled gardens they had tended, can perhaps be traced to its failure to invest more in this kind of simple, dependable and robust plant, a pleasure to garden with.

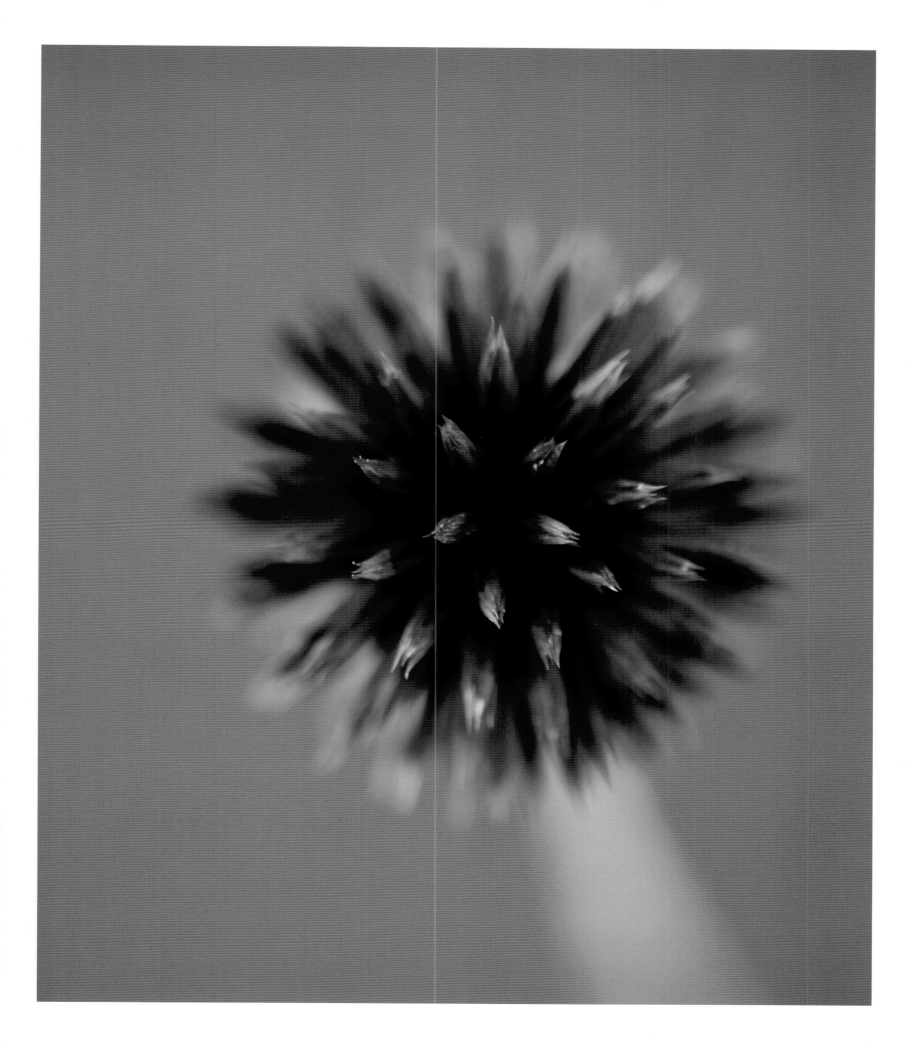

Paeonia suffruticosa 'Duchess of Kent'

This variety may celebrate a British aristocrat, but tree peonies are first and foremost Chinese; indeed, they are to Chinese gardens what roses are to European ones. Cultivation of the plant has a long history in China, with a wide range of varieties in cultivation as long ago as the Tang dynasty (AD 618–907). Symbolizing wealth, choice varieties were coveted by emperors, merchants and the class of highly educated state bureaucrats who ran China.

Peonies were long known to Europeans only as pictures on porcelain, paintings or embroideries, and it took many attempts before plants were brought back alive to Europe in the late eighteenth century; many perished during the long sea voyage. The first plant to reach England in 1787 did not survive its first winter. There was more luck in 1794, when three plants survived the voyage to create a sensation when they flowered at the Royal Botanic Gardens, Kew.

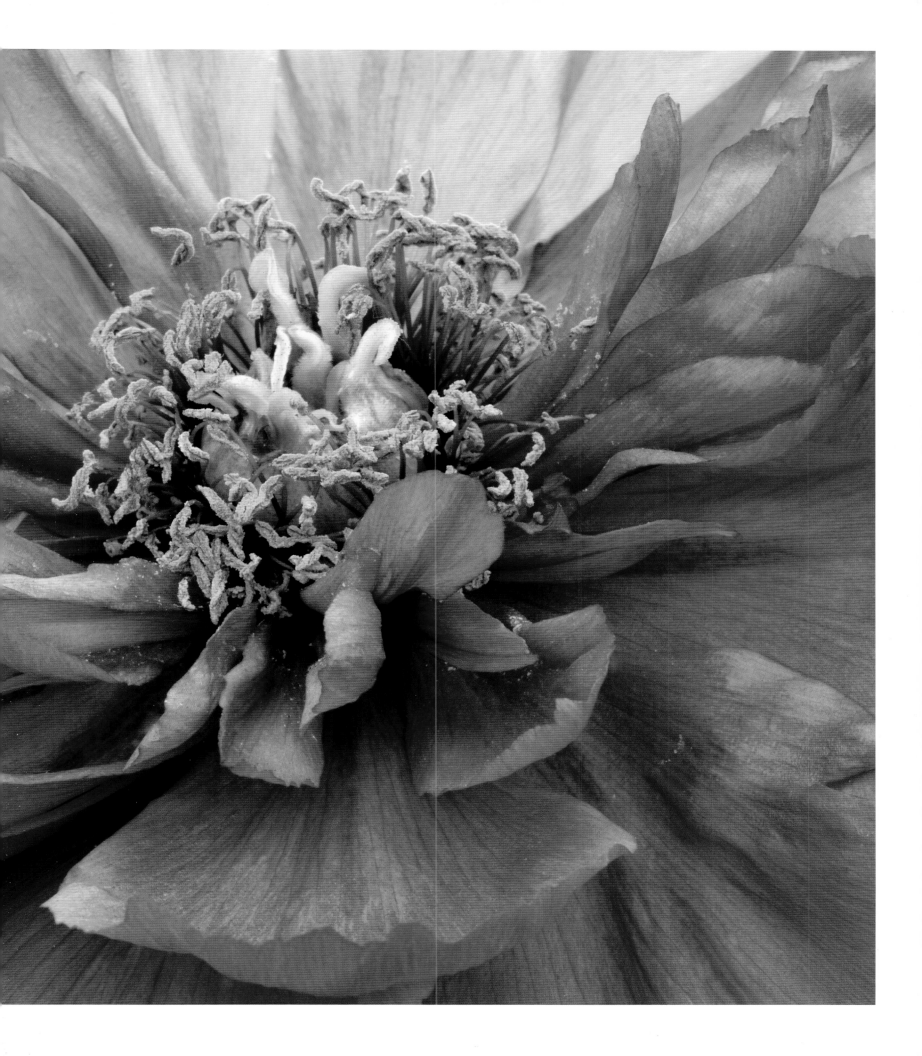

Rosa 'Juliet'

'It's a hard life being a rose seedling', says a
member of the breeding staff at David Austin
Roses, which bred this variety. The company
trials some 250,000 plants every year, but from
these very few are picked out and propagated,
and between three and six are taken as far as
commercial introduction, which the company
does annually at the RHS Chelsea Flower Show
in London. The breeding of new varieties is
based on looks, but increasingly concerned with
resistance to disease; roses are notoriously
disease-prone, and since no one likes dousing
them with fungicides to fight mildew and black
spot, the aim is that, in future, all new plants
will be naturally healthy.

'Juliet', launched in 1989, is part of a group
(being worked on by David Austin Roses) that
goes back to the Noisette roses. Originally bred
in the nineteenth century in the United States,
Noisettes were derived partly from species
imported from China.

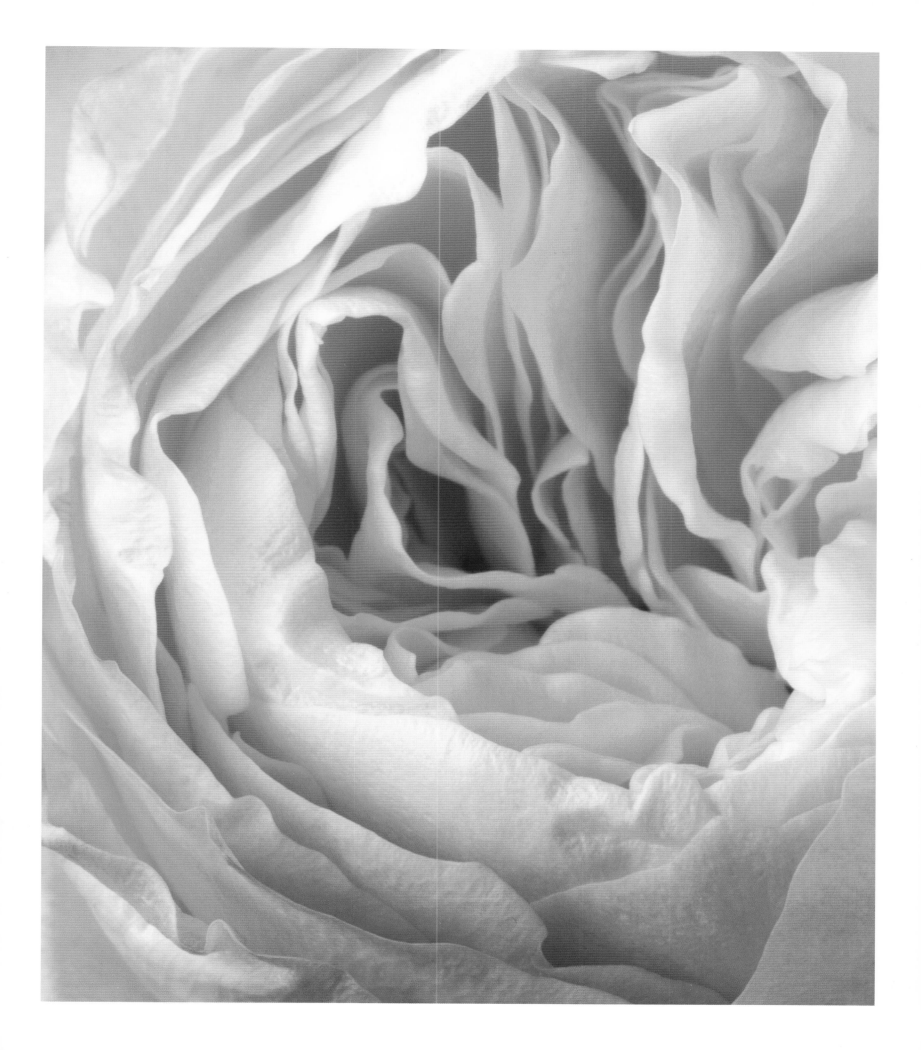

Erythronium revolutum 'Wild Salmon'

Erythroniums (see also pp. 102–103) are members of the lily family (*Liliaceae*) known as dog-tooth violets, after the pointed shape of their tubers. Found mostly in woodland habitats across the northern hemisphere, they are similar to many other woodland plants in that they grow very well in good conditions, but sulk in less-than-ideal ones. In particular, they love the deep, soft layer of humus that accumulates with centuries of dead leaves. The ancestral species for this modern cultivar comes from the Pacific North-west of the United States, where it forms extensive and colourful patches in deep forest or along river banks. Such patches are only rarely seen in cultivation, as it takes many years for seeds to spread sufficiently. 'Wild Salmon' is a selection that seems more adaptable in the garden, and has particularly fine foliage, blotched and marbled with maroon and silver.

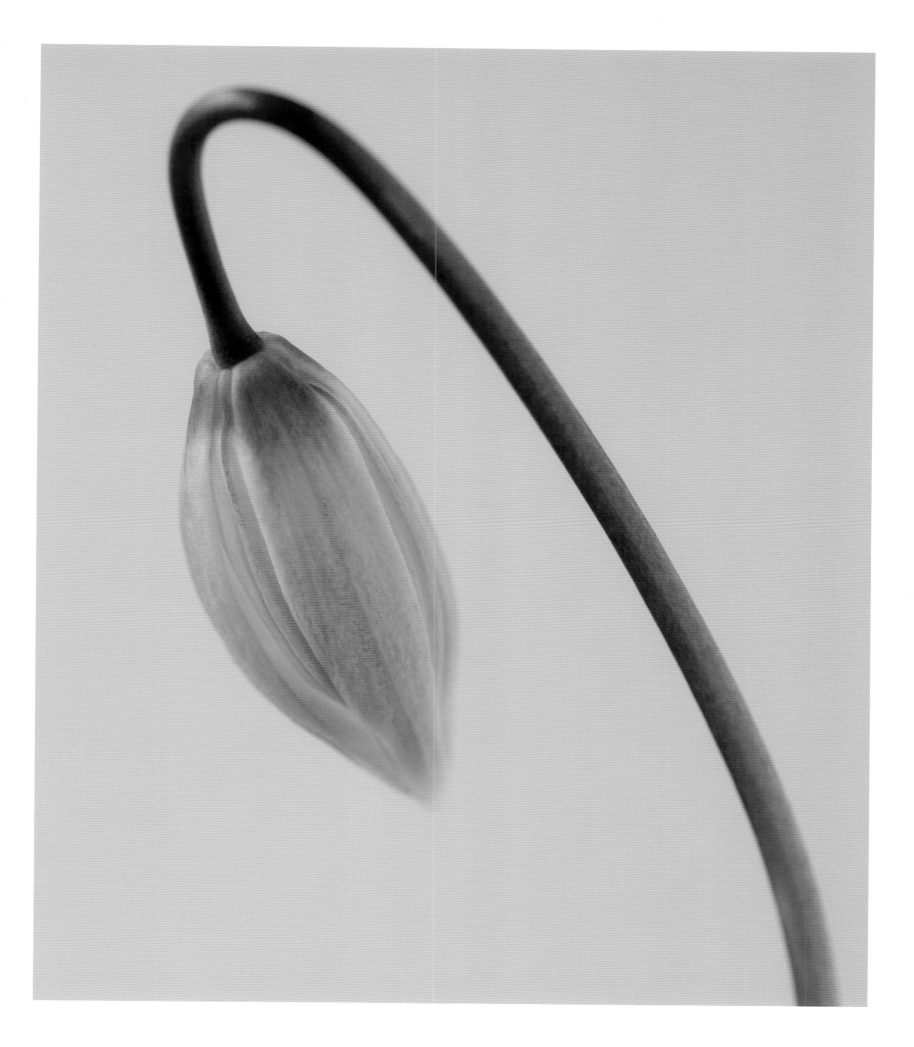

Camellia japonica 'Compacta Alba'

Of all the floral exports of the East to the West, the camellia has been one of the most successful. Its perfect, intensely coloured flowers, set off by the lustrous dark green of its elegant foliage, have ensured centuries of popularity. Long cultivated in China, it was also important historically in Japan, although its popularity there has waxed and waned over time. Many early European introductions came from nurseries in the Far East, where selection of cultivars for flower colour or shape had been carried out over many years. The arrival of the camellia in Europe in the nineteenth century led to a further explosion of selection: articles in garden journals of the time list innumerable cultivars, most of which are now extinct. Many were not fully hardy and were grown in conservatories and greenhouses, and it was only the later introduction of such species as C. japonica or the breeding of such hybrids as C. x williamsii, which were better able to withstand cold winters, that enabled the plant to become genuinely popular.

There is something about the perfection of the flower – compact and easily used as a buttonhole – that has long encouraged its use as an emblem. For the Japanese it was traditionally a symbol of the sun goddess Amaterasu, although Christians in Japan used it as a secret symbol for Christ during their centuries of persecution under the Tokugawa shogunate. In the American South during the years following the Civil War, the Knights of the White Camellia were an organization opposed to Yankee 'carpetbaggers'; the Knights had a romantic name, but were little better than a genteel version of the Ku Klux Klan.

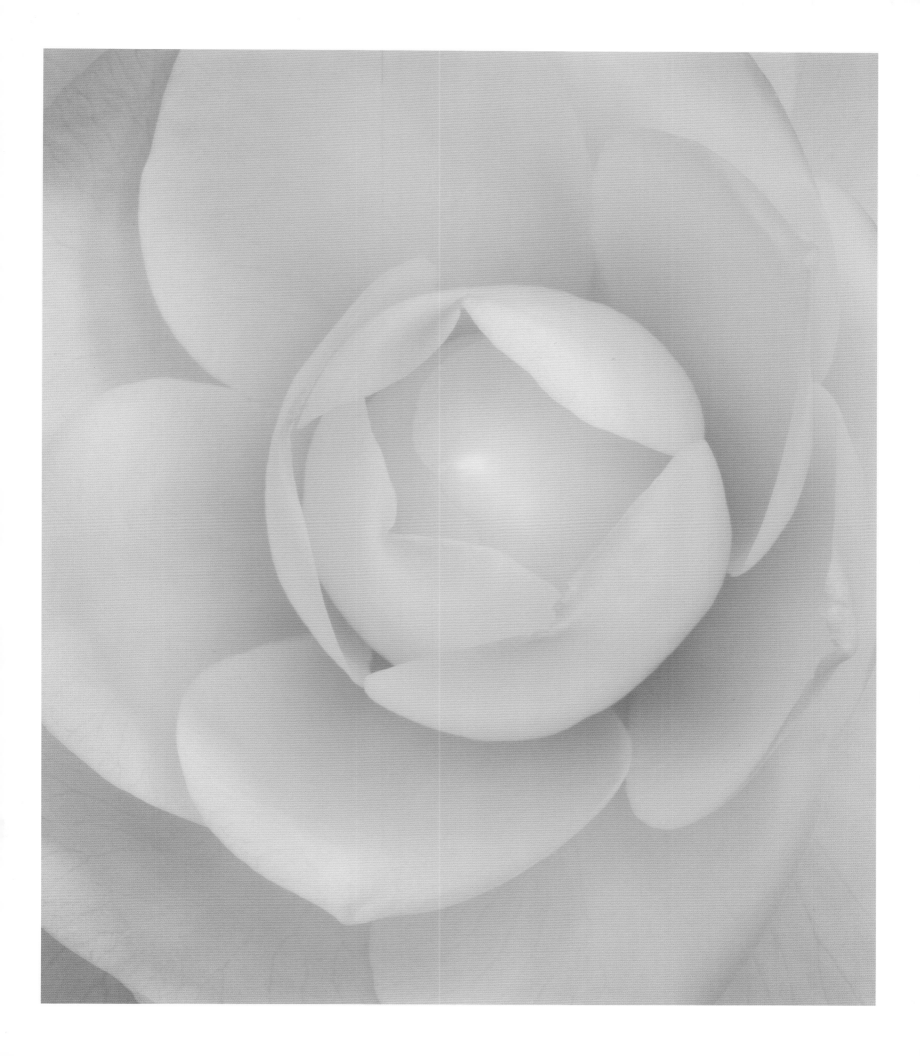

Hippeastrum 'Santa Fe'

Hippeastrum 'Prelude' (page 76)

Hippeastrum 'Black Pearl' (page 77)

The obsessive streak among gardeners is illustrated well by the story of Veronica Read and hippeastrums, those trumpet-like flowers that emerge dramatically and without leaves from large bulbs. When she saw a display of them in 1993 at the famous Dutch bulb garden Keukenhof, she was transfixed. From then on they were her life's mission. She converted her house in the suburbs of London into a nursery, with powerful lights to enable the plants to be grown away from the windows. In 2002 she was the subject of a video installation by artist Kutlug Ataman, who filmed her over the course of a year tending her hundreds of plants. Projected on to four giant screens with Veronica giving a commentary, the video was first shown at the eleventh Documenta, the leading German art show now held every five years, and then at two of the United Kingdom's most important centres for contemporary art, the Serpentine Gallery and Tate Britain.

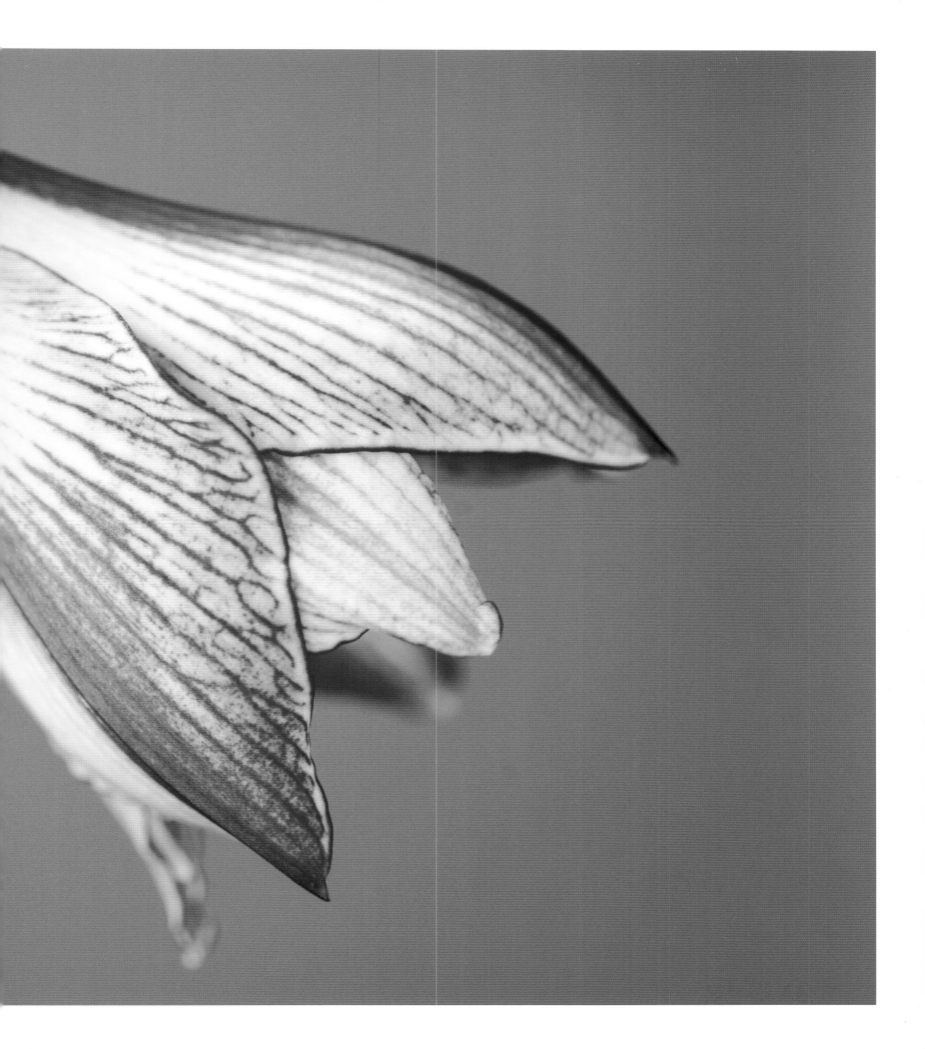

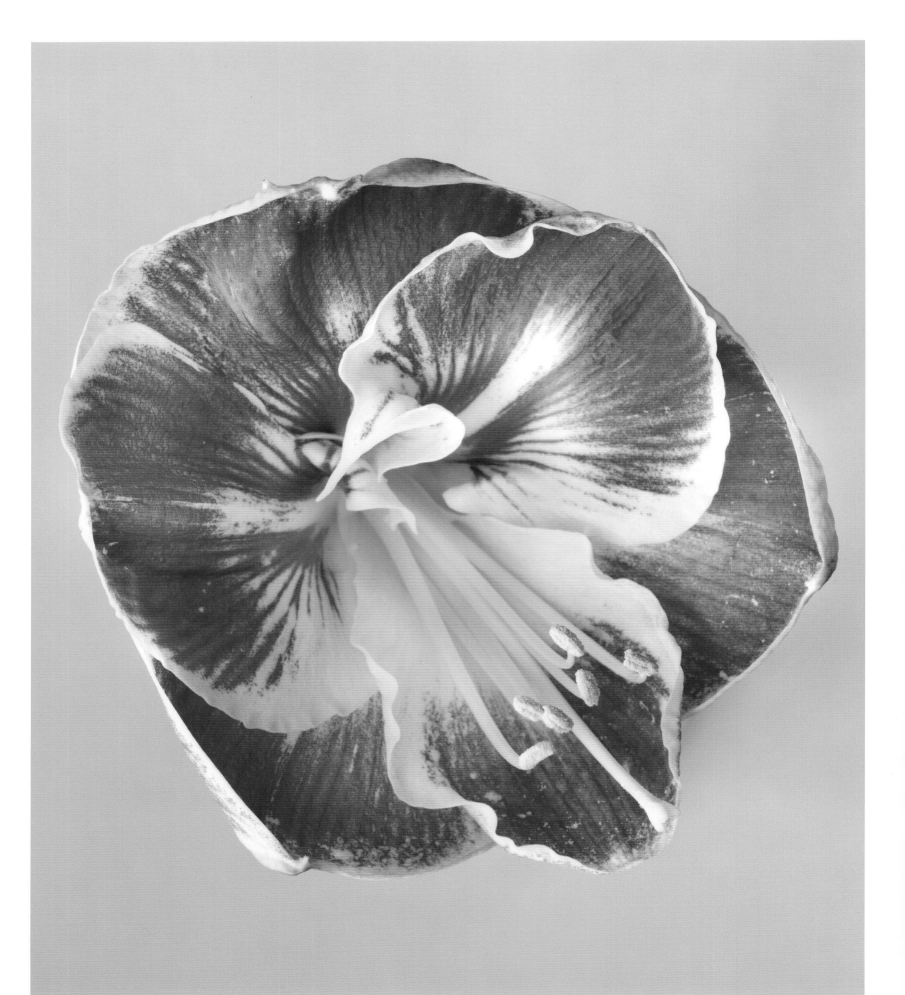

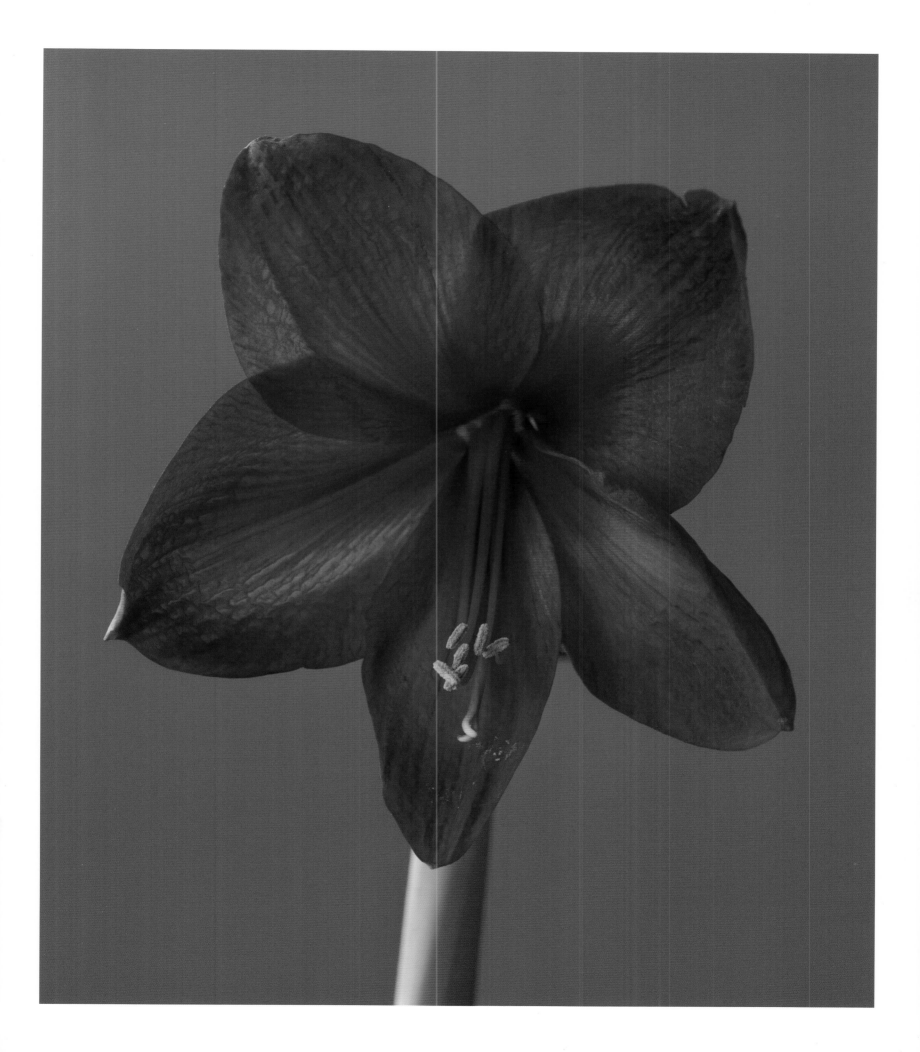

Euphorbia myrsinites

The German name for species of *Euphorbia* –
Wolfsmilch, or 'wolf's milk' – says it all. The pure-
white sap is sticky and acrid, burning sensitive
skin and the eyes of anyone who is foolish
enough to rub their face after handling these
plants. Such toxins are a good defence against
being eaten, a useful thing to remember if
rabbits or deer are a problem in the garden.
While *Euphorbia* has been little used in
traditional herbal medicine, its chemicals may
have a use in the future, especially as some of
them appear to be antiviral agents.

This particular species is rather an oddity.
Originating in dry places in southern Europe,
it has sprawling stems surrounded by whorls
of grey leaves, which look thoroughly exotic;
but it is very tough and hardy, needs no special
conditions and is a blessing for dry, stony
banks, which it adorns with yellowy green
flowers in spring.

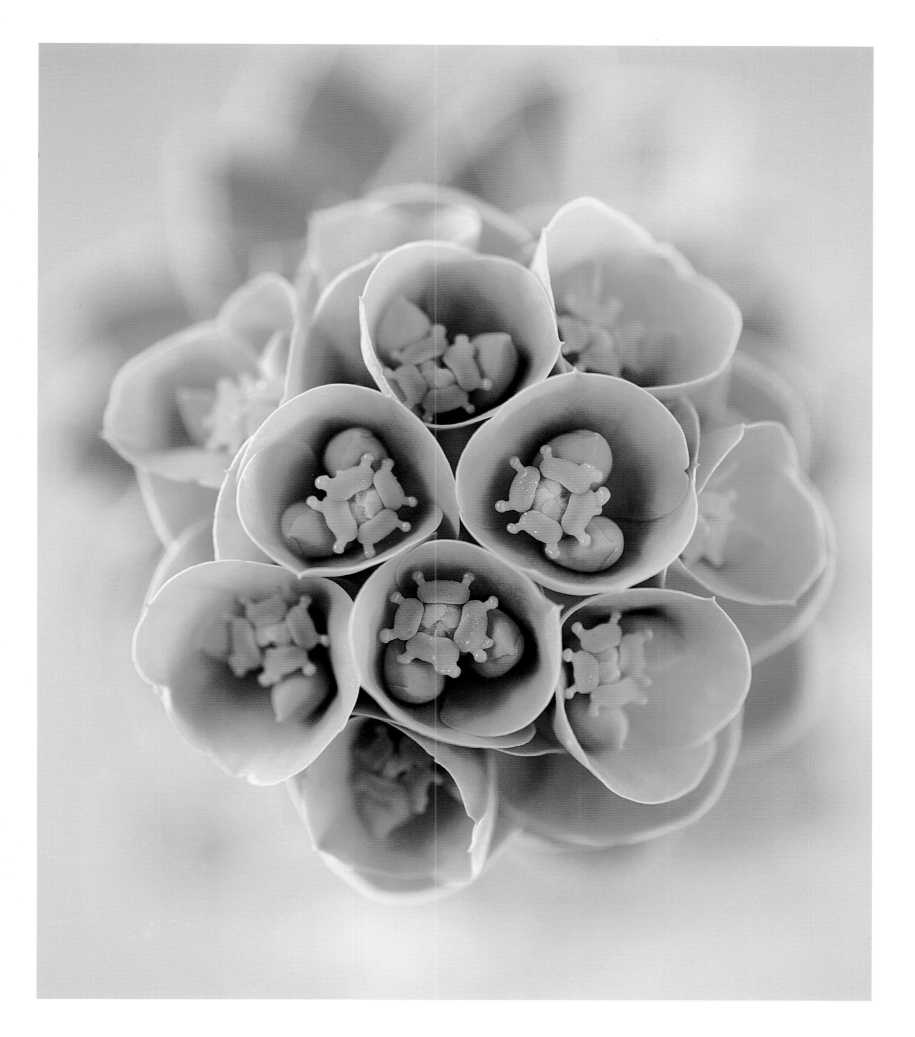

Hyacinthus orientalis 'Blue Pearl'

Hyacinthus orientalis 'Pink Pearl'

Most of us grow hyacinths on our windowsills, adoring their colour and scent as the first signs of spring. We have been doing it for a surprisingly long time: one of the first mass-produced garden plants, the hyacinth was initially grown by the Arabs, then the Ottomans, and reached Europe in the sixteenth century along with many irises, tulips and anemones. The great *Hortus Eystettensis* of 1613, arguably Europe's first illustrated book of garden plants, listed 17 different varieties; by 1752 Dutch and German nurseries had made available some 242 double and 107 single varieties. By the early nineteenth century, nurseries were growing millions of bulbs. At one stage, the hyacinth became so popular as a business proposition in France that speculators investing in new varieties created a financial bubble, similar to the one in The Netherlands in the 1630s, caused by tulips (see p. 84).

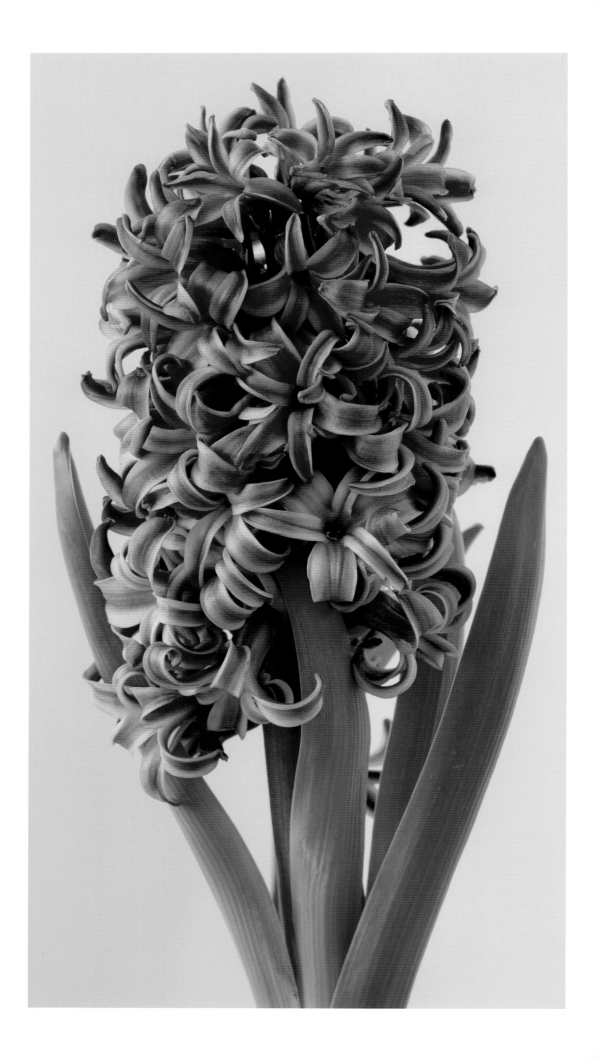

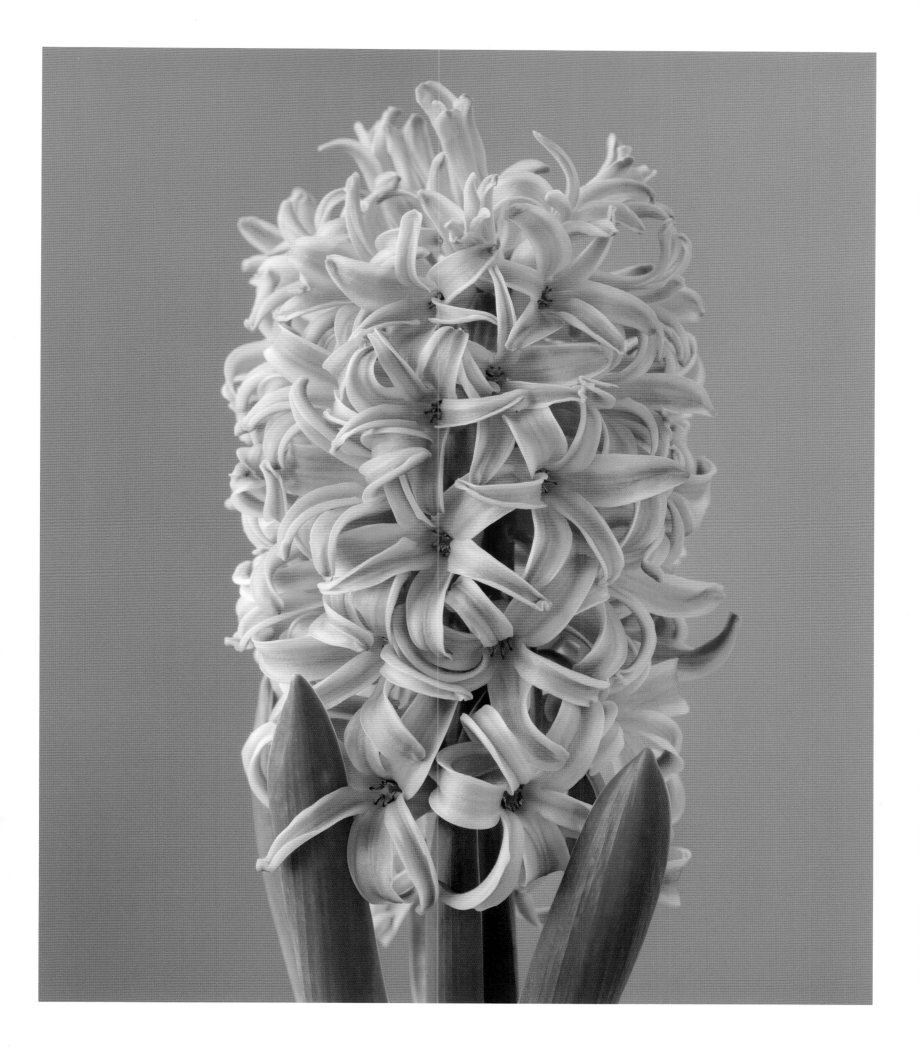

Galanthus nivalis 'Spetchley Yellow'

The first events in the social calendar of the
more exclusive echelons of the British garden
scene are 'snowdrop lunches'. Participants
(known as galanthophiles) eat, drink, gossip
and examine one another's collections of
snowdrops. *Galanthus nivalis* tends to vary in
the pattern of green on its flowers, leading to
distinctive plants being given cultivar names and
propagated, sometimes selling for considerable
sums of money. The truth is, however, that the
snowdrop population of the United Kingdom
is not a natural one, so there is little variation,
and any new pattern stands out boldly. In
Central Europe, where it is found as a wild
plant, almost any woodland would throw up
enough variation to keep a snowdrop lunch
in session for days. Consequently, there is a
growing feeling that what could be termed
'galanthomania' is getting out of hand, with
the tiniest variation leading to new cultivar
names. Yellow varieties are, however, genuinely
rare and worth getting excited about, and have
even in some cases been stolen.

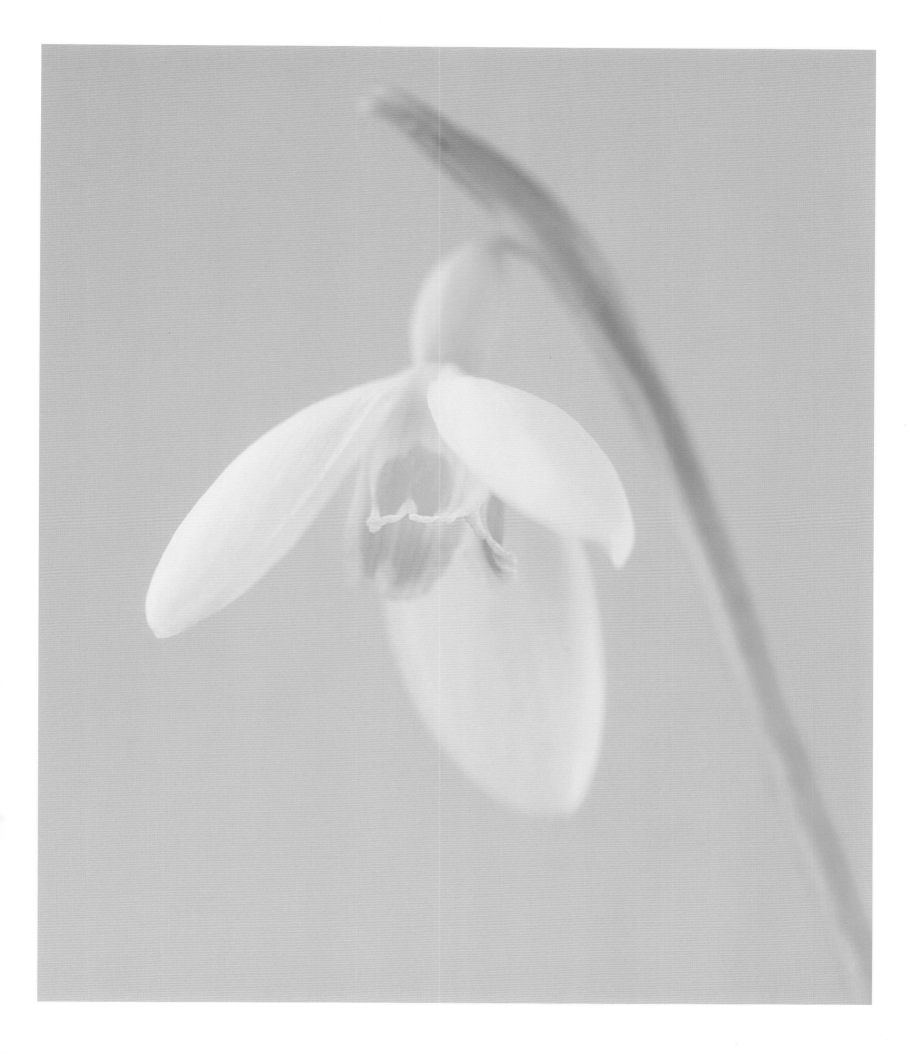

Tulipa 'Blumex'

If there is one episode in the history of plant-breeding about which everyone knows, it is 'tulip mania': the extraordinary outburst of financial speculation that took place in The Netherlands during the 1630s. An increasing love of fine tulips inflated the prices of the bulbs, and particularly fine examples regularly sold for hundreds of florins when a pig might cost only thirty. Given the inventiveness of Amsterdam's financiers, it is not surprising that a futures market developed, in bulbs that had not even been planted. Tulips were traded on stock markets, the less wealthy members of society joined in and a speculative bubble grew; when traders could no longer get the prices they wanted for their bulbs, the bubble burst, and many people were ruined.

The most sought-after were tulips with elaborately streaked petals, the result of an infection (tulip breaking potyvirus) that eventually weakened the plant. A tulip was only as good as its infection, and – since there was no understanding of either genetics or viruses – that had to be left entirely to chance. Desperate measures were employed to produce more or better streaked tulips; one grower even tied together half a red tulip bulb and half a white one in an attempt to create striped flowers.

It was not only the Dutch who went mad over tulips. The French had experienced a similar if less overwhelming craze for the bulb during the first two decades of the seventeenth century. In Turkey, breeding had resulted in many fine inter-specific hybrids well before tulips were exported to Europe, but during the reign of Sultan Ahmed III (1703–1730), the Ottomans imported millions of bulbs from the Dutch, stimulating a breeding frenzy among merchants. The Sultan became obsessed and held extravagant tulip festivals, the costs of which contributed to fomenting a military rebellion, which ended in his abdication.

There were even rumours of another Dutch tulip scandal in the first years of the twenty-first century, involving public money being put into the researching of new tulip varieties. Clearly the tulip's ability to cause hard-nosed men to lose their senses will continue.

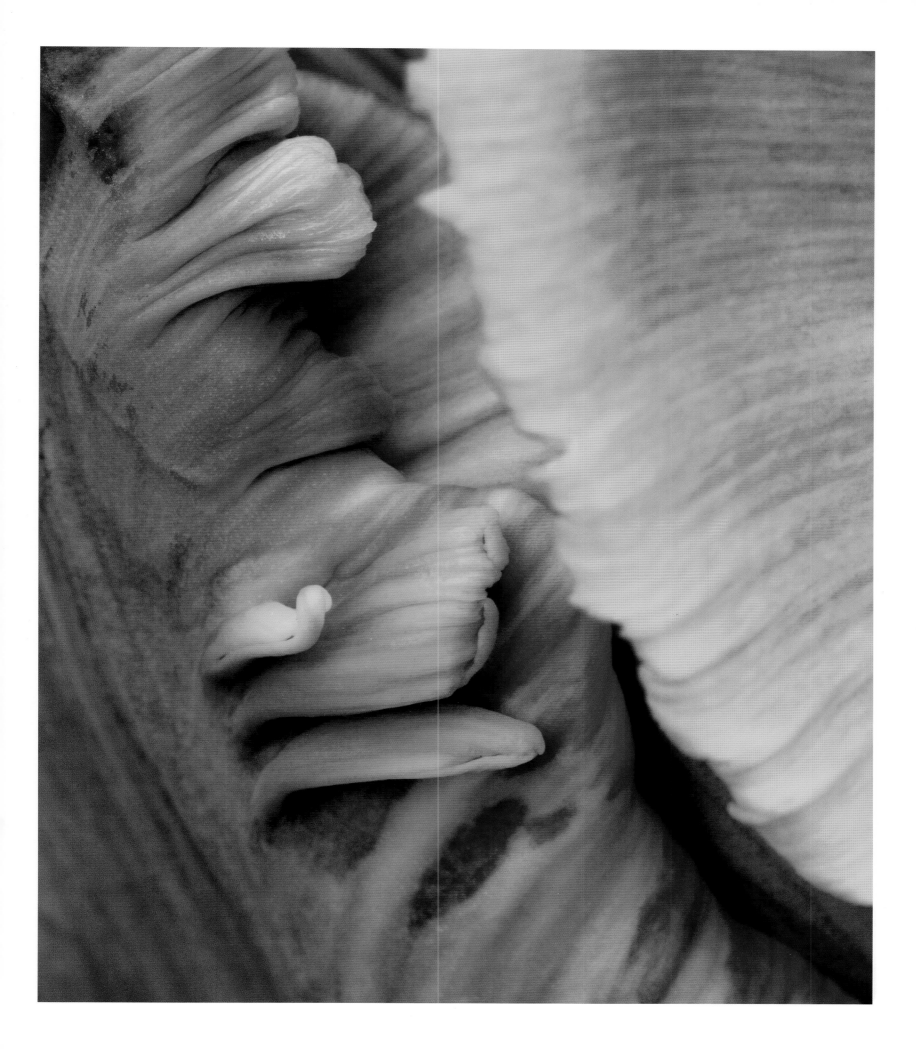

Dicentra spectabilis

Few plants look quite so *designed* as *Dicentra*, so it is not surprising that it has a long history of cultivation in its native China and Siberia; so much so, in fact, that its original natural distribution is now obscure. It was introduced to the West in the mid-nineteenth century, where it proved an immediate hit with the Victorians, with their thoroughly sentimental approach to romantic love. It has been popular ever since, but is not to be seen in every front garden. One wonders why not.

Dicentra was apparently first introduced to Britain in 1816, but disappeared, not surviving in cultivation until 1846, when it was reintroduced by the plant collector Robert Fortune (1812–1880). This initial disappearance is not surprising: despite being described as 'perennial', in practice it is anything but. With its soft, juicy foliage it is top of the menu for slugs and snails, but even if protected with a wall of slug repellent it still tends to disappear after a few years. It just *is* short-lived.

In nature, *Dicentra* is a plant of cool, moist, wooded valleys. Woodland changes over time: trees grow, die and are blown over, and the underlying plants must constantly respond to the resulting changes in light and shade, soil moisture and nutrient levels. With so much going on, it should come as no surprise that many woodland plants have evolved to adapt. Woodland-edge species, including *Dicentra*, are subject to even more rapid changes in their environment. One way of surviving is to accept the inevitable, and simply die when things get too bad, leaving a legacy of plentiful seed; another is to creep. *Dicentra spectabilis* does a bit of both; clearly a good adaptation, but not so convenient for the gardener.

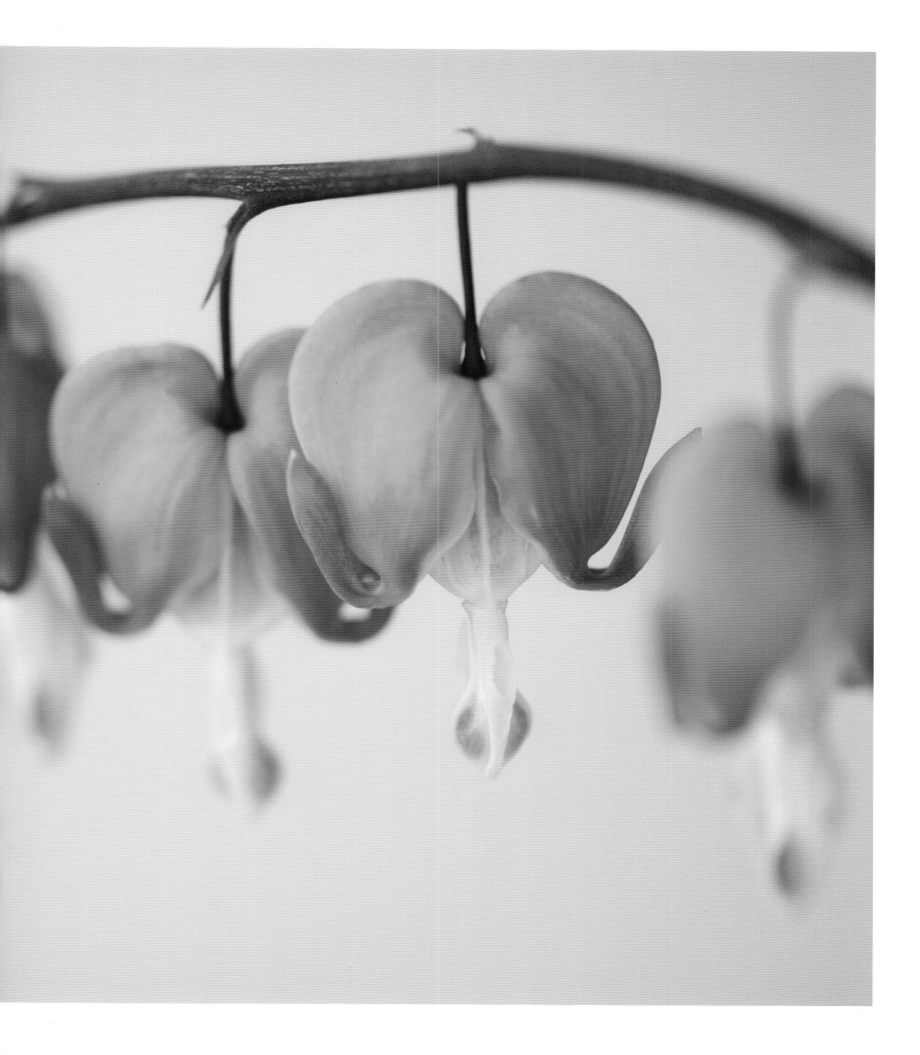

Cosmos atrosanguineus

'Chocolate, it smells of chocolate!' is inevitably the cry as someone lifts a flower head of *Cosmos atrosanguineus* to their nose. Indeed it does, and with its darkly mysterious colour, this is a popular plant for adorning the late summer border, despite not being very hardy or long-lived.

The chocolate cosmos is a plant of mysterious origins. Collected in Mexico in the very early years of the nineteenth century, it has not been seen since in the wild; this may mean that it was a garden selection and not a genuine wild species. Consequently it survives only in cultivation, but as a single clone. It must therefore be propagated by cuttings and not from seed, and the lack of viable seed means that it has not been possible to produce any new varieties or improve the stock in cultivation. Despite this, the plant has become immensely popular with the gardening public, and is widely available.

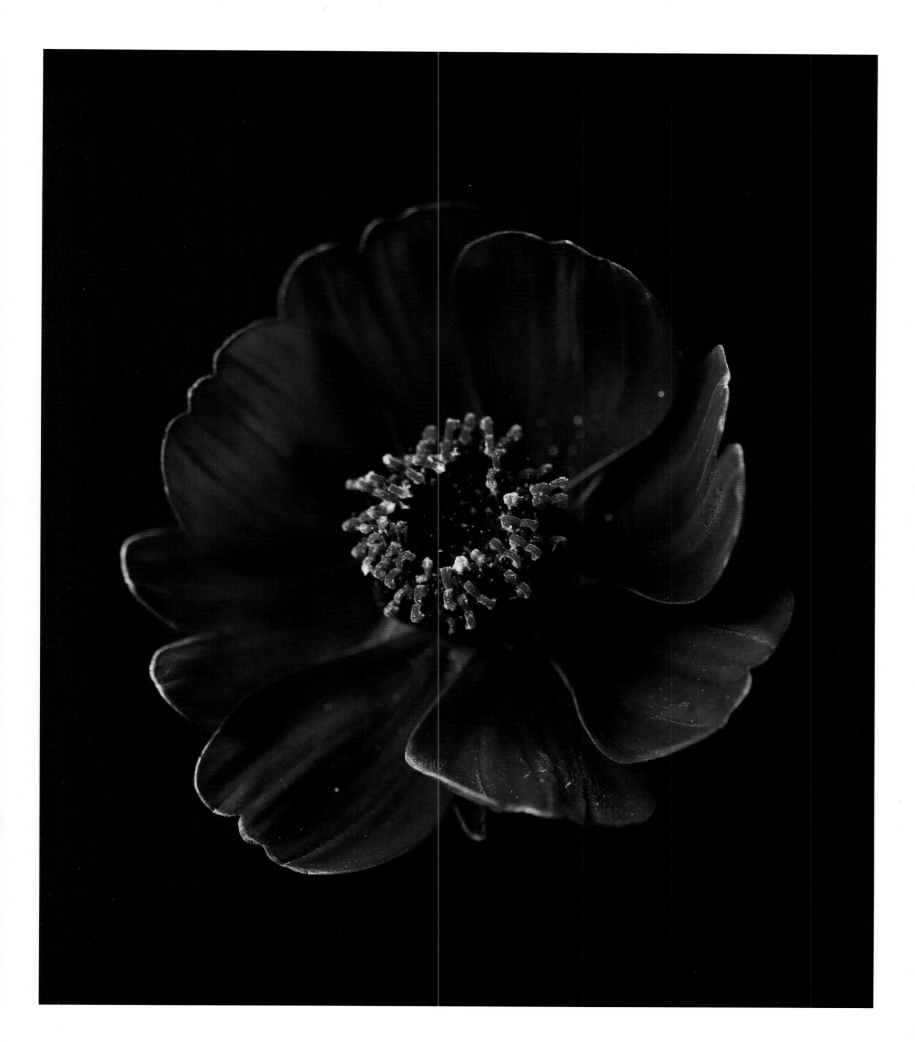

Arisaema ringens

Arisaema sikokianum (overleaf)

Arisaemas are members of the *Araceae*, a vast
family containing about 3700 species, most of
which are tropical. Arisaemas illustrate rather
elegantly two of the family's key characteristics:
arrow-shaped leaves, and a 'flower' composed
of a densely packed head of what are really tiny
individual flowers surrounded by a pale, leafy
sheath. It has an oddly sexual appearance,
and I am not referring simply to the fact that
all flowers are fundamentally sexual; the British
native woodland member of the family is
known popularly as 'lords and ladies', for in
the past it was only the aristocracy who had
any time for extra-marital shenanigans.

The rod-like structure, or spadix, is nearly
always surrounded by an adapted leaf called a
spathe. This flower structure attracts not bees
but other pollinators, particularly flies and
beetles; as a consequence, colour is not a major
part of the flower, but smell and sometimes
heat are. The plants' sophisticated chemistry
enables them to generate heat inside the lower
part of the spathe, a particularly effective
method for attracting insects in early spring.

Arisaemas may not be colourful, but they have
a certain beauty; the spathe often displays
subtle colours and complex and undeniably
attractive markings, and the foliage can be
a feature in its own right. They are found
primarily in North America and eastern Asia,
and the finest tend to be those from Japan,
Korea and China. Some gardeners can become
obsessive about collecting them. Their appeal
is similar to that of carnivorous plants, where
normal standards of beauty do not apply;
they have a certain gothic charm, or the allure
of the downright weird. It is not a proven fact,
but most arisaema-fanciers are probably men.

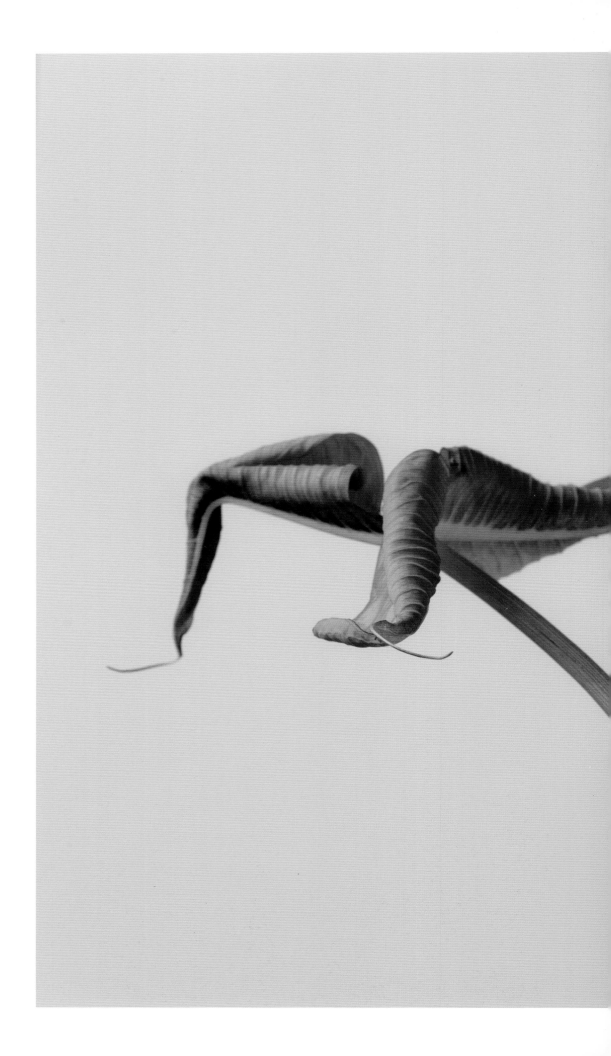

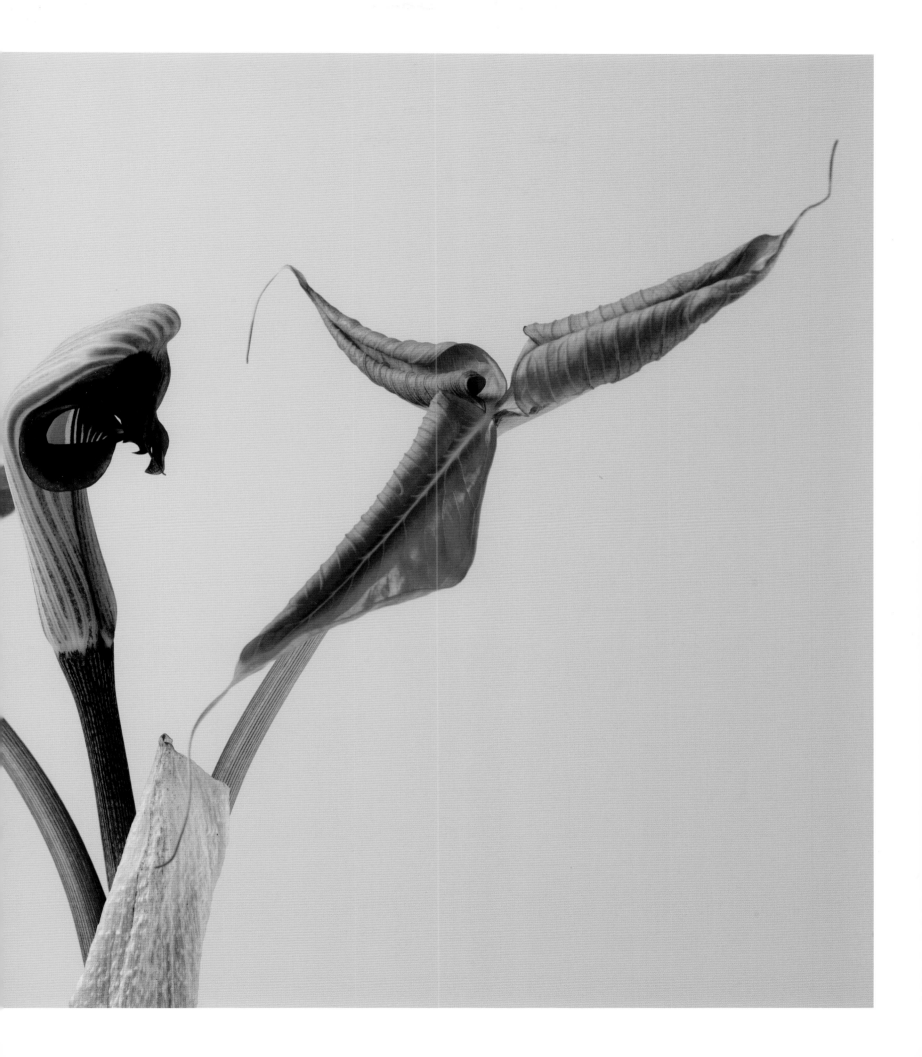

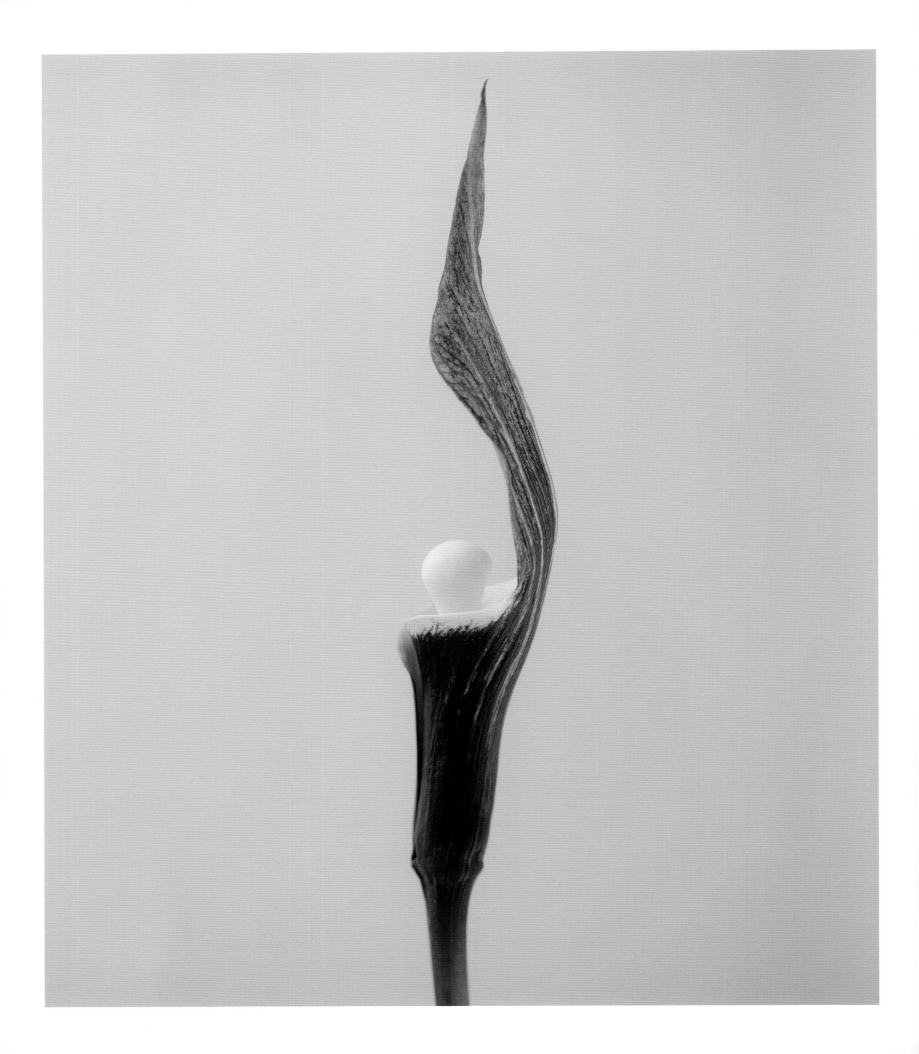

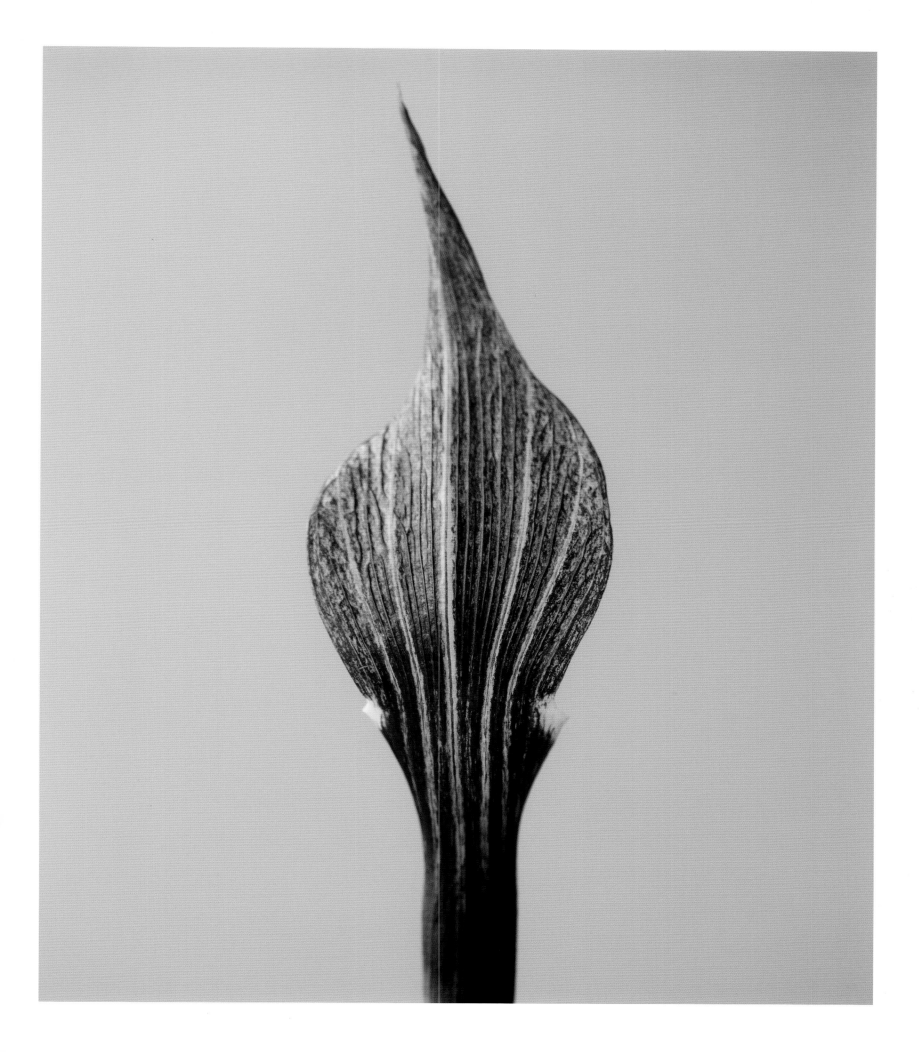

Anemone hupehensis var. japonica 'Pamina'

Lush woodland plants in their native Japan or China, Japanese anemones, as they are known, are stalwarts of older gardens, in which great muscular clumps can be found at the back of herbaceous borders, where the gardener has not waded in to divide them. Since they flower in late summer and autumn, their life cycle takes advantage of the monsoon climate of their homeland, where summer rainfall and high humidity provide ideal growing conditions during the warmest part of the year – so they can afford to flower and set seed late.

It was Dutch traders who first introduced these anemones – originally cultivated as garden plants in China and Japan – to a European public. Not allowed to leave their base on an island in Nagasaki harbour, during the Edo period (1603–1868), botanically minded Europeans relied on Japanese colleagues to bring them plants to describe, and eventually to send back home.

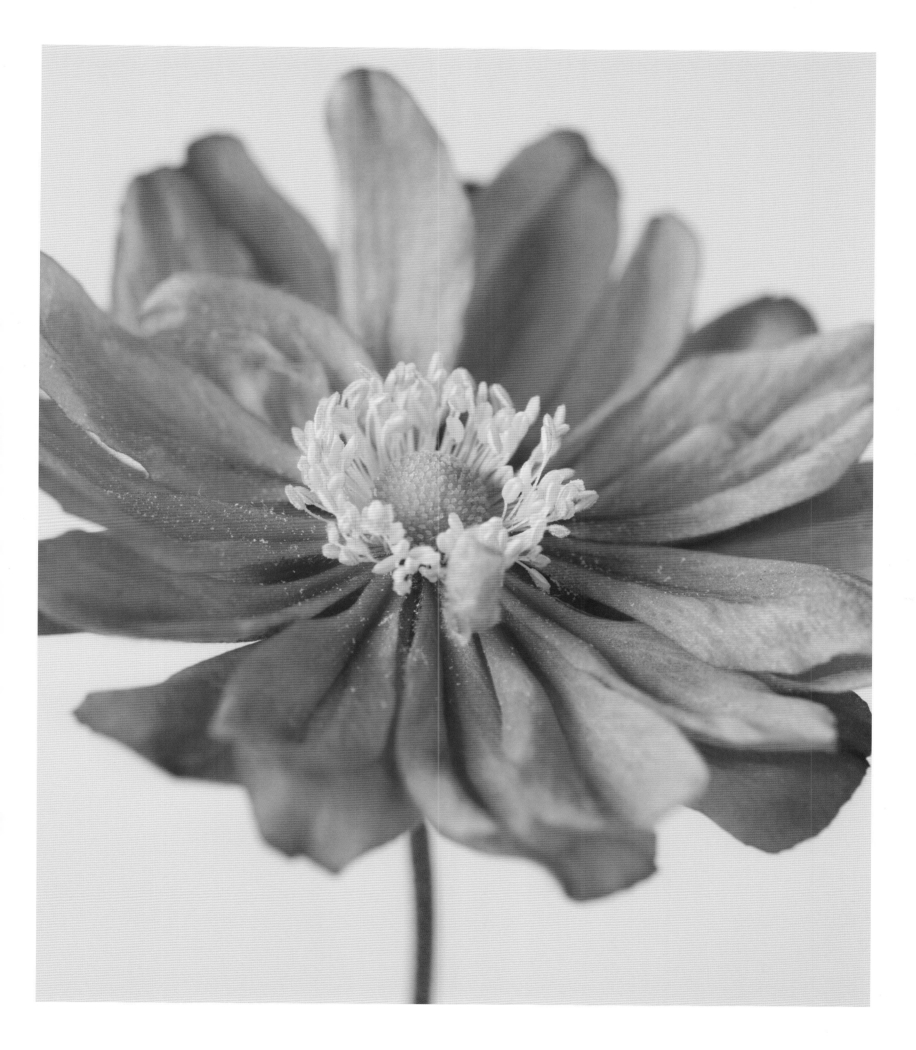

Bellevalia paradoxa (syn. *Muscari paradoxum*)

Of the many plants attractive enough to lure gardeners into growing them, only some become important commercially. Whether this happens often depends as much on historical accident as on anything else. Bellevalias are among those that appear to have missed the boat.

All those who grow this plant agree that it is easy and reliable in a sunny spot in well-drained soil. At one time included in the very similar – and far better-known – genus *Muscari* (grape hyacinths; see pp. 26–27), bellevalias are dramatic plants, with larger flowers than their more familiar cousins: dark navy blue, but with turquoise interiors. They come from similar habitats in the same area as *Muscari*: open places in the eastern Mediterranean and the Middle East. Unsurprisingly, the distinction between the two genera is lost on everyone outside the botanical community.

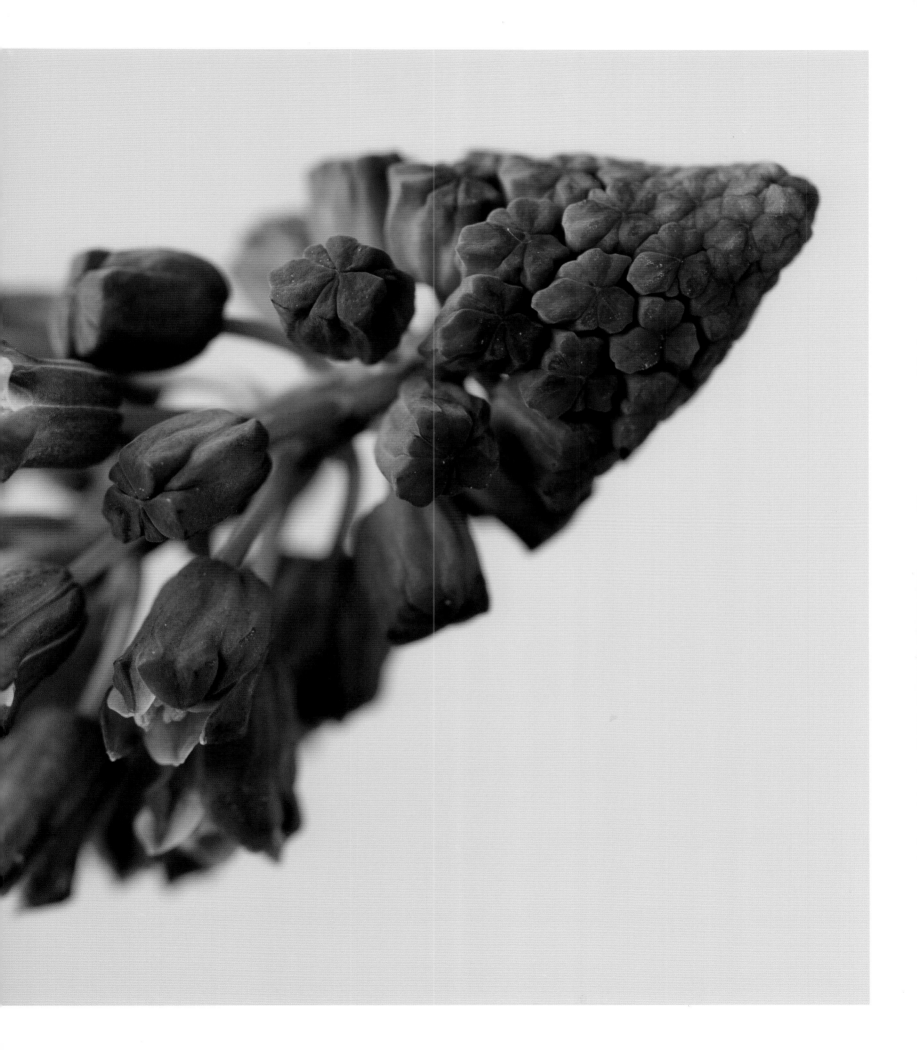

Helenium 'Rubinzwerg'

Russet tones, from pure yellow to dark red, are what heleniums do really well. This particular deep orange–red variety was first produced by the German company Peter und Bärbel zur Linden in 1989, has won an Award of Merit from Britain's Royal Horticultural Society and has been featured on a Dutch postage stamp.

Heleniums are originally plants of damp prairie, meadow or riverside habitats in central and eastern North America. They were first introduced to the United Kingdom in 1729, and by the late eighteenth century several were available from nursery catalogues. The breeding of new varieties got under way in the nineteenth century. During the twentieth century the best new varieties were mostly produced by Dutch and German nurseries. Older varieties can vary widely; it is clear that, over time, many have become muddled, and in some cases it is not known which was originally named as a good garden plant – the 'real thing'.

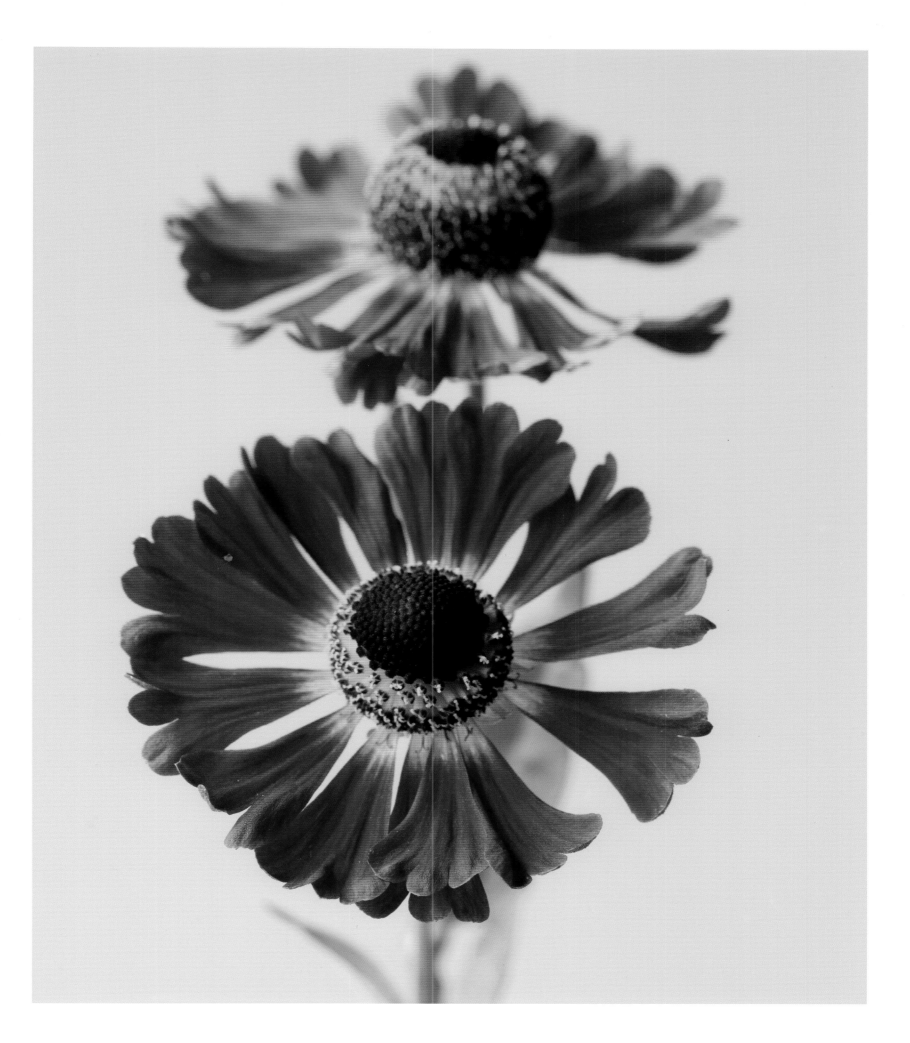

Cyclamen pseudibericum

Of all the twenty-two species of cyclamen, this is one of the finest, with intensely coloured and delicately scented flowers in early spring. It will grow outside only in regions where winters are mild, as – like many other wild cyclamen – it is used to the Mediterranean climate.

Wild cyclamen are a good example of what could be called a cult plant. Their undoubted beauty is reason enough to become enthusiastic about growing them, but they have an additional appeal: the wide level of genetic variation many of them display. This endears them to gardeners of a botanical bent, who are prepared to provide the conditions the plants need to survive the winter (often simply a cold frame), but who are driven by a passion for exploring the variation that some species exhibit. There is even the Cyclamen Society for true aficionados. Members exchange seeds, swap plants, exhibit them, write about them and even organize expeditions to their homelands to collect seed from regional variations.

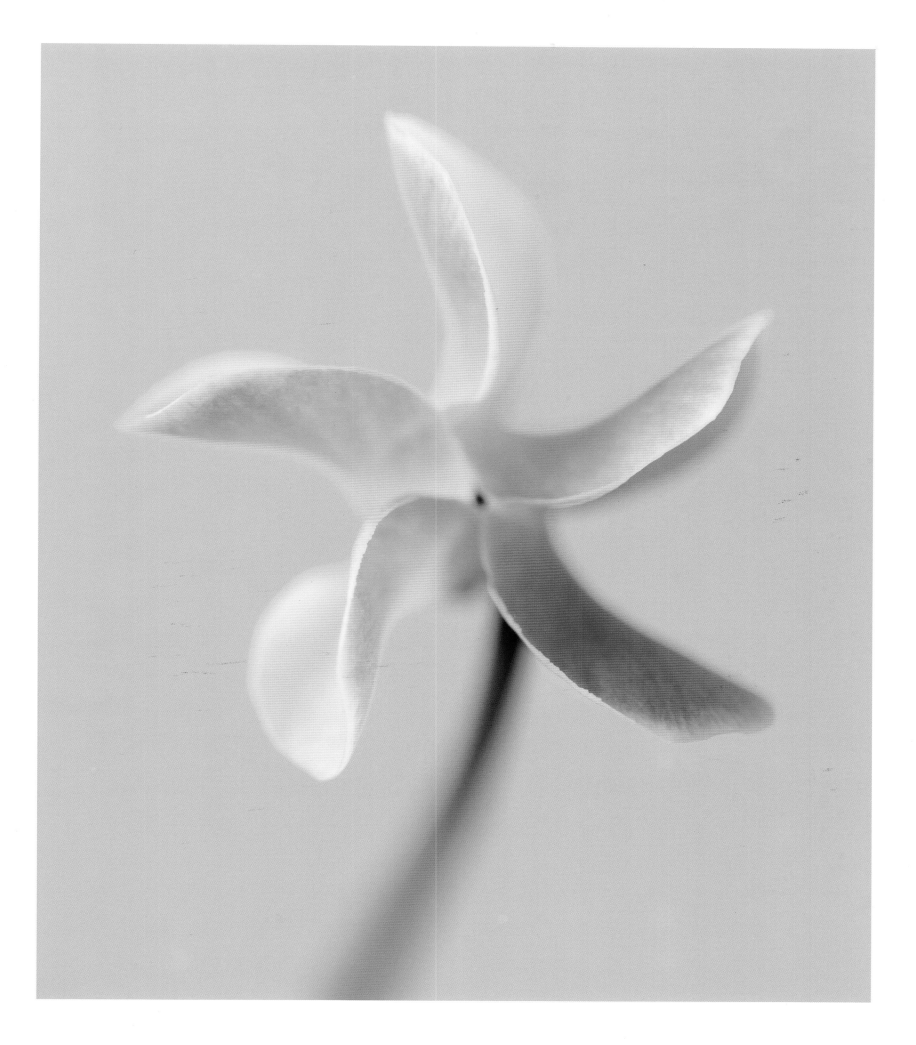

Erythronium 'Kondo'

Pale-yellow flowers suffused with green, such as those of the primrose, are in fact quite rare among plants. This dog-tooth violet is a hybrid between two North American species (*E. tuolumnense* and *E. californicum*), and – as is the case with many hybrids – is naturally more vigorous than either parent. The phenomenon of 'hybrid vigour' has been very important in plant-breeding for centuries. The reasons for the stronger growth and sometimes greater size of hybrids vary from one plant to another, but broadly speaking concern the new combinations of genes that are created. It can be a boon for gardeners, as the plants are often easier to grow than their slower-growing and less adaptable wild parents. Flowers are often bigger, and sometimes – as with 'Kondo' – there are more flowers on the spike.

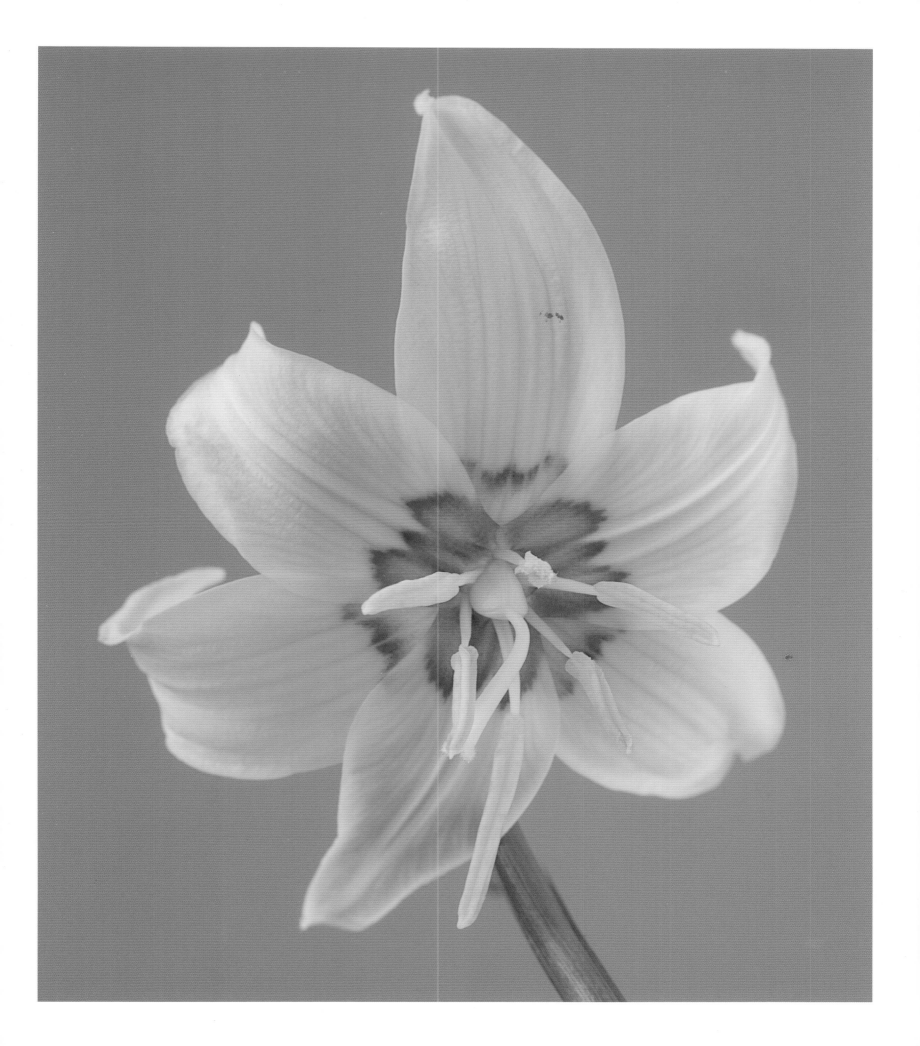

Gladiolus papilio 'Ruby'

For most people, gladioli are simply brightly coloured flowers with a bearing so upright that 'military' seems the only suitable word to describe them. In common with many cultivated flowers, however, they bear little resemblance to their wild relatives, although wild gladioli do exhibit a wide range of strong colours. Several species of South African origin were grown in mid-nineteenth-century Europe and the United States; they hybridized easily, and so many colourful hybrids were produced during the years that followed.

Times change, however, and by the 1980s the 'glad' was looked down on by many as too bright, too garish, and utterly lacking in grace. Snobbery had a part to play: from the 1950s onwards, the elite of the garden world had fallen in love with a more subtle look (see *Astrantia*, pp. 42–43), and the gladiolus, together with the dahlia and the chrysanthemum, was seen as a working-class flower. Bulb enthusiasts did, however, grow some of the numerous wild species, and the wonderful dark-magenta *Gladiolus communis* subsp. *byzantinus* flourished in British borders and wild-flower lawns.

Despite all this, the hybrid gladiolus never lost its popularity in Eastern Europe; in a part of the world with long, cold winters and an oppressive political system, flowers were immensely important. I remember a group of Russian gladiolus-growers arriving in London in the early 1980s, during the last few years of the Communist regime, and – much to their surprise – being feted by the Royal Horticultural Society. They were even given a stand at a flower show.

The 'classic' gladiolus has still not recovered its former status, but gardeners who prefer the natural look have begun to pay more attention to the wild species. As a result, selections have been made, named, propagated and distributed by the nursery trade. The next stage is a new generation of hybrids. It is as if we can never leave plants alone: we might reject 'unnatural' and 'garish' hybrids for the grace of the wild, but the process starts again with the selection and crossing of the new gene pool. This is illustrated to perfection by G. *papilio* 'Ruby', a selection made in New Zealand from one of the many South African wild species.

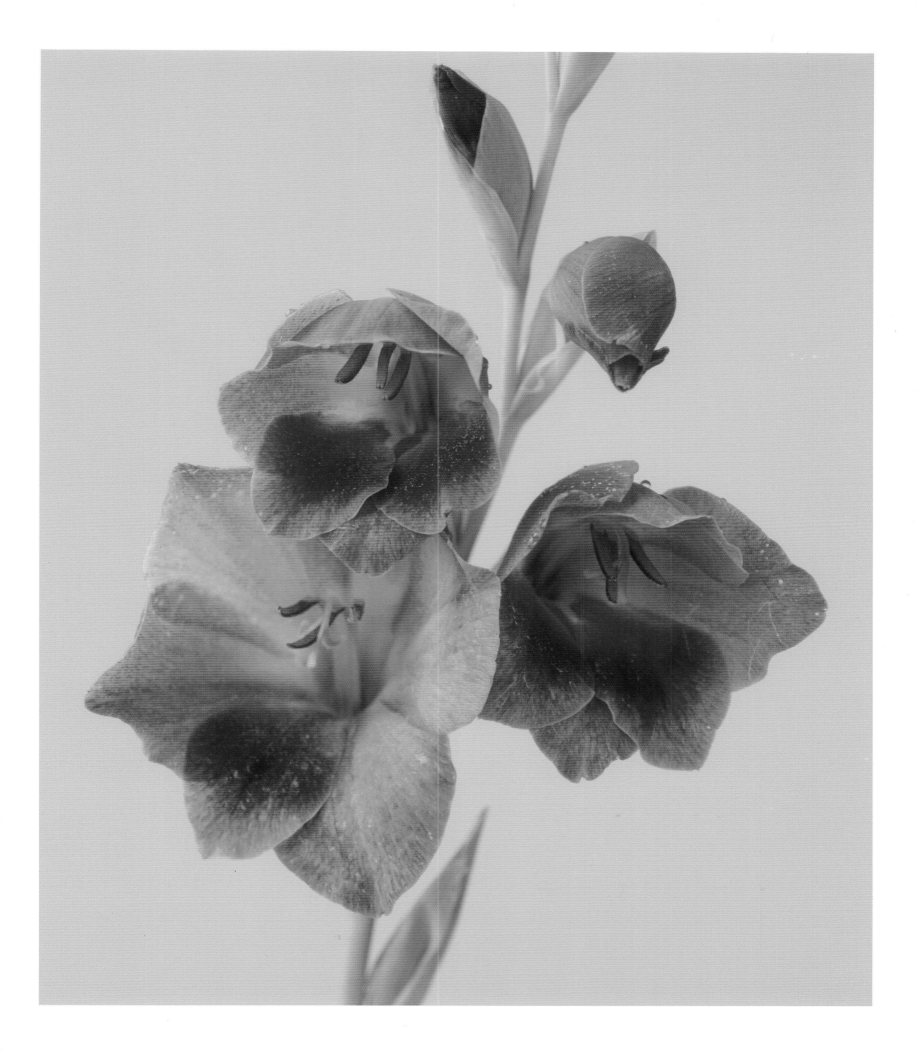

Ranunculus asiaticus cultivars (opposite; pages 108 and 109)

Like the tulip, the ranunculus is a product of
the Ottoman Empire. Since it dies down to
small tubers, the plant – also like the tulip, and
that other import from the Islamic Middle East,
the bearded iris – was easy to export, in the
saddlebags of crusaders or the panniers of a
mule train of Balkan traders. It was also easy
to steal. As so often happened, the owners
of these special plants did not want others to
have them, and the plants reached new homes
only through theft; the story of the ranunculus
is that a servant managed to steal a plant
from a Turkish garden and get it to Clusius
(see p. 24), who distributed it widely in Europe.
Huguenot refugees brought the plant to
England and the Protestant Low Countries
(now The Netherlands and Belgium), where for
many years it was a 'florists' flower' – 'florist'
being the name given to amateur growers of
particular flowers, who typically grew plants in
pots and exhibited them at competitive shows.

The Ottomans had both single and double
ranunculus, in a range of colours. Many new
varieties were produced in Europe, and as
gardening (as distinct from the florist culture
of pot plants) became more popular, the
plant grew in importance; in 1820 a catalogue
produced by a London-based importer listed
400 varieties. They were commonly planted out
as border flowers, although without care and
feeding they would not necessarily flower again;
but they were quick for nurserymen to bulk up,
and so it was easy and cheap to replace them
every year. Given the frequency with which new
varieties could be bred, that made them an
attractive proposition. Ranunculus have now
become popular once more, as the nursery
trade recognizes their value as short-lived pot
plants for instant impact.

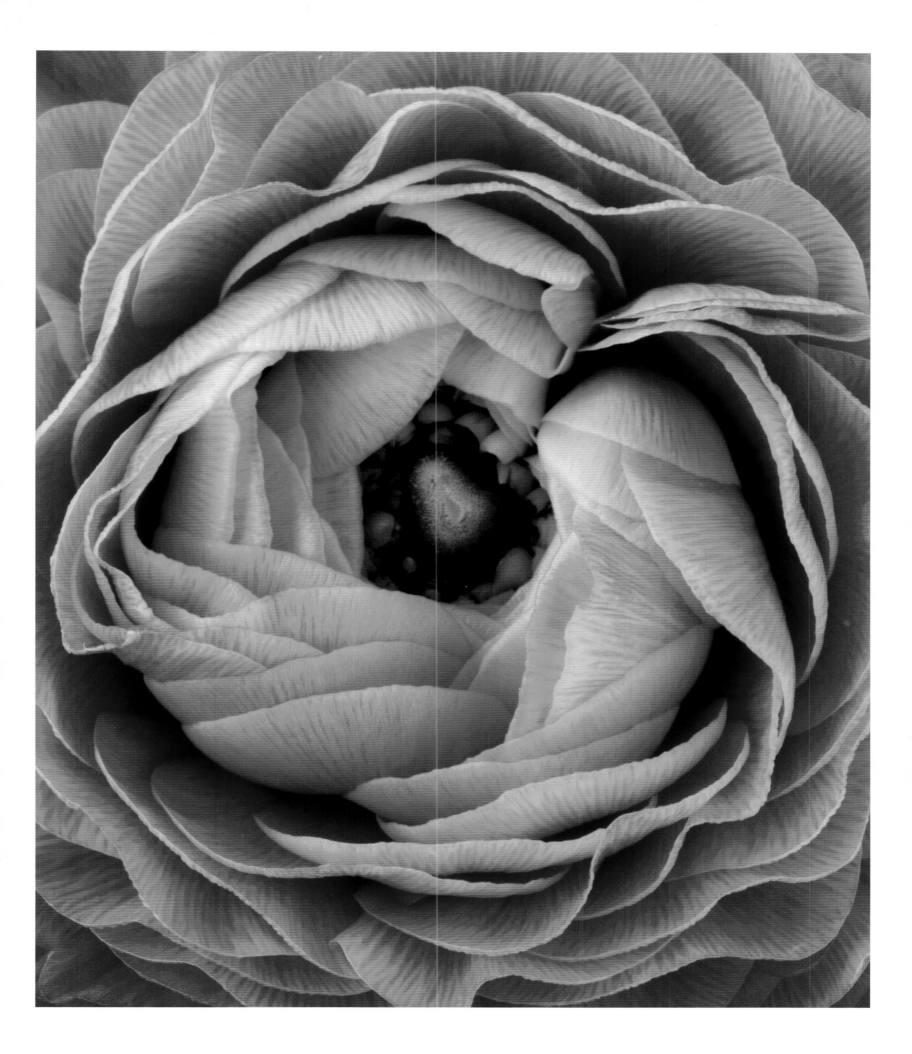

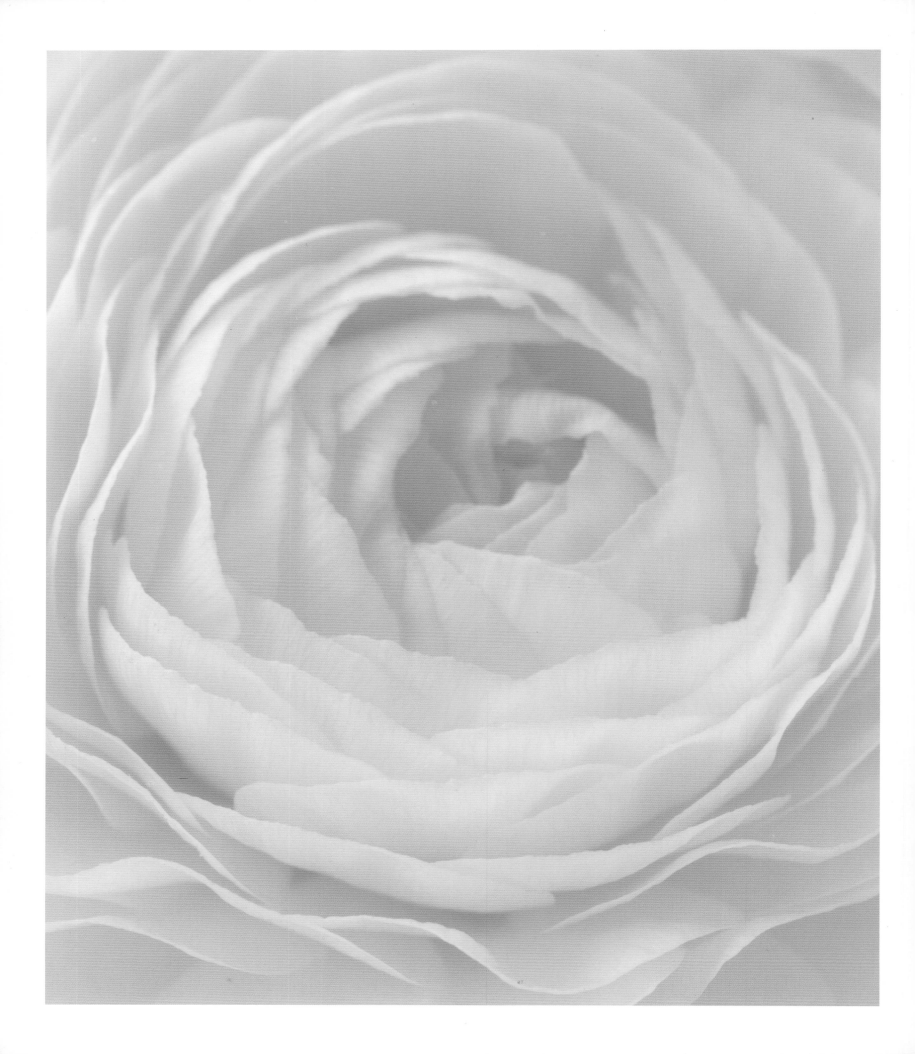

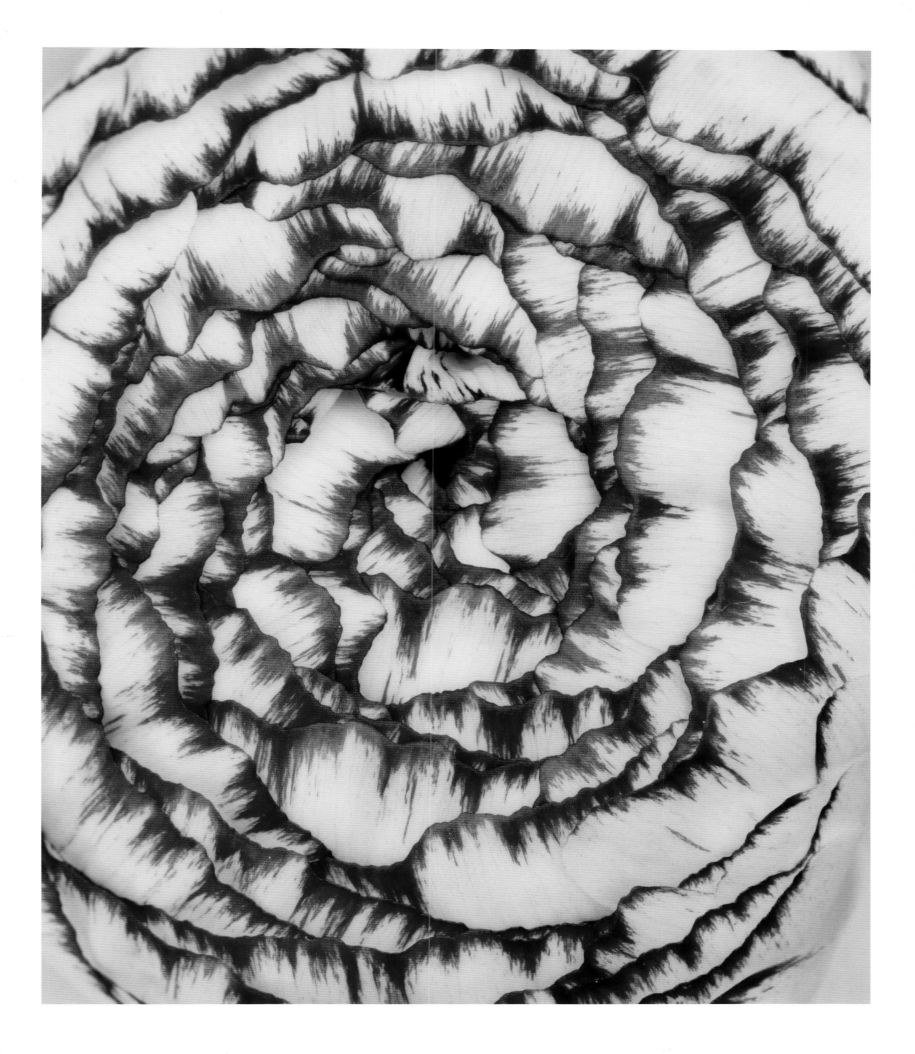

Astilbe cultivar

Astilbes are colourful, long-lived plants for damp places. A variety of species were introduced into Europe from Asia over the course of the nineteenth century. It was inevitable that one of the most obsessive hybridizers of all time, the Frenchman Victor Lemoine (1823–1911), would make the first crosses, but it was the German nurseryman Georg Arends (1863–1952) who really put astilbes on the map, making them one of Germany's best-loved garden plants. Before Arends, there were only white and pink types; afterwards, one could find every shade in between, as well as some good reds and mauve–purples.

Astilbes' stiff habit and often bright colours have not endeared them to everyone. The Dutch writer and gardener Henk Gerritsen (1948–2008), for example, described the hundreds of cultivars as 'trying to outdo each other in sheer pomposity … you have an entire genus of plants which can be thrown straight on to the compost heap'.

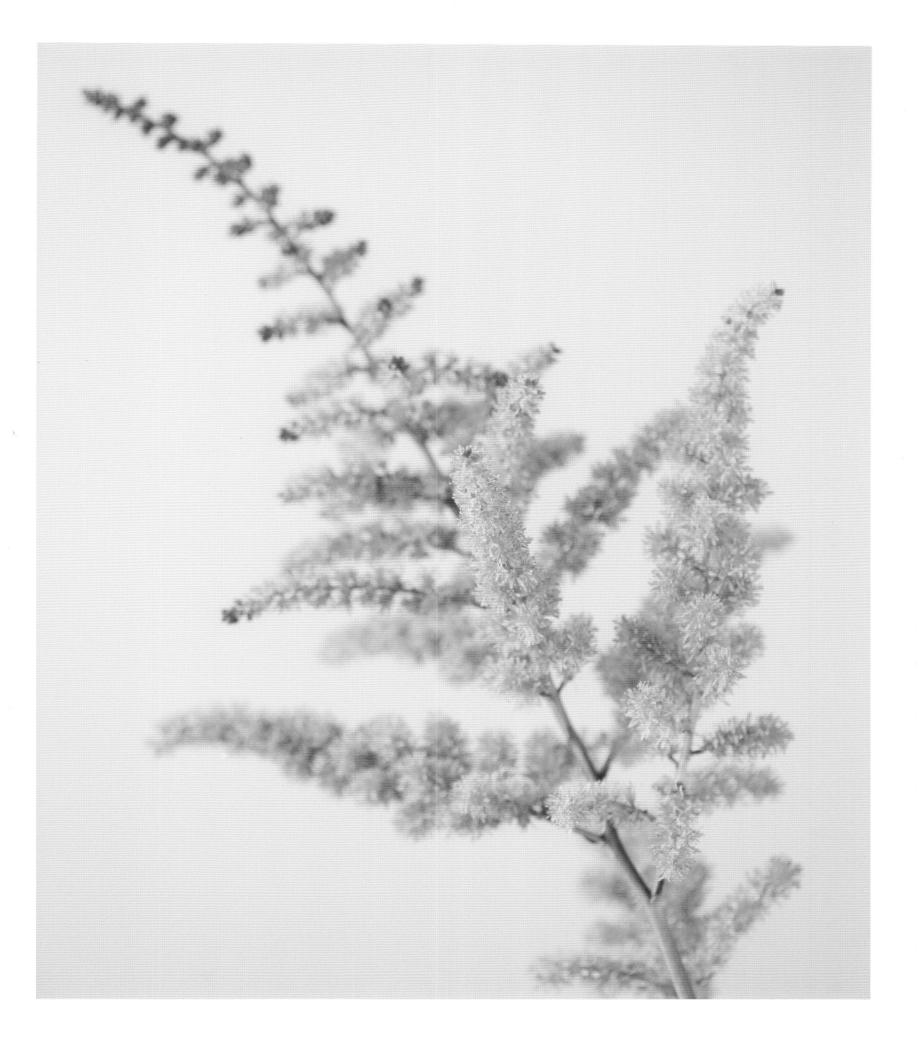

Iris 'Pauline'

Varieties of *Iris reticulata* (of which 'Pauline' is one) are to be found each autumn in almost every garden centre as bulbs, usually Dutch-grown. Those with experience of bulb-growing are in incredulous awe of the Dutch industry; such scientifically driven growing is aimed at 'one-hit wonders', bulbs packed with potential for one spring, but which lack the capacity to continue performing after that.

Irises can, of course, flower again in future years, but only if the summer is dry and hot, allowing the bulbs to ripen. Keen growers keep them in pots, so that they can be stored in a greenhouse or cold frame over the summer, in an attempt to approximate the conditions 'back home' in the Middle East. Most of us, though, do not have this level of dedication, and are perfectly content with our cheap-and-cheerful one-season specials.

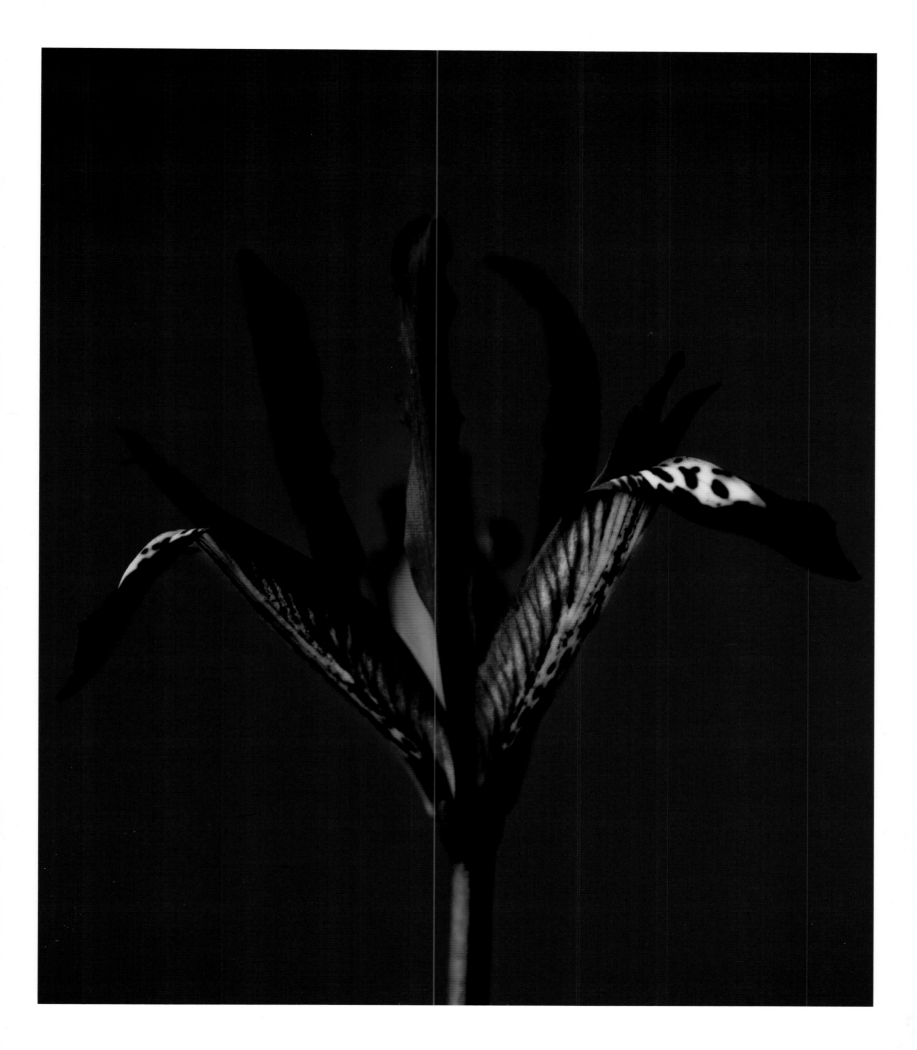

Chrysanthemum indicum cultivar

Chrysanthemums are one of the most important flowers of the Far East; the Chinese grew them at the time of Confucius (*c.* 500 BCE), and later they spread to Korea and Japan. So highly esteemed were they by the Japanese that, for a time, only the Imperial family was permitted to grow them, the Order of the Chrysanthemum was the highest honour that could be bestowed, and they featured on the national flag.

The plant appeared in Europe only at the very end of the eighteenth century, and it was not until well into the nineteenth that breeding made much impact. The first British flower show exclusively for chrysanthemums was held in Norwich, Norfolk, in 1843, and in 1846 the Chrysanthemum Society was formed. The opening up of Japan in 1852, and its early exploration by Western botanists and plant-collectors, resulted in the introduction of many new varieties during the latter half of the century.

Always popular with the cut-flower industry and in gardens, the chrysanthemum has for many years been a favourite show flower among working-class garden enthusiasts in the United Kingdom. Enormous flowers are exhibited at competitive flower shows, and growers remove all side buds so that the plant's energy is put solely into the production of this one bloom of perfection. The total control over their plants exhibited by British growers, however, is as naught compared to that shown by the Japanese. *Kiku* is the art of chrysanthemum-growing, in particular of training plants over complex bamboo frames. The aim is to have exactly one flower at each of many points, so that the plant forms what is best described as a sculpture. Enormous attention to detail, great skill and complete ruthlessness are required: it is the ultimate expression of the mastery of human over plant.

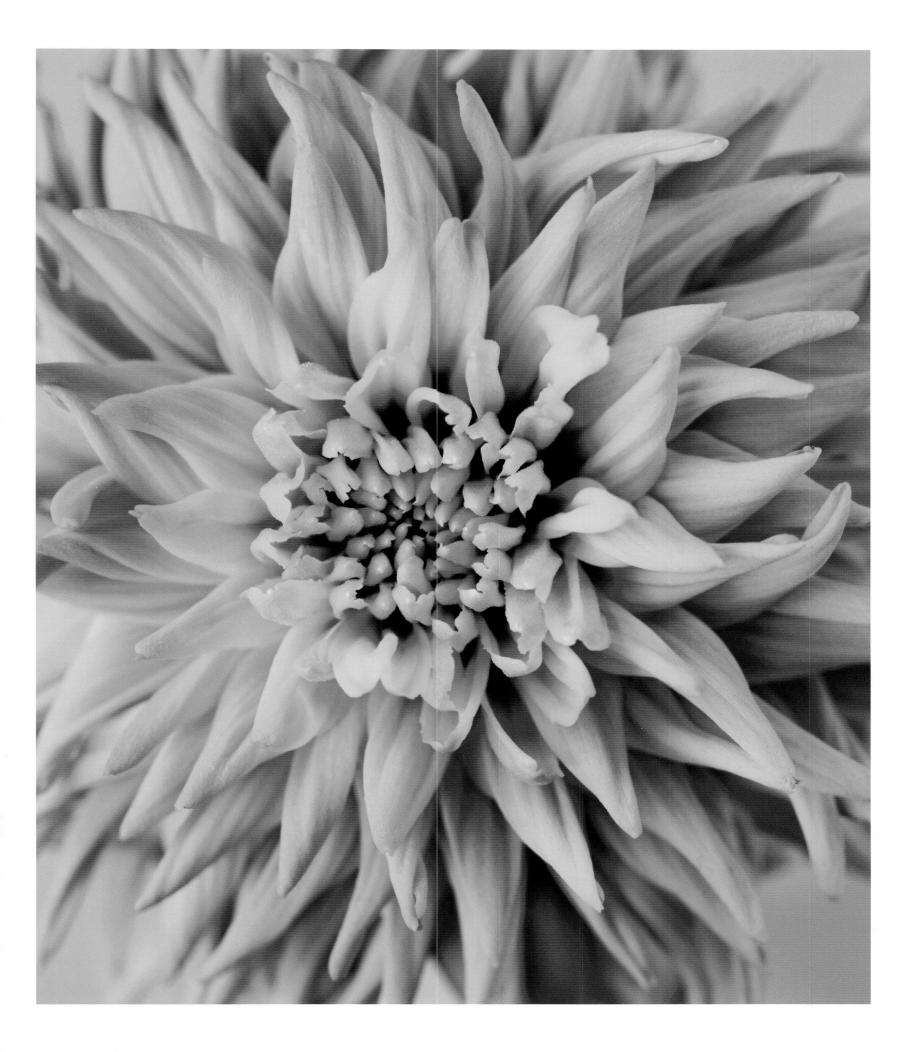

Tulipa altaica

Tulipa turkestanica (opposite)

'Species' tulips are the little ones, either identical or very similar to the wild plants whose centre of distribution is the northern Middle East and Central Asia. *Tulipa altaica* reaches as far north as tulips go, into parts of Siberia, and *T. turkestanica* as far east, into China. These tulips trickled into cultivation during the nineteenth century, and had a period of great popularity in the late nineteenth and early twentieth centuries, when many gardeners reacted against the blowsy hybrid tulips, and against formal planting in general. Rock gardens became popular, planted with species from wild and faraway places. Species tulips were ideal for the new craggy look, especially since – when surrounded by rocks during the summer – there would be a good chance that their bulbs would ripen enough to flower again the next year, which in normal garden conditions cannot be guaranteed.

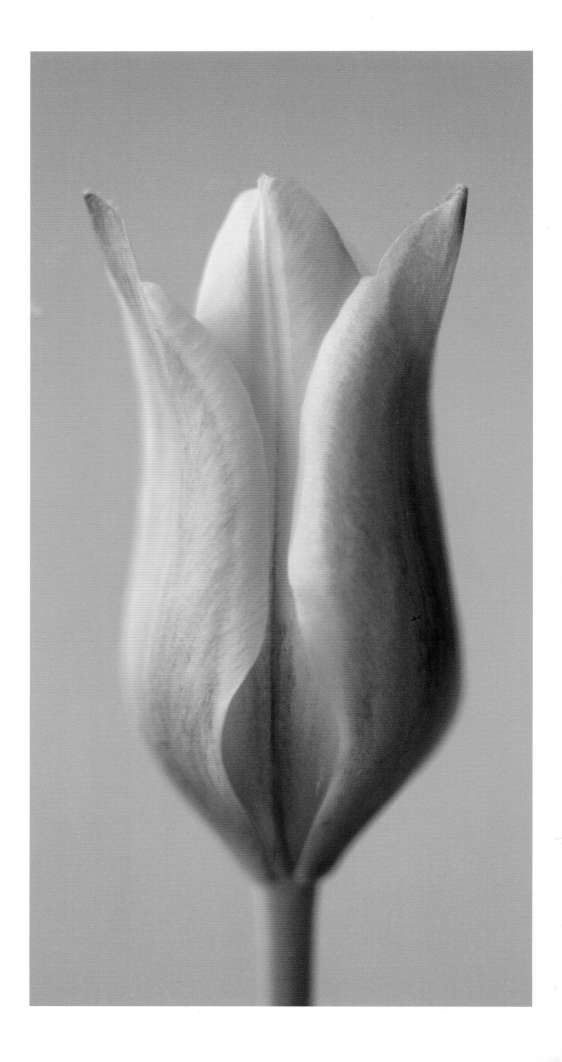

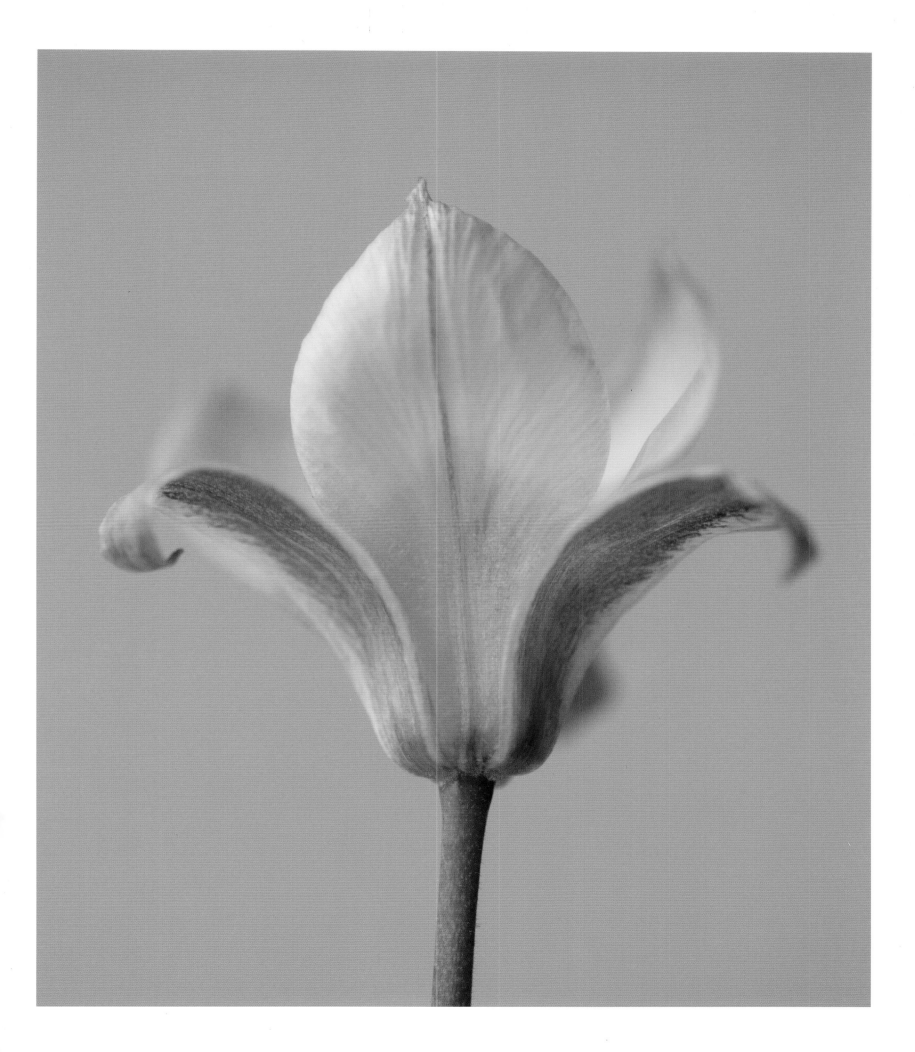

Aechmea fasciata 'Primera'

Aechmeas are bromeliads, a family that shows many extraordinary adaptations to difficult environments. Their long-lasting, leathery leaves have evolved to withstand drought, making them popular plants for the house and office. Indeed, they are an important member of a flora that will forever be linked with 1960s Modernism, hotel lobbies and light, functionalist architecture.

There are 3170 species of bromeliad and 225 of Aechmea, all originating in tropical America, from Mexico southwards. Many have evolved to live without soil, instead hanging on to rock faces (as lithophytes) or tree branches (epiphytes) with their roots. Humid tropical environments can provide enough water from rain or vapour, and enough nutrients from accumulated dust and organic debris, to allow the plants to thrive.

Aechmea fasciata is one of many bromeliads with a central 'urn' – formed by the wrapping together of the lower parts of its leaves – which collects rainwater and decaying organic matter. In its Brazilian home, it grows in serried ranks on the more horizontal-tending branches of rainforest trees, and anywhere else that offers a foothold. After flowering, the plant releases large quantities of tiny seed, some of which lodge where they can absorb moisture and grow to start the next generation. Once the seed has been scattered the parent plant dies, but it is succeeded by 'daughter' rosettes, which do their best to hang on to neighbouring sections of branch.

Aechmeas and other bromeliads flourish alongside a great many orchids, epiphytic cacti and ferns many tens of metres above ground, where they get far more light than on the dark forest floor. The plants provide a home for insects and frogs, too, and some invertebrate and amphibian species may spend their entire lives high up in the air in these water-filled urns.

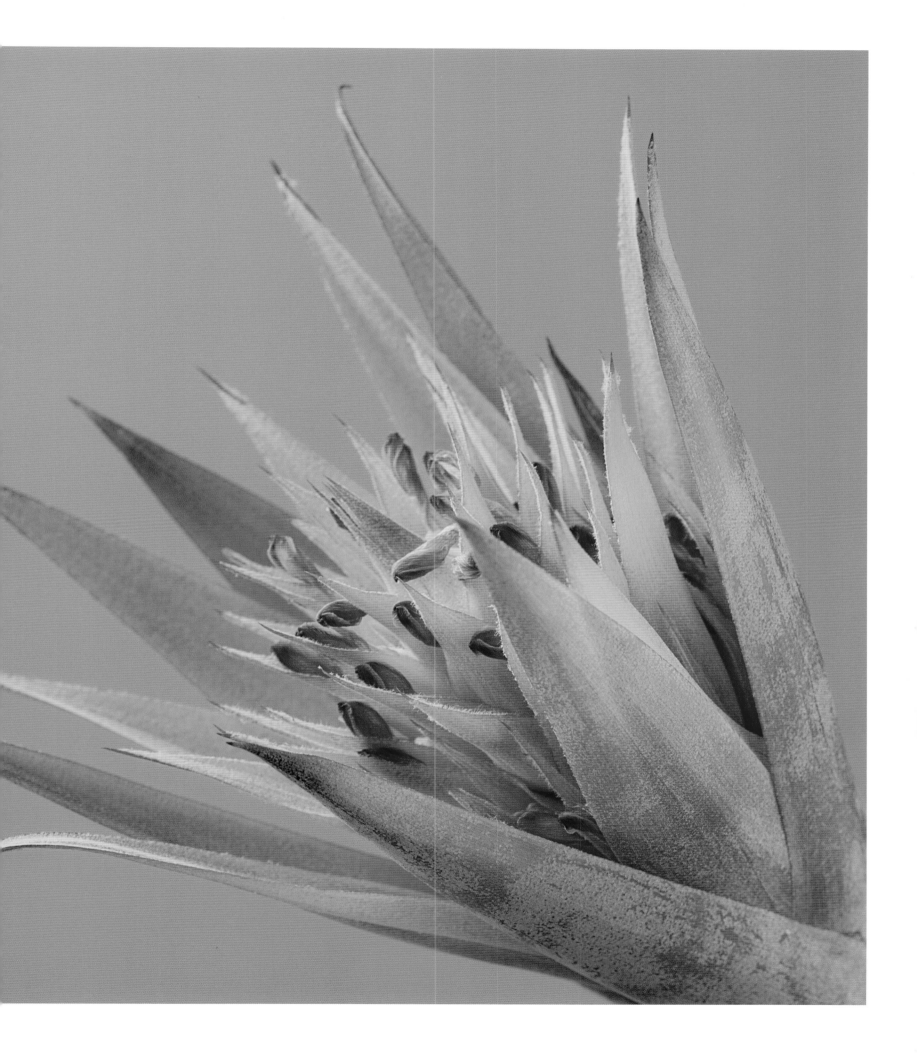

Dahlia 'Tiptoe'

What is most extraordinary about the dahlia is the apparent speed of its development. Six species were introduced to Europe between 1789 and 1804, but by 1806 the Berlin Botanic Garden had fifty-five cultivars in flower, and by 1830 some thousand cultivars were known, in nearly all the colours with which we are now familiar. The real reason European breeders were able to make such progress in a short period of time may be that the work had already been done for them: the dahlia had been a favourite flower of the Aztecs.

No other plant offered such exoticism combined with such ease of growth. For those with small gardens or rented allotments, the plants were a boon. A few could be planted alongside the potatoes, and then families and friends won over by the colourful and sumptuously tropical-looking flowers, which also last very well when cut.

It is no surprise, then, that the dahlia became a favourite with working-class gardeners throughout Western Europe. And it is therefore no more of a surprise that, as garden taste was extensively reworked in the 1970s and 1980s, this once fashionable plant fell from favour with the horticultural elite. But once the garden guru Christopher Lloyd (1921–2006), the doyen of upper-middle-class British garden society, had given his approval by planting some dahlias in his garden, their popularity in the United Kingdom soared.

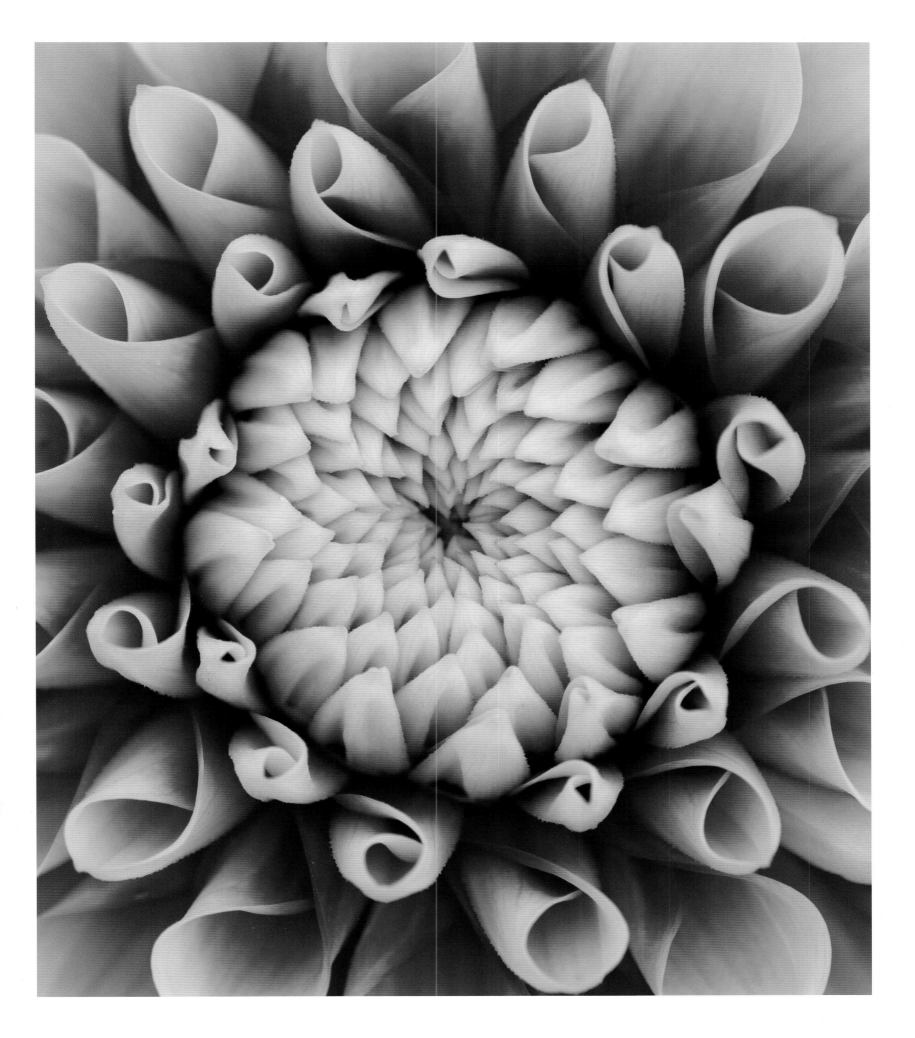

Pennisetum orientale 'Karley Rose'

The popularity of these grasses, with their delightfully fluffy flower and seed heads, has been increasing steadily over the last few decades. 'Karley Rose', with its rose-pink (as opposed to sandy-pink) flowers, is a far more ornamental plant than the established garden plant *Pennisetum orientale*. It is also superior for its long season of interest and greater hardiness.

Selected by David Skwiot at a nursery in Kensington, Connecticut, this plant was patented in 2002, and is protected by the Plant Breeders Rights system. Anyone wanting to propagate it for sale must obtain permission and pay a royalty. The system is intended to encourage innovation and reward those who develop new plants, but it remains controversial among gardeners, many of whom point out that numerous new plants are the result of accidental discovery rather than dedicated breeding programmes.

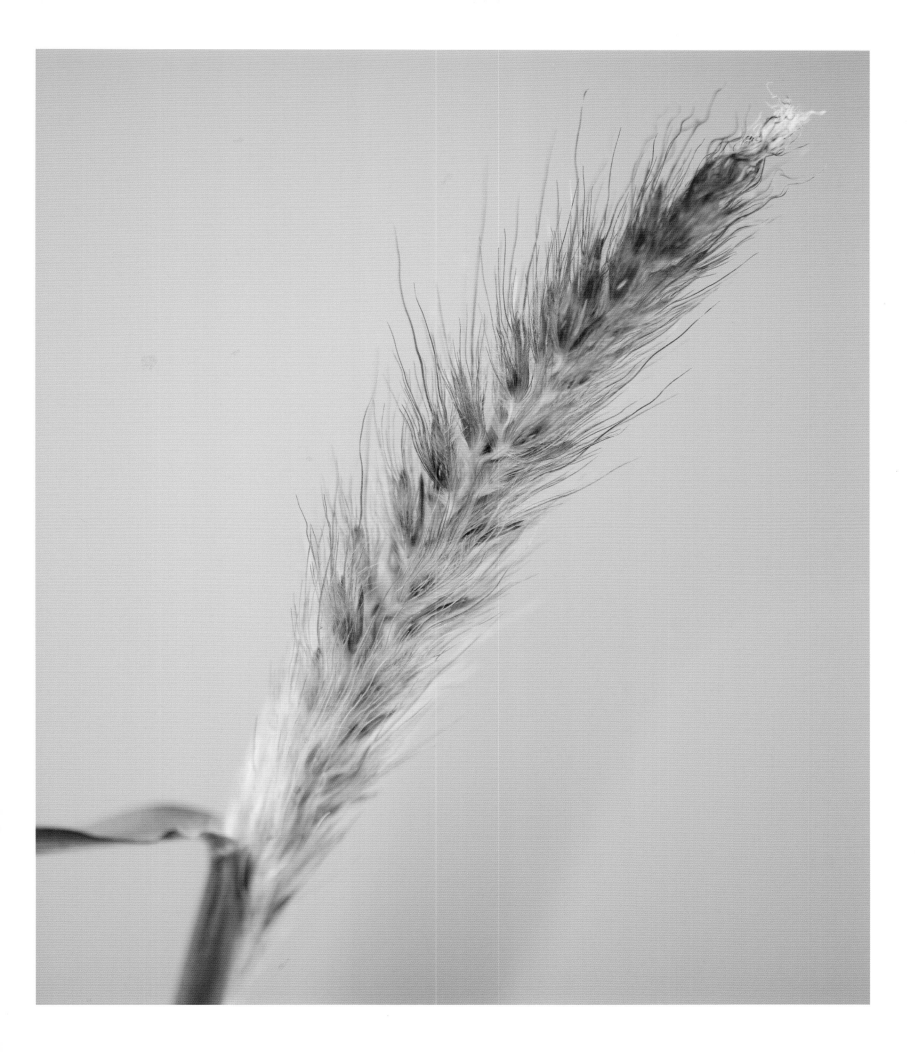

Fritillaria sinica

There are more than 100 *Fritillaria* species (see also pp. 138–39), most of them from regions with a warm and dry summer climate; one centre of distribution is the Middle East, the other the western United States. Enthusiasts in wetter regions must give the plants some sort of cover to protect them from the worst of the winter cold and wet. Nearly all fritillaries are happy with high moisture levels while they are actively growing and flowering, but most need dry soil and sun during their period of summer dormancy.

The rewards of growing *Fritillaria* include the opportunity to appreciate a wonderful range of subtle flower colours; the chequerboard pink and white of the well-known European species *F. meleagris* is about as flash as it gets. *F. sinica*, from the mountain grasslands of Sichuan province in China, is another species with this very unusual patterning.

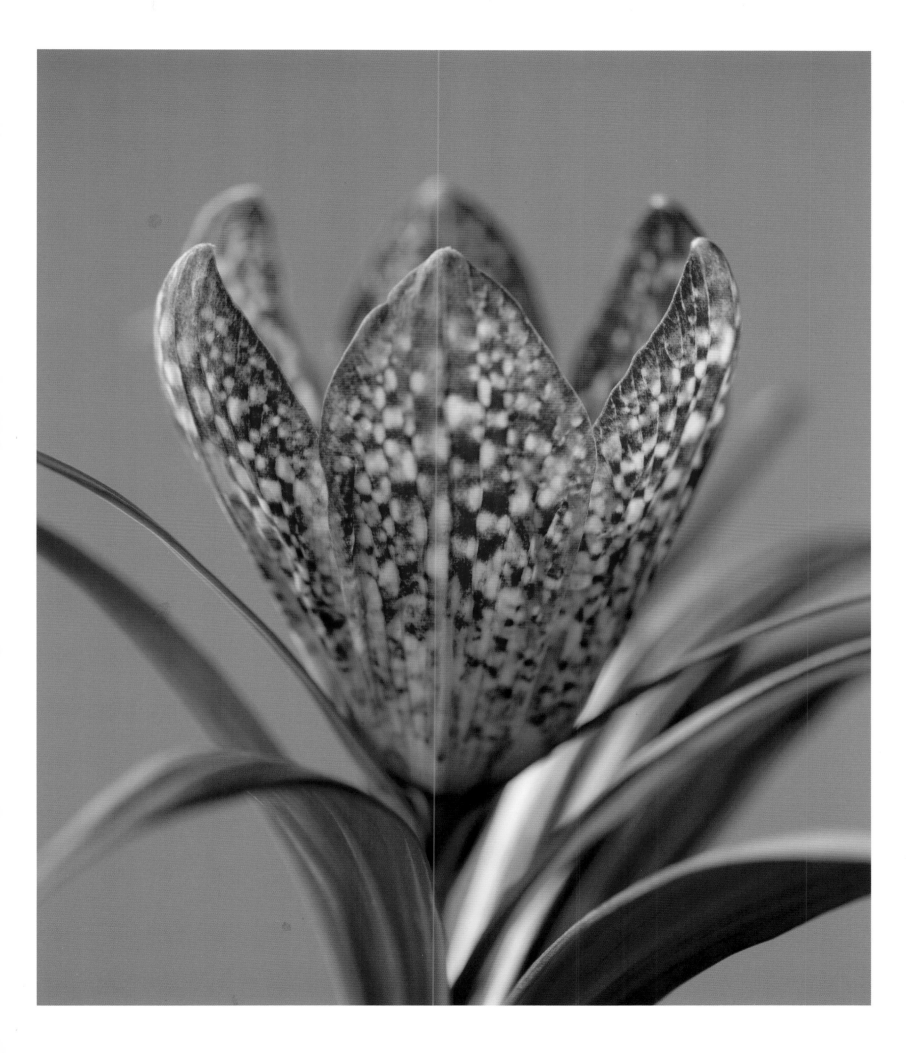

Dahlia 'Rip City'

The dahlia, with its remarkably wide range of colours as intense as any flower can offer, and some truly extraordinary shapes (such as the almost spherical Pompom group), has the habit of dying back to a tuber, which can be dried and sent cheaply by post, and has thus long been a favourite with bulb merchants. Its success as a garden plant can be attributed to a combination of the extraordinary variety of colour and shape offered by the plants, and their ease of growth. Not hardy, they have to be dug up each autumn and replanted in spring, but – since the plant dies back to a neat tuber – this is not a chore, and splitting the tubers enables the propagation and distribution of new varieties to run at quite a pace, too. Production from seed is also easy.

'Rip City' is a strong, vigorous variety, much-loved for its dark, luscious, ruffled petals. Growers of this dahlia are in good company: it has a place in that most romantic of gardens, the one that belonged to Claude Monet (1840–1926), at Giverny in France.

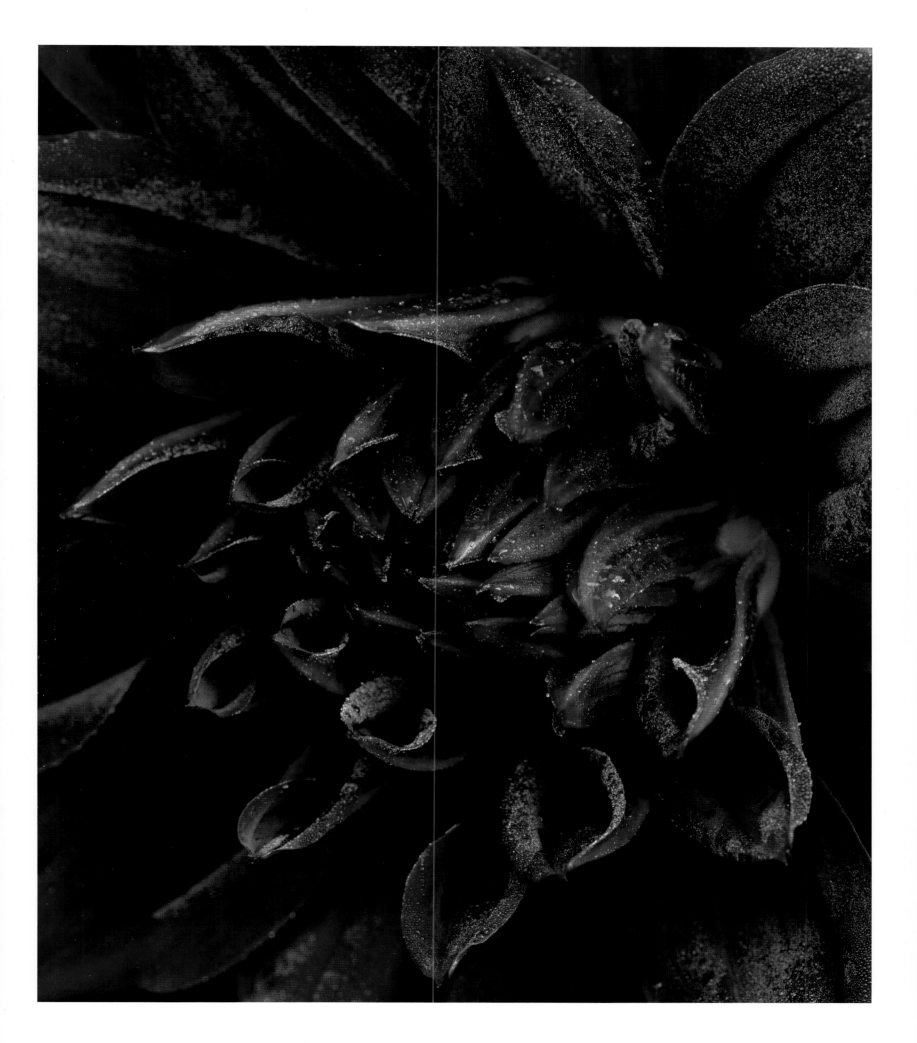

Anemone pavonina

The brilliant scarlet flowers of this anemone adorn many a Mediterranean hillside in spring. It was the Ottoman Turks who first grew it as a garden flower, with European travellers acquiring plants in the sixteenth century. It was a popular spring garden flower during the eighteenth century, as it was very easy to look after: dug up once its leaves had died back in summer, it was stored in a dry place to be replanted the next autumn. Large numbers of the plant could also be raised from seed, making it an attractive proposition compared to such bulbs as tulips, since it flowered so much more quickly. A great many varieties were bred during the nineteenth century, and crossing with the very similar *A. coronaria* (see pp. 144–47) has since resulted in a range of cheerful hybrids. Anemones have therefore enjoyed one of the longest periods of continued popularity of any flower.

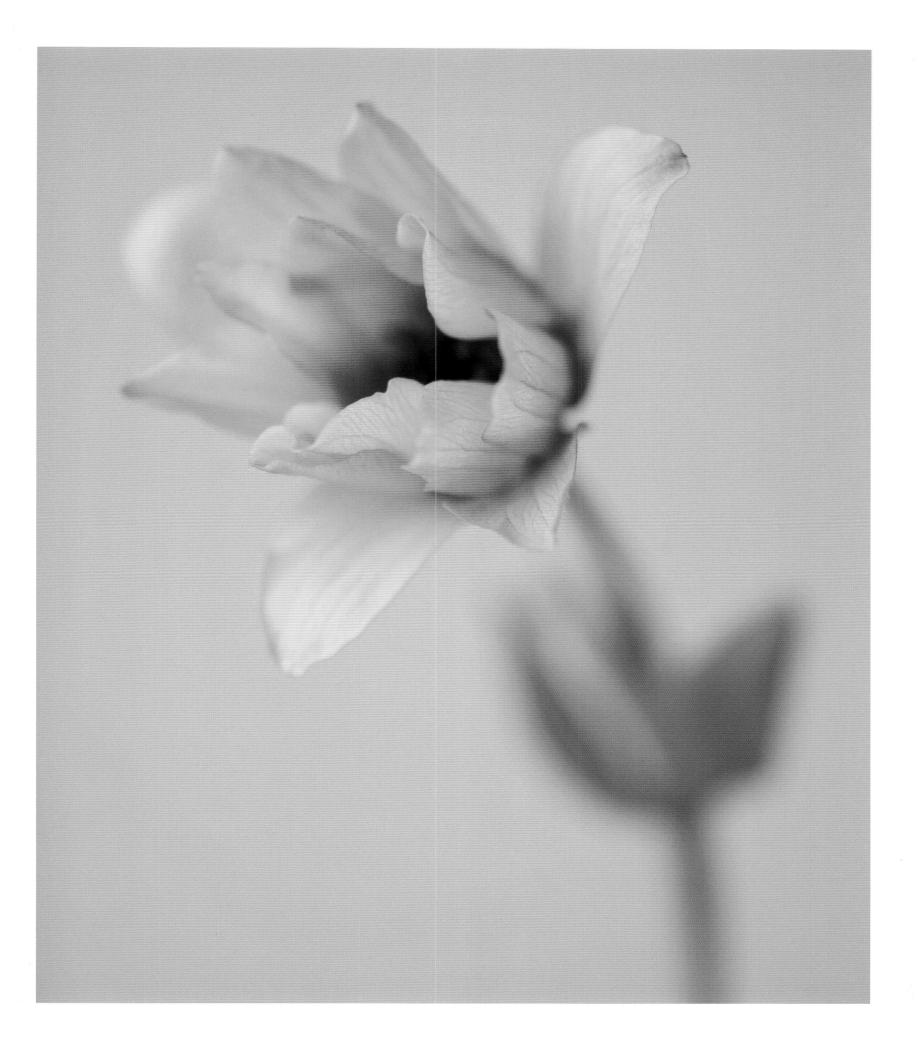

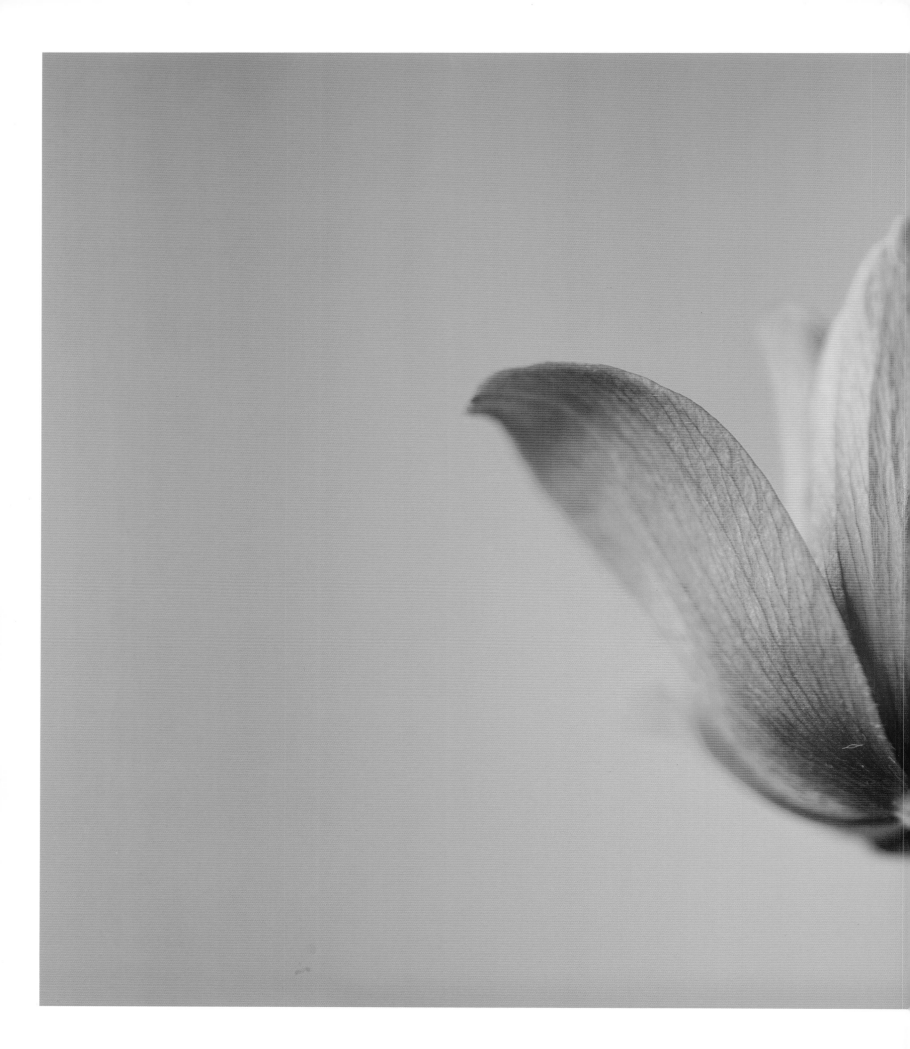

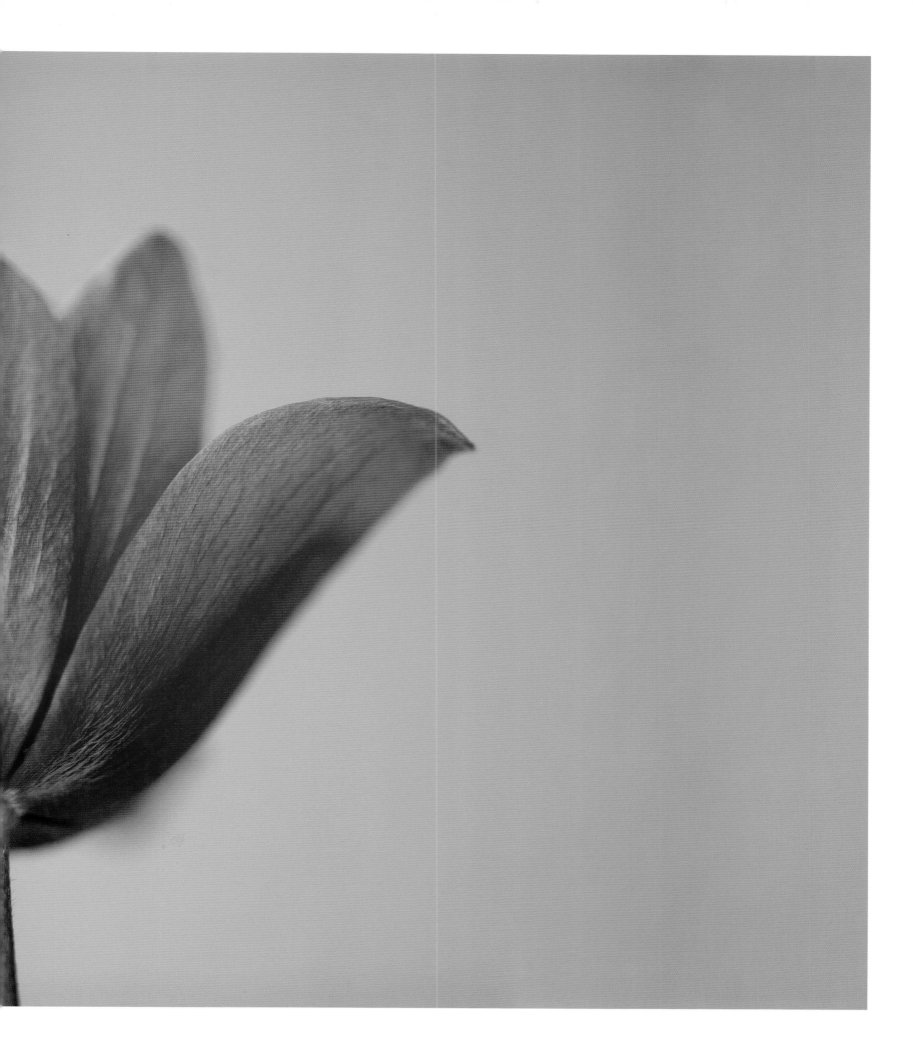

Celosia cultivar

The congested, plume-like heads of these annual flowers are not to everyone's taste. They were popular in the nineteenth century, but their rather artificial, stiff appearance does not endear them to today's gardeners, who like their flowers to look more natural. Celosias also need high temperatures, so do not perform well outside in cooler climates. However, they remain popular in India and Pakistan, where the tradition of showy spring and summer planting, introduced under the British Raj, continues. Plants may be grown in borders with other annuals, or in pots.

Like their close relative, *Amaranthus*, celosias are good to eat, their leaves being used as a vegetable in some tropical countries. That they are very easy to grow in tropical climates, needing little care, has been suggested as a good reason to promote their wider use for food.

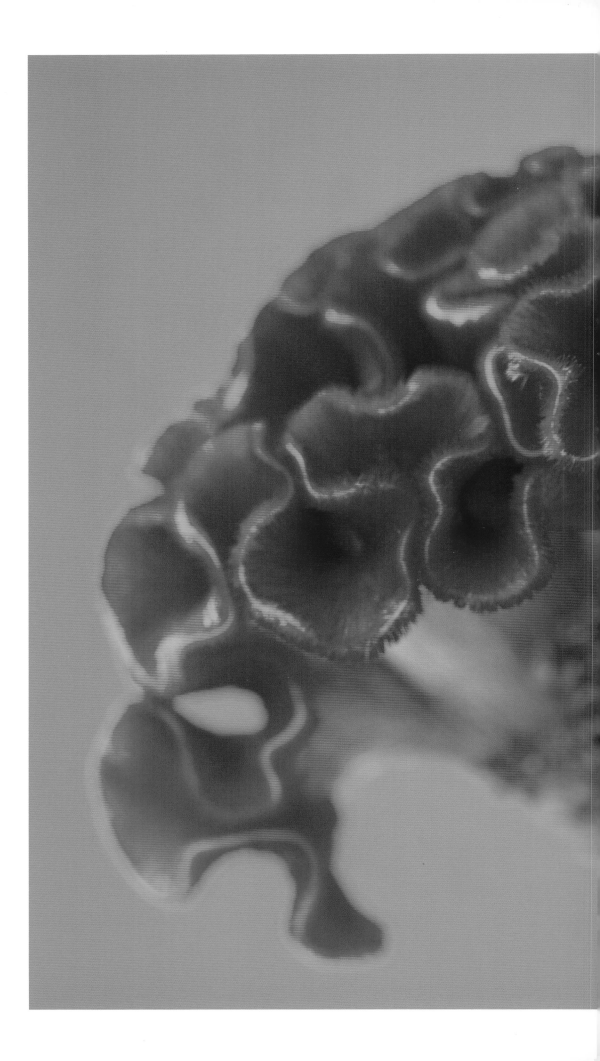

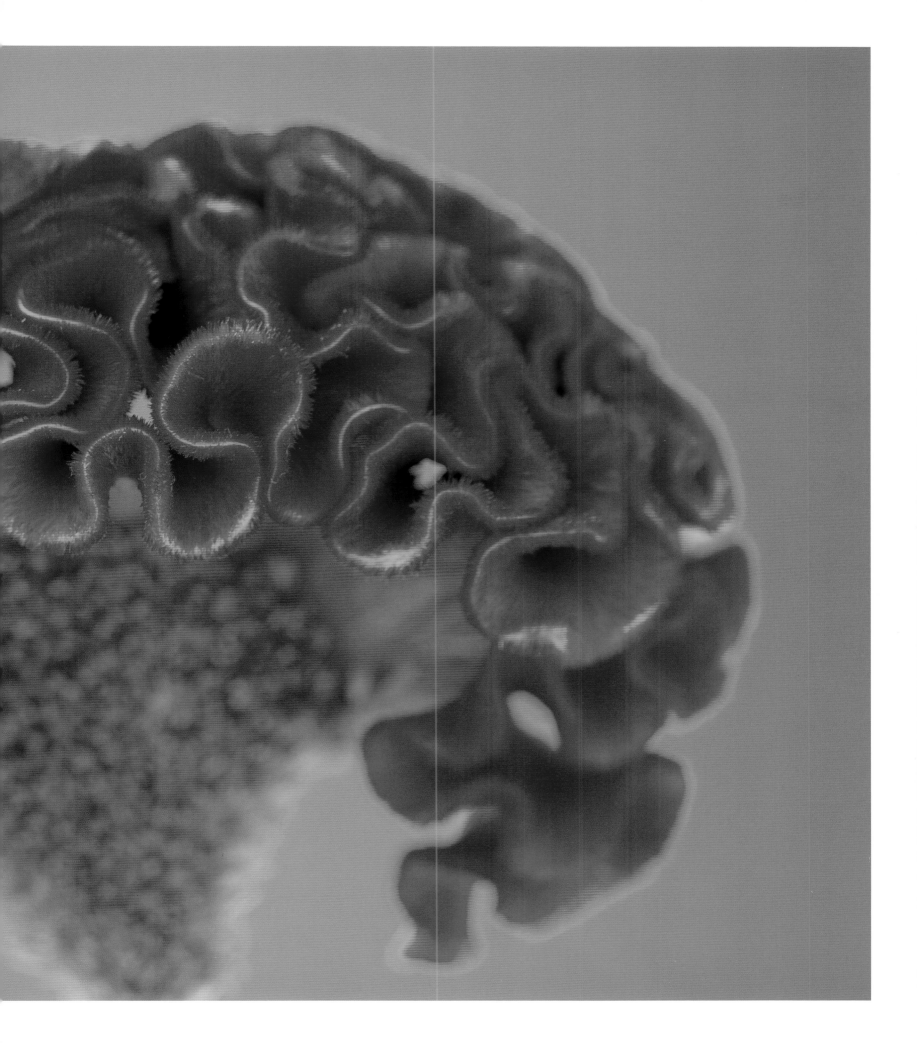

Muscari armeniacum 'Blue Spike'

This is a garden variety of a small bulb that originates from south-eastern Europe and the Caucasus. An easy garden plant, and – for a bulb – very quick to flower from seed, it often naturalizes, spreading by seed to form extensive patches of a spectacularly vivid blue. Not everyone is happy with a plant that 'does its own thing', however, and some gardening books intimate that this behaviour might cause problems. But since this species of grape hyacinth (see also pp. 26–27) is very low-growing and dormant by midsummer, only the most obsessively tidy gardeners are likely to object. Such spreading behaviour can be useful, as on green roofs, which are ideal for small bulbs from seasonally dry climates. So successful are grape hyacinths at colonizing rooftop grass that they are capable of turning whole areas blue.

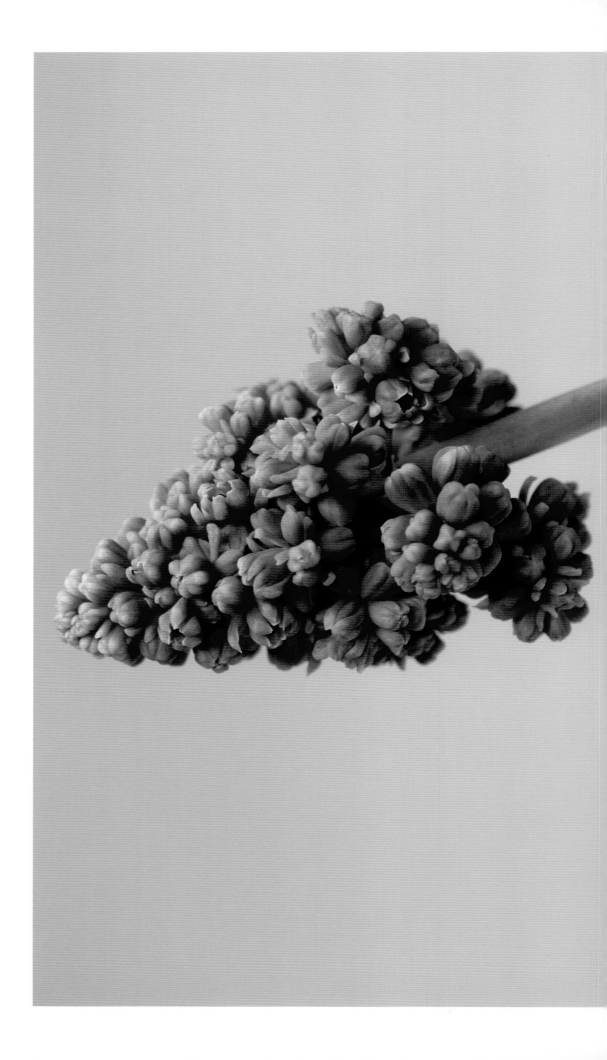

Physalis alkekengi

Known as 'Chinese lanterns' for its pendent bright-orange fruit cases, this strongly spreading herbaceous perennial is unique for its ability to bring colour and life to the late autumn and early winter garden. Inconspicuous white flowers in summer lead to the production of the distinctive 6-centimetre-long (2½ in.) 'lanterns' of the calyx (the outer leaf-like structure of the flower). The fruit itself – a small orange berry with an attractive sour flavour – is hidden inside; the related *Physalis peruviana* (cape gooseberry) is indeed grown commercially for its fruit, which is most commonly seen as a garnish on desserts in stylish restaurants.

The papery lanterns are frequently cut and used indoors in dried-flower arrangements. If left outside in the garden, they tend to decay, but in such a way as to leave the veins of the lantern intact, producing an exquisitely delicate filigree effect, the fruit usually still relatively fresh inside.

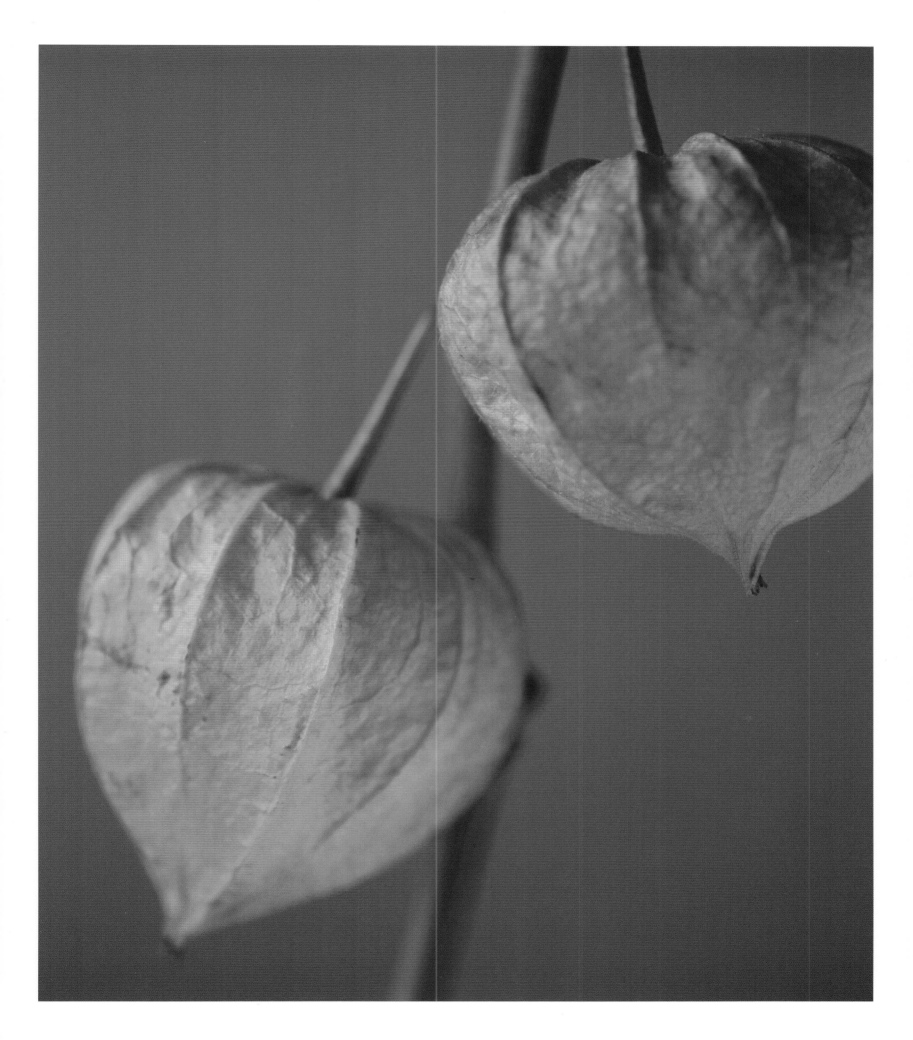

Fritillaria uva-vulpis

Like other genera with flowers in shades too
murky to earn the interest of the throng,
Fritillaria attracts enthusiasm that verges on the
fanatical. In gardening circles, the plants' fans
are known as 'fritters'; the United Kingdom's
Alpine Garden Society even has a Fritillaria
Group. In early spring, when these little bulbs
flower, the group gathers for a Frit Weekend,
to listen to lectures, compare notes and admire
flowers in a couple of local gardens, or plants
in pots brought along by members.

F. uva-vulpis is an example of the classic murky
frit. But unlike some, it is easy to grow, and
increases well from offsets. For some reason
no one understands, it has the highest count of
DNA per cell of any living thing: around twenty-
five times that of a human being. The plant can
certainly reproduce rapidly, and is apparently
something of a weed in the fields of its native
Turkey–Iran border region. In the garden, it is
one of the easier frits, needing only sun and
a well-drained soil.

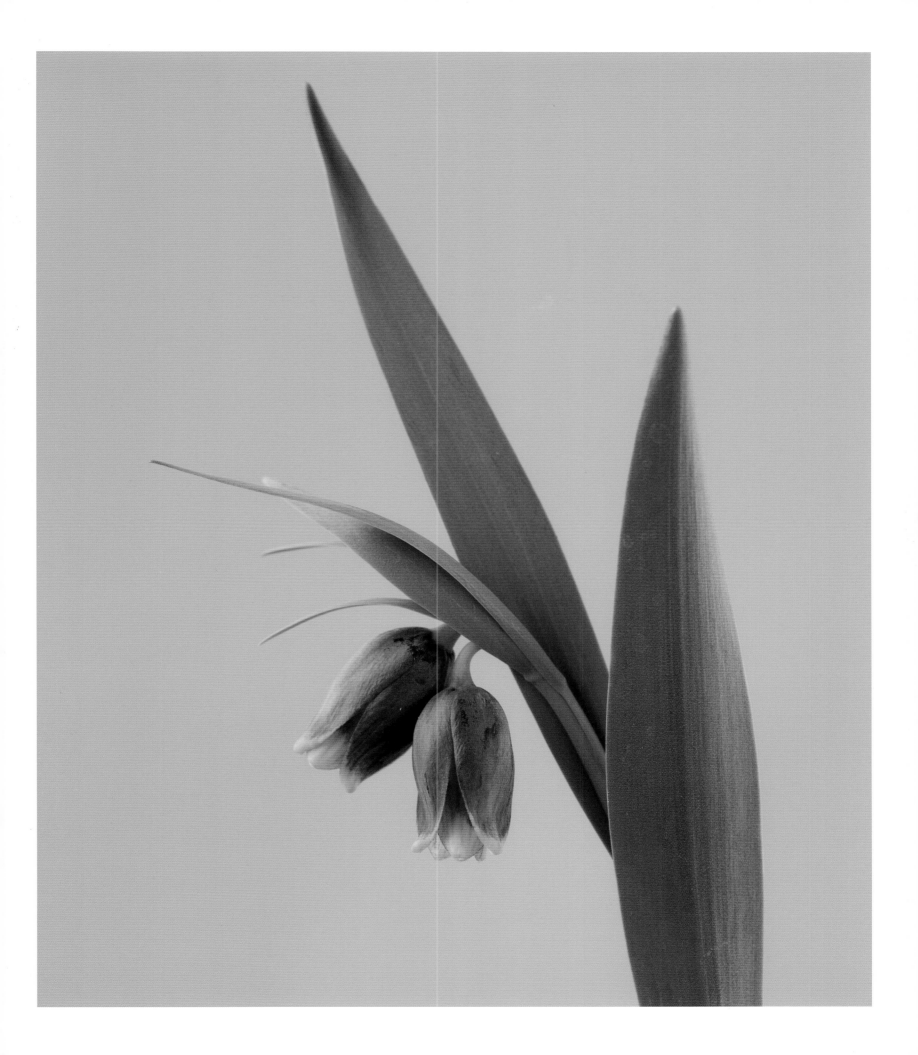

Rosa 'Iceberg'

Of the thousands of varieties of rose that have been bred, most are fated to adorn catalogues and garden centres for a relatively brief time, soon to be superseded by better varieties: freer- or longer-flowering, more disease-resistant, displaying new shades or shapes. Occasionally, however, a variety is produced that becomes a true classic. Such is 'Iceberg'.

'Iceberg' was bred by Wilhelm Kordes II (1891–1976), the second generation of the family to run the Kordes rose nurseries, renowned as the source of the best new varieties in Germany. Kordes had been interned as an enemy alien on the Isle of Man, off the British coast, during the First World War; he used the time to study Gregor Mendel's work on genetics. On returning to his homeland, Kordes found that he had a head start over other growers, who were slow to adopt the new science. 'Schneewittchen' (Snow White) was produced in 1958, but had to be renamed 'Iceberg' to appeal to English-speaking gardeners.

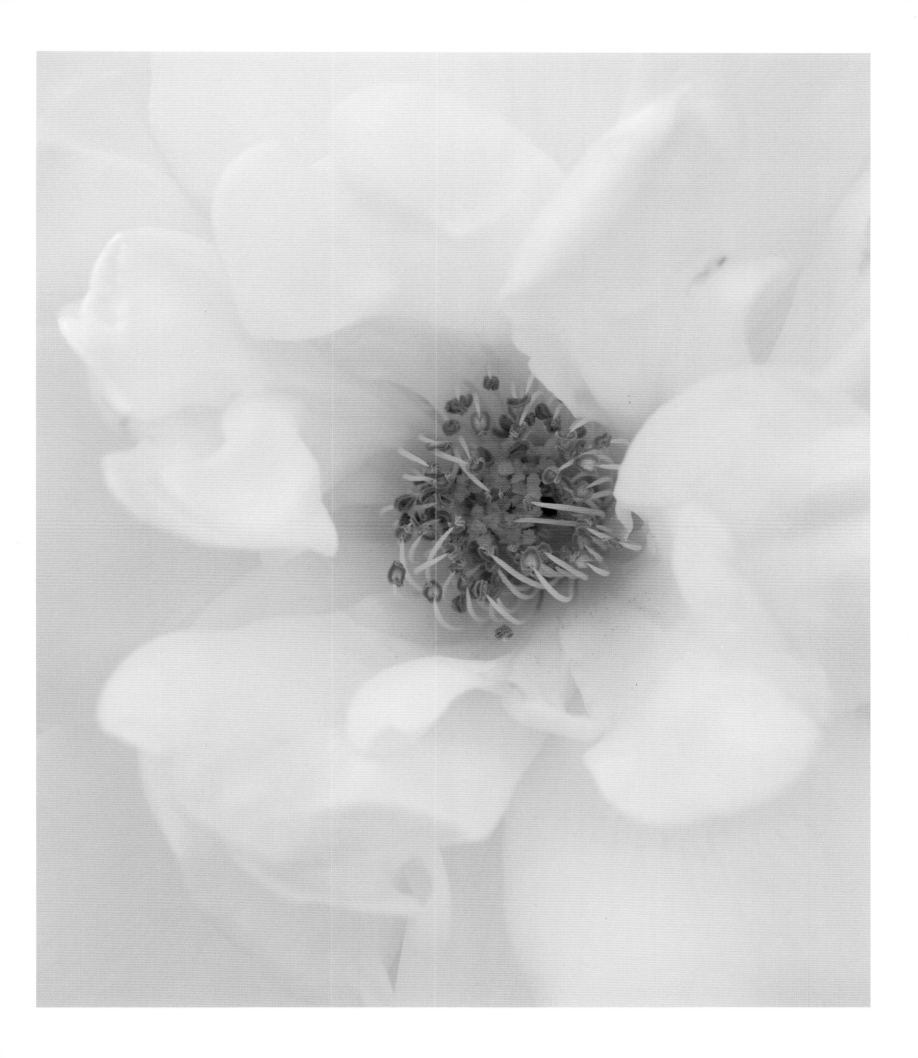

Rosa 'Black Baccara'

Red is a dark colour in any case (red flowers are the first to disappear at dusk), and dark reds begin to verge on black. With roses, dark reds show up a velvety quality to the petals, which in darker flowers takes on a deep and sumptuous intensity. Until recently the darkest rose known was 'Souvenir du Docteur Jamain', a variety dating from 1865; a gorgeous dark red, it has a deep and full-blown fragrance to match. Not a strong grower, or very long-flowering, it also needs careful placing in the garden, as full sunlight can bleach the blooms.

The good doctor has now met his match in this ultra-dark rose from French breeder Alain Meilland, whose father, Francis, bred 'Peace', one of the most successful roses ever. 'Baccara' was bred for the cut-flower trade, and florists and flower arrangers love its velvety texture and colour. Gardeners, however, are rightly suspicious of flowers bred for cutting, since all too often what is good for cutting is not easy to grow. 'Black Baccara', like 'Souvenir du Docteur Jamain', fades and bleaches in the sun; it, too, is not recommended for beginners.

Unlike its predecessor, however, 'Black Baccara' lacks a scent. This common complaint about 'modern' roses is now, perhaps, unjustified, as many breeders have been working hard to incorporate fragrance in their newer varieties, even employing people who have worked in the perfumery industry. Through the latter part of the twentieth century, the complaint may have had more weight, but Harry Wheatcroft (1898–1977), a leading British rose-breeder and grower, was scathing: that roses were now scentless was a claim he described in 1959 as being 'regularly trotted out by people who should know better ... a perennial complaint ... like sighs for the good old days'. His sneer was remarkably prescient, for it warned that nostalgia was about to become very important in the world of rose-growing, at least in the United Kingdom (see p. 44). That this was less the case in France might explain why the French were the first to produce an almost black rose.

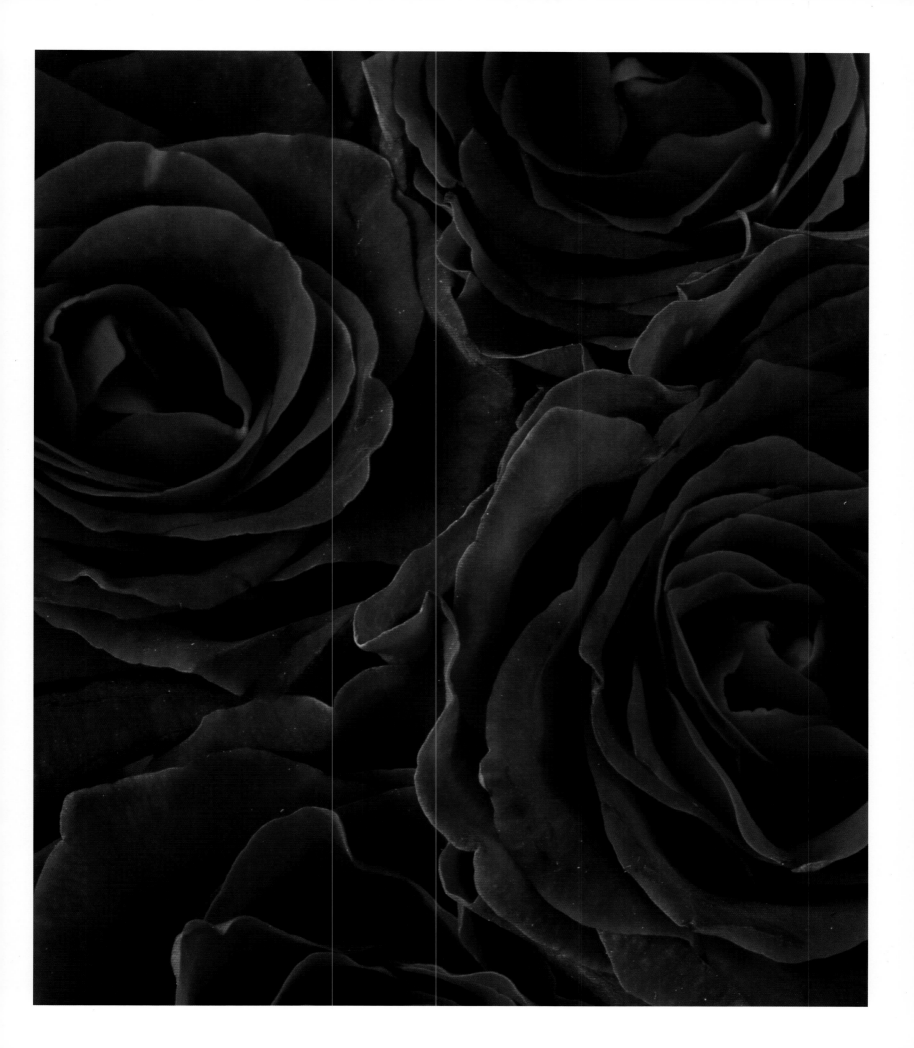

Anemone coronaria 'Harmony Mix' (opposite; pages 146 and 147)

Anemones, as flowers of the Classical world,
have various mythical stories attached to them.
The Anemoi were the Greek wind gods, and
Anemone herself was a nymph beloved by
Zephyr (the west wind). The goddess Flora was
jealous, throwing Anemone out of her court
and turning her into a flower. Zephyr then
abandoned her, passing her on to his brusquer
colleague, Boreas (the north wind). As a result,
the anemone flowers early and fades quickly.
Another Classical association is with the blood
of Venus's lover Adonis, who died while hunting
wild boar, his blood turning into flowers as
it hit the ground. Adonis has been equated
with Tammuz, the Sumerian god of food
and vegetation, whose Phoenician name was
Nea'man, hinting at an origin for 'anemone'
among these key traders of the ancient world.

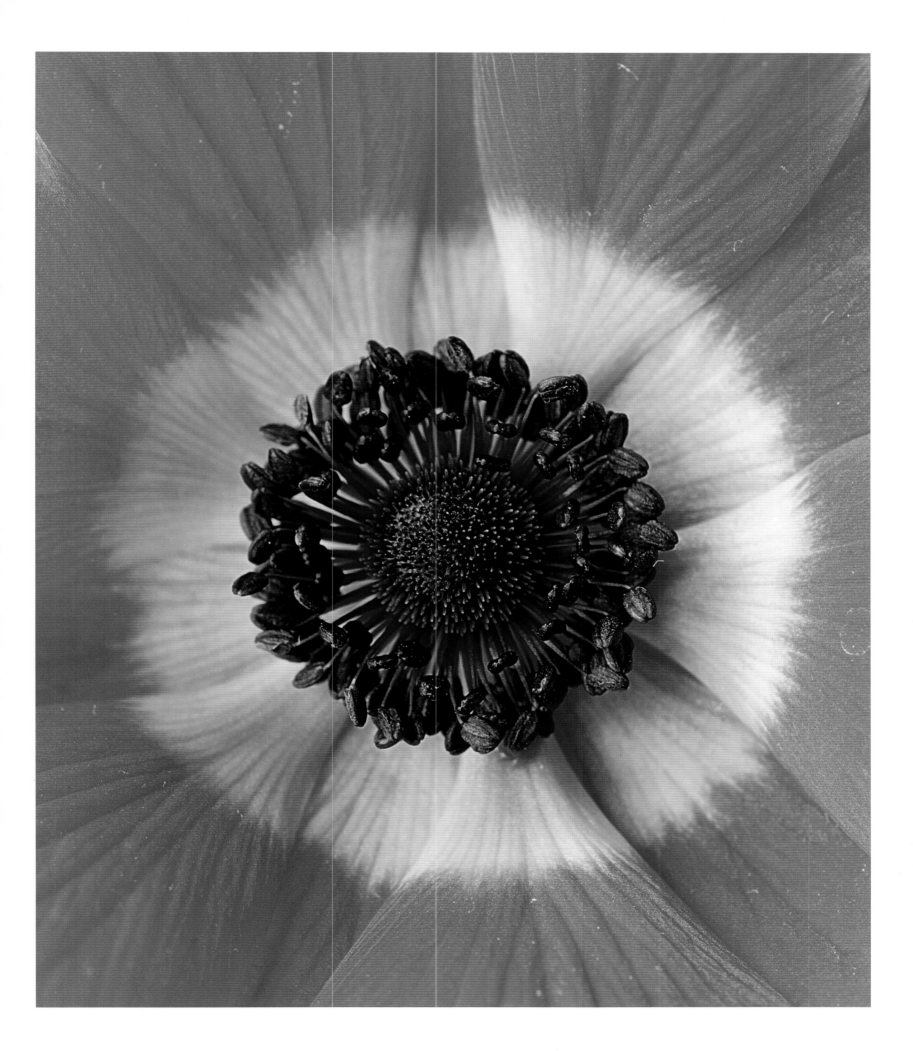

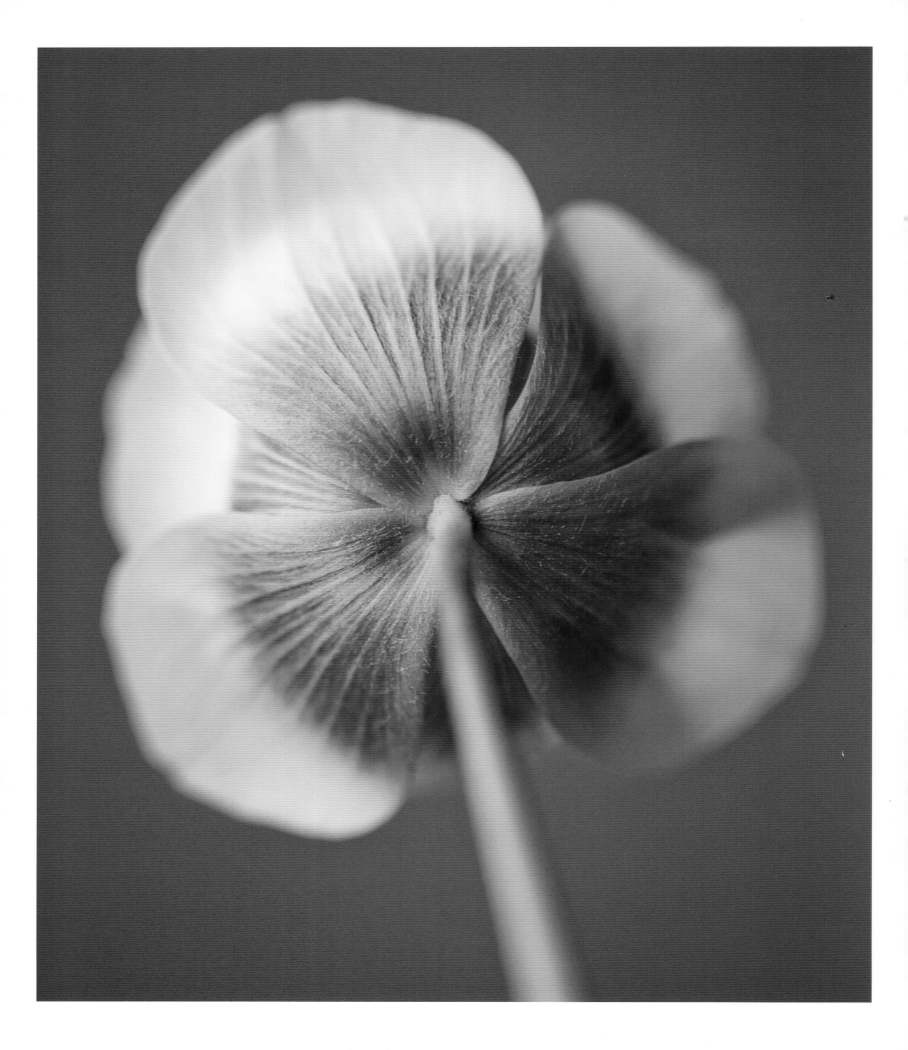

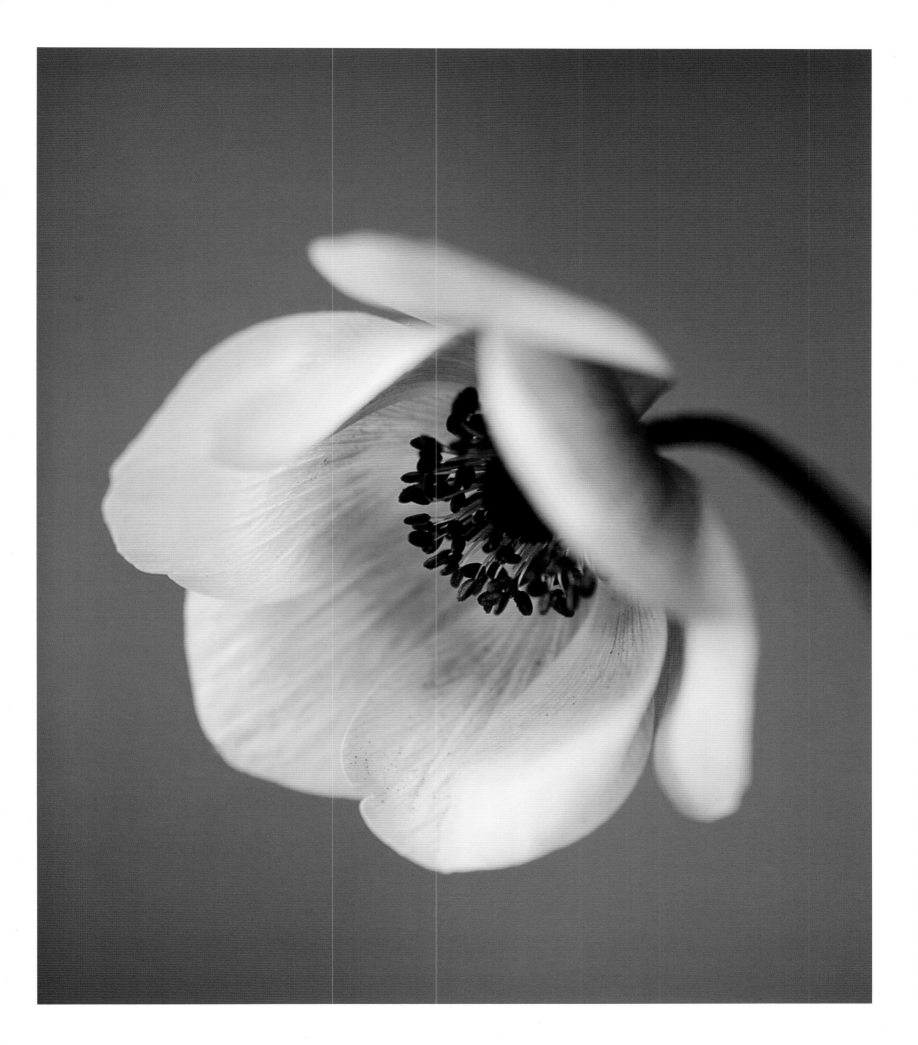

Clematis 'Peppermint'

Clematis-breeder Raymond Evison (see also p. 18) has built up a collection of about 150 cultivars, all garden cultivars, which form the basis of his breeding programme. Some of these varieties hark back to the very first hybrids produced in France, Germany and the United Kingdom in the nineteenth century. Evison first became aware of clematis in the early 1960s, while helping a well-known nurseryman of the time, Percy Picton (1904–1985), put up an exhibit at London's Chelsea Flower Show.

Evison has strict criteria for good new clematis: small-growing plants that produce flowers early, starting on last year's wood; good colours; a long flowering season; and multi-flowering, where several buds are clustered on each flower head. Breeders must have a ruthless streak to be successful. 'We look out for good intense blues and reds in particular,' Evison says, 'but being multi-flowering is very important. Even good new colour breaks are thrown out if there is no multi-flowering potential.' Some qualities are elusive and frustrating: 'We've tried bringing in scent, from "Fair Rosamond", a variety that has a very good scent, but it's very difficult.'

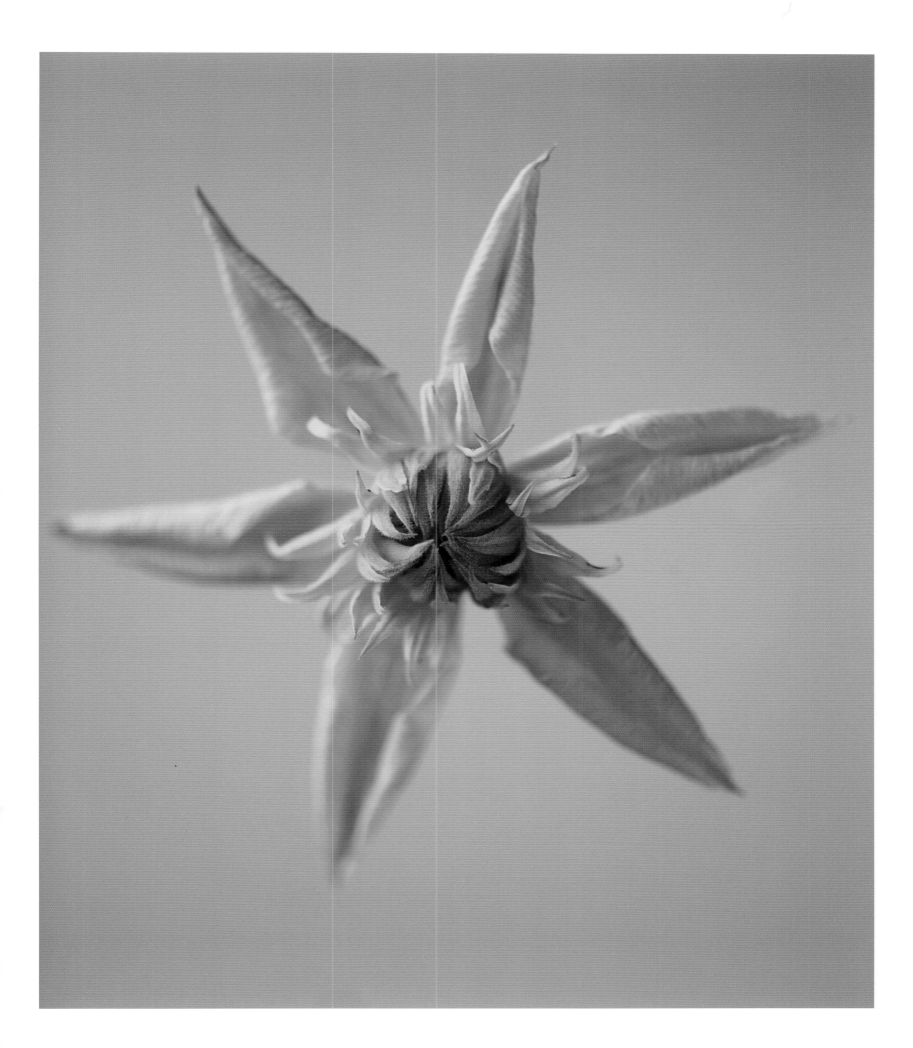

Scabiosa atropurpurea 'Chilli Pepper'

The Victorians grew far more annuals than we do now. Leafing through a Victorian book on annuals can be a frustrating experience, since all the wonderful-sounding plants are no longer available. One that has returned from banishment, however, is this species of scabious from southern Europe; there are even some good new varieties around, of which 'Chilli Pepper' is a fine example. It is one of those annuals that can be sown straight into the soil where it is to flower, for months of most unusually coloured blooms. It will often live for a second year, too.

The plant's name in almost every language except English contains a link to the idea of death, after the colour of the nearly black forms that have always been popular. The Portuguese even use it in wreaths. More prosaically, the English name 'scabious' evokes the plant's long association with a herbal cure for skin diseases.

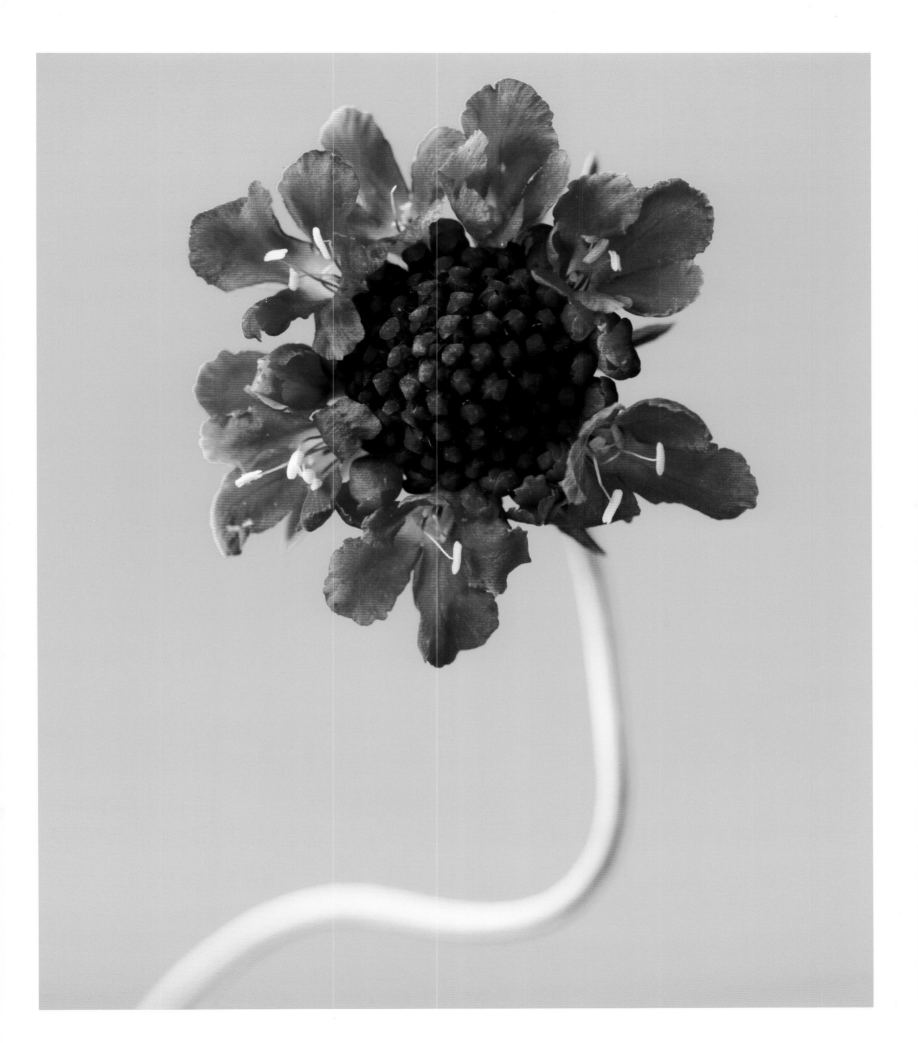

Viola 'Tiger Eyes'

Violas and their various offspring (pansies and violettas) are among our most familiar garden plants, and have been in cultivation since the late Middle Ages. The smaller flowers of violas and violettas are closer to those of the original species, *Viola tricolor*, a common weedy annual of arable land or sandy soils, known in English as heartsease. Many violas have delicate lines on the face of the flower: known as 'nectar guides', they act in a similar way to runway lights, directing arriving bees to the nectar. A chance mutation in the early nineteenth century in the garden of an English aristocrat saw the delicate nectar guides replaced by a big blotch, giving the plant a whole new look. This was the birth of the pansy.

Pansies, with their big cheerful faces, took off (see also p. 164), leaving the subtler violas rather in the shade. Violas are tougher, however, and can offer colours that pansies cannot, so recent years have seen more breeding work being done. Particularly striking are those, such as 'Tiger Eyes', where the nectar guides are re-emphasized, giving the flower a striped or eye-like appearance.

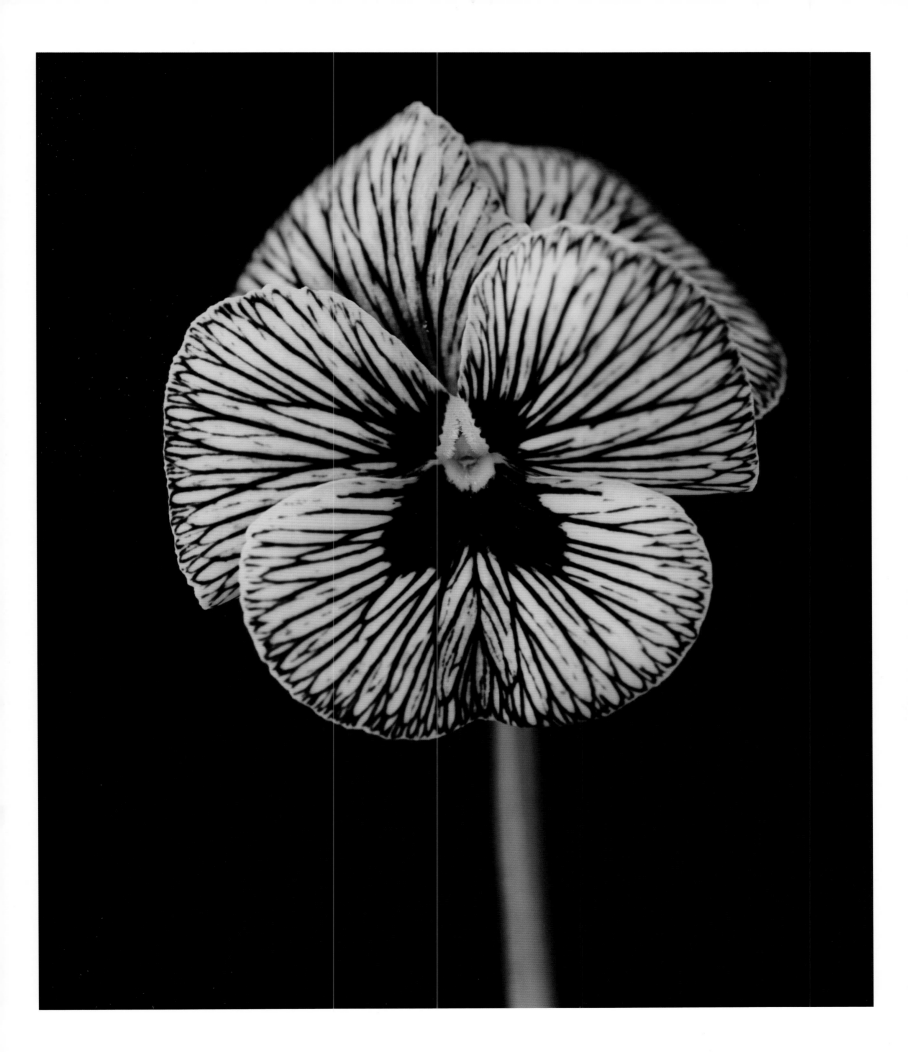

Primula 'Gold Laced' group

Black or dark-red flowers laced with gold create a striking impression. Descended from a cross between the common cowslip (*Primula veris*) and the primrose (*P. vulgaris*), the polyanthus has long been established in the garden.
A plant with red flowers and gold lacing was first recorded in 1750 (although it is quite possible that the gold-laced plant goes back much further), and around this time plants with black flowers and gold edging also appeared. During the rest of that century and much of the nineteenth, gold-laced polyanthus were among the most widely grown flowers by the British. Varieties were named on the basis of minute variations, and many were exhibited at spring shows. However, they are not long-lived plants, and self-sown seedlings are never an exact copy of the parent, so by the end of the nineteenth century every single named variety had died out.

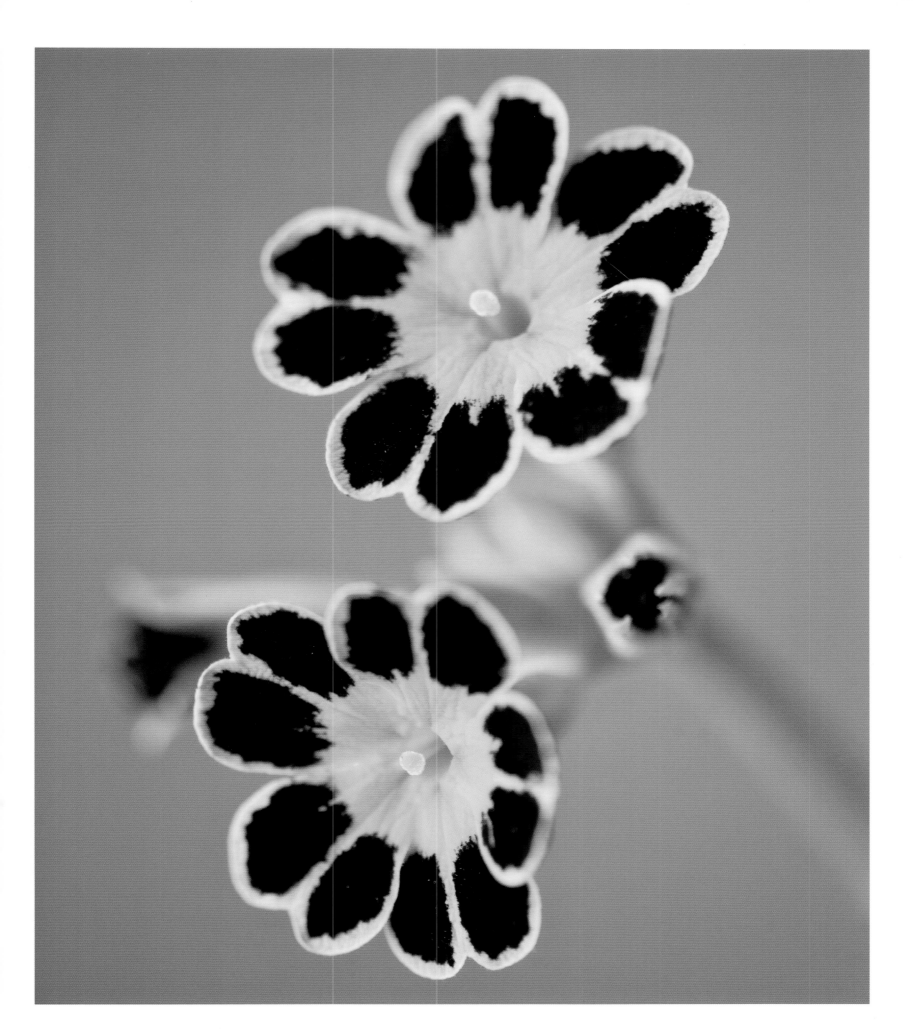

Strongylodon macrobotrys

The great clusters of the jade flower are difficult to see from ground level: anyone hoping to find one must search on the ground for the dead flowers and then look upwards. One of the most extraordinarily coloured of all flowers, and a climbing member of the pea family (*Fabaceae*) from the rainforests of The Philippines, the vine is pollinated by one specific species of wasp and one butterfly – both of which are thought to have evolved in conjunction with it – and also by fruit bats, which home in on the sweet nectar the flowers produce.

Popular in botanical garden greenhouses for the sensation it creates, the jade flower is threatened in the wild by the destruction of forests; only about 20 per cent of its habitat remains. In warm climates it can be grown as a garden plant, although it needs a large, sturdy pergola-type structure for support.

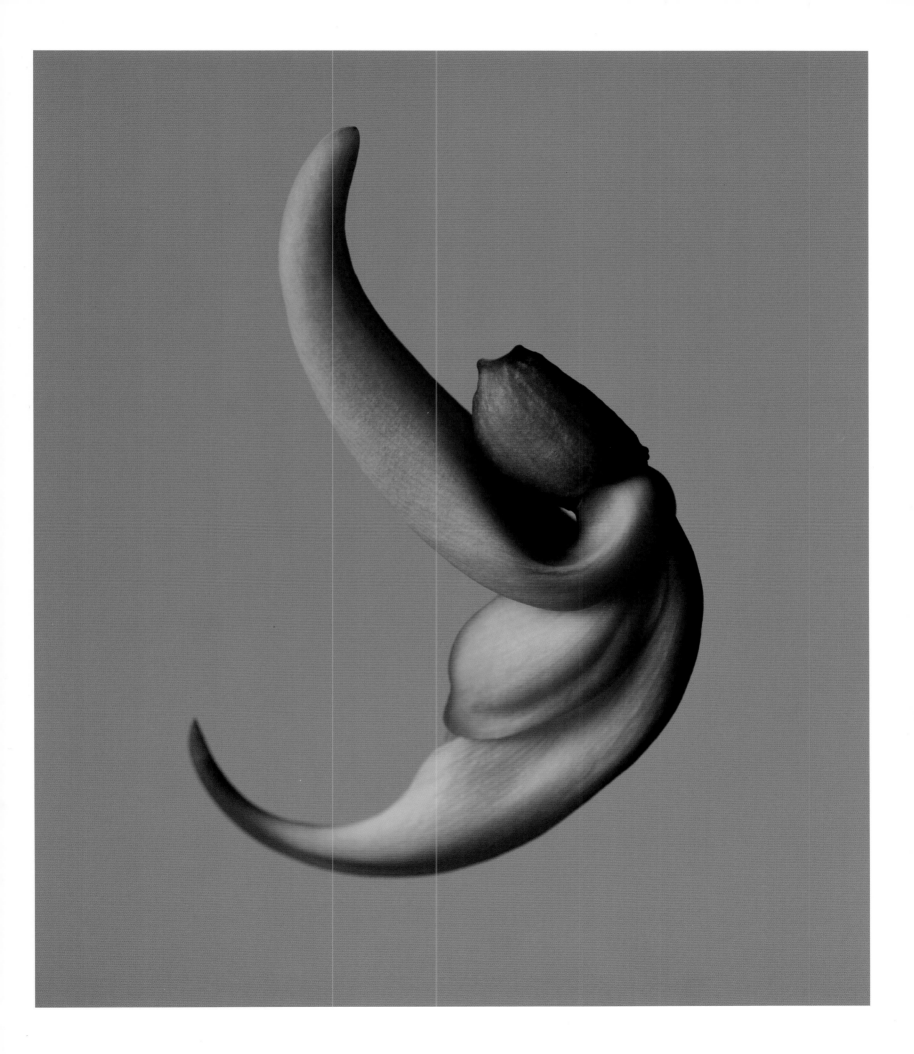

Anthurium andraeanum

'Is it real?' is the question many ask of this flower. The florist's 'flamingo flower' is a hybrid group based on *Anthurium andraeanum* or *A. scherzerianum*, both of which have a colourful spathe – for this is another member of the arum family (see p. 22). The spathe (in reality an adapted leaf) attracts pollinating insects, which are then drawn in by the fragrance of the tiny flowers gathered on the protuberant spadix (rod-like structure). The genus *Anthurium* itself is huge, with up to 1000 species, mostly found in humid forest environments in Central and South America.

The unnaturally long life and oil-cloth appearance of these anthuriums does not endear them to those in cooler countries, who decry the exotic and would prefer that buyers turned to the plants of their own climes. The long-lived blooms, however, are a boon to flower-arrangers and the cut-flower trade, and are exported all over the world by growers of tropical flowers.

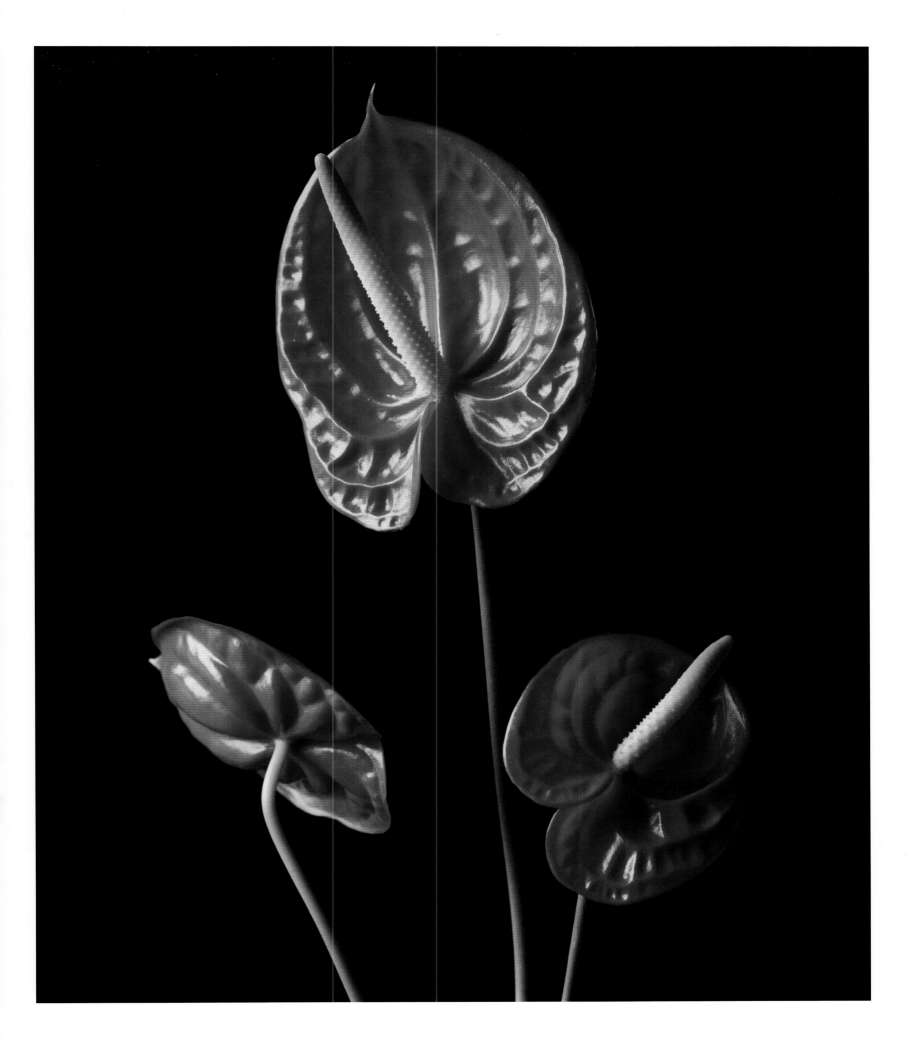

Narcissus 'Rip Van Winkle'

There are some 27,000 registered varieties of daffodil – an extraordinary number for a species that is really available in only two colours: yellow and white. Our appreciation of daffodil flowers is as much about form as anything else; doubles, such as this one, are the most dramatic in terms of shape. They are surprisingly rare: the overwhelming majority of daffodils are single.

Garden daffodils sometimes cross with one another to produce seedlings, and occasionally one of the seedlings has flowers with far more petals than nature intended. These doubles may be freaks as far as nature is concerned, but their appeal to us gives them an advantage if it means they are dug up, named, propagated and distributed far and wide. 'Rip Van Winkle' (an old variety, found and defined in Ireland in 1884) has another great advantage: it flowers very early; and its small stature, about 20 centimetres (8 in.) high, makes it less vulnerable to wind damage at its blowy and blustery flowering time.

A vast number of varieties have been produced over time, and most are still around. Daffodils are extraordinarily difficult to kill, as is shown by the story of the daffodil fields of the Tamar valley in Cornwall. Established in the late nineteenth century as the main source of early cut daffodils, the fields were largely cleared during the Second World War to make way for food production, and the bulbs dumped in hedges and on waste ground. Many survived, and so there are now a great many heritage varieties naturalized among the grass and wild flowers all over the district.

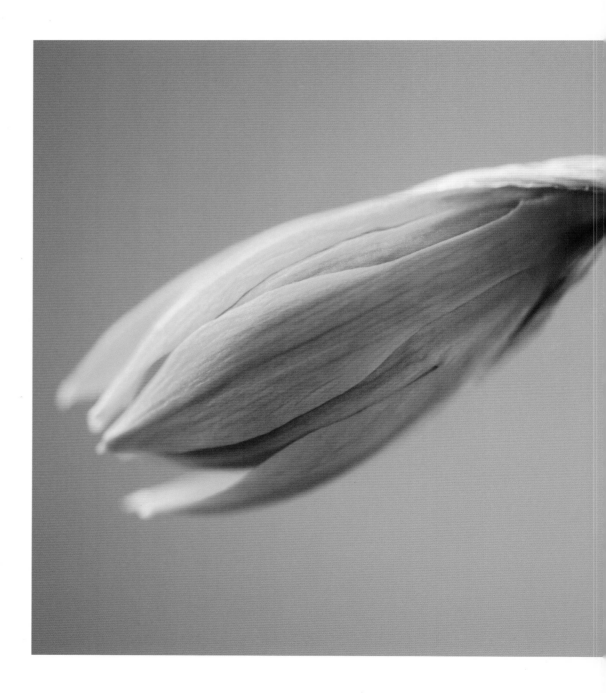

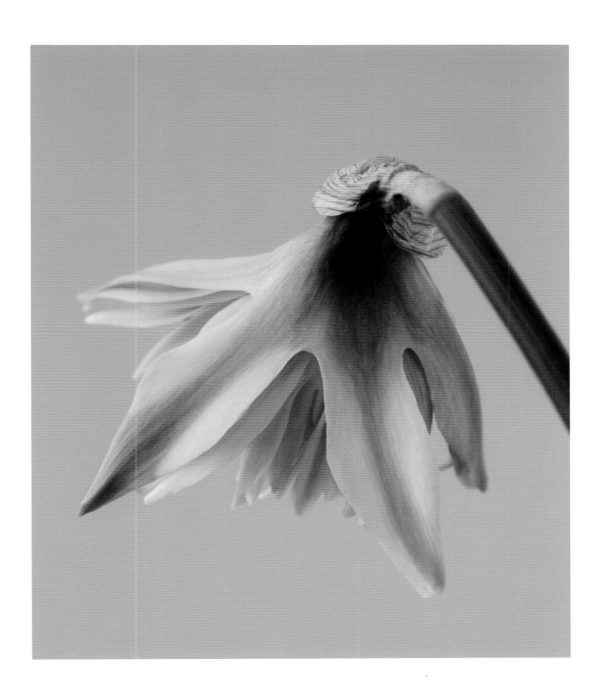

Phalaenopsis cultivar

Orchids were once regarded as the flowers of the rich, tended in specially designed hothouses and brought into the home for only a few weeks of flower. *Phalaenopsis* have changed all that. Their temperature and humidity requirements are remarkably similar to ours, so they make ideal plants with which to share our centrally heated houses. They like soft, diffused light, too, which makes them perfect for dotting around the home. Breeding has resulted in many colourful varieties of an easy-going constitution and unusually long flowering times; often, once one flower spike has died, another breaks out further down the stem.

Perhaps the biggest factor in the democratization of orchid-growing has been laboratory micropropagation. Thousands of identical plantlets can now be produced, grown on in nurseries in the Far East and exported all over the world. What was once the preserve of the wealthy is now available in supermarkets for everyone to try.

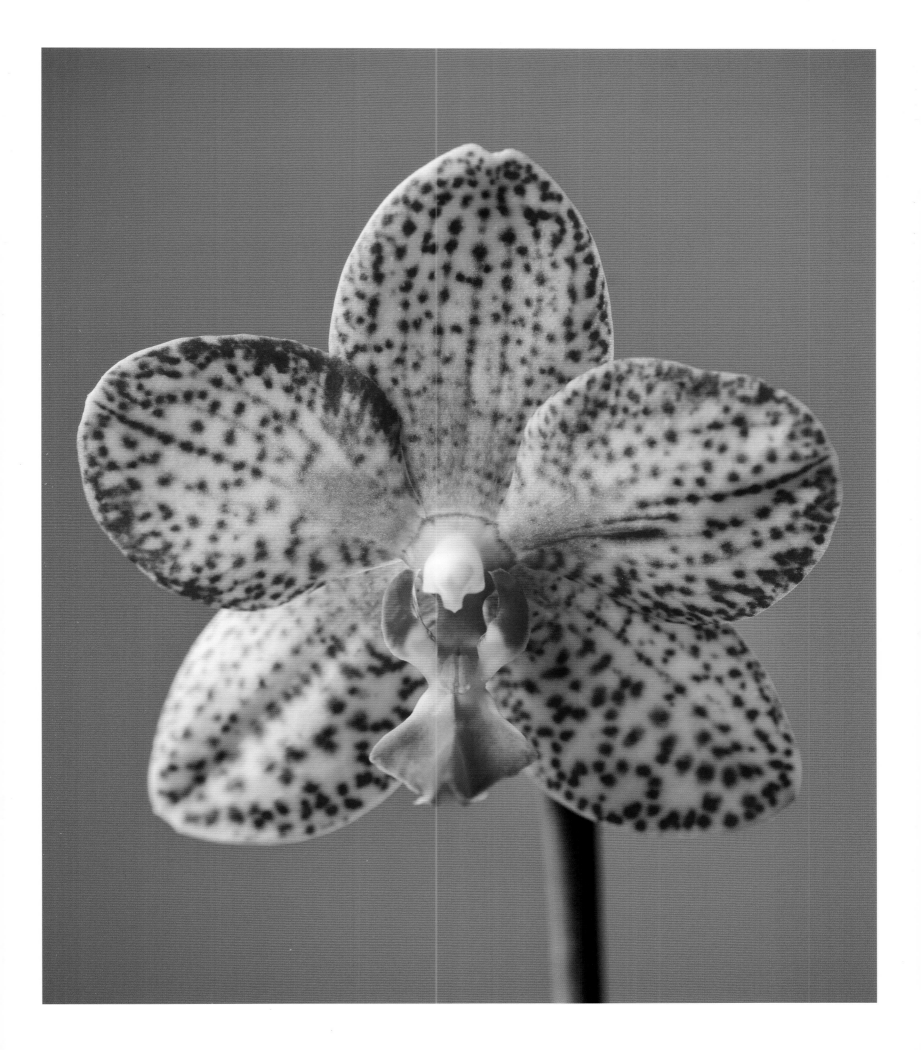

Viola wittrockiana 'Delta Antique Surprise'

Pansies include several *Viola* species in their parentage, and developed into the plant with which we are now familiar in the early nineteenth century (see p. 152). In the United Kingdom, the Victorians loved them; pansy societies and shows were held across the country by mid-century, and Charles Darwin (1809–1882) recognized some 400 named varieties. The show rules for what was acceptable were very strict; but plants that broke the rules were often easier to grow, and it is those that are the ancestors of the modern garden flower.

The pansy carries an extraordinary amount of symbolism. The name comes from the French word *pensée* (thought), reflecting the face-like flower. This has led to an association with rationalism and free thinking; the flower is even used as an emblem by the Freedom from Religion Foundation in the United States. More familiar is the association with male homosexuality, but this is only the result of a coincidence with an Elizabethan English term for an effeminate man. In German the plants are classed with violas as *Stiefmütterchen* – little stepmothers.

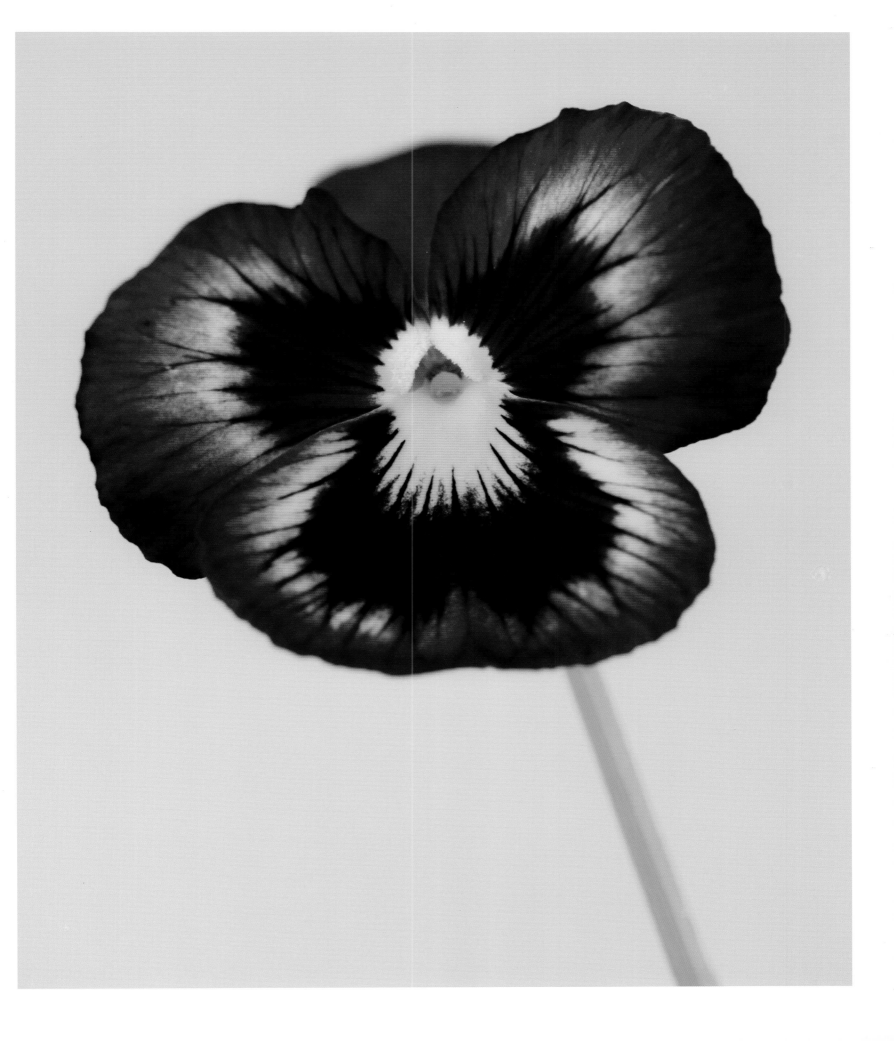

Rosa cultivar

Rosa 'Miranda' (overleaf)

Other breeders have been inspired to follow the
lead of David Austin Roses (see also pp. 44 and
68). There are now, therefore, roses with the
'old-fashioned' form of flower and a good scent,
but in a range of colours the oldsters never
had (such as yellow) and with long flowering
seasons – first-rate garden plants, in other words.
Earlier English roses aimed for the 'quartered'
petal, whereby the flower is tightly packed with
petals seemingly arranged into four quarters,
and with a notably flat front to the flower. Later
breeding has aimed to introduce characteristics
of other heritage rose groups. The modern rose
'Miranda', introduced by David Austin Roses
purely for the cut-flower trade and for growing
under glass, is quite unsuitable for garden use,
but its voluptuous and heavily fragrant blooms
are perfect for bouquets.

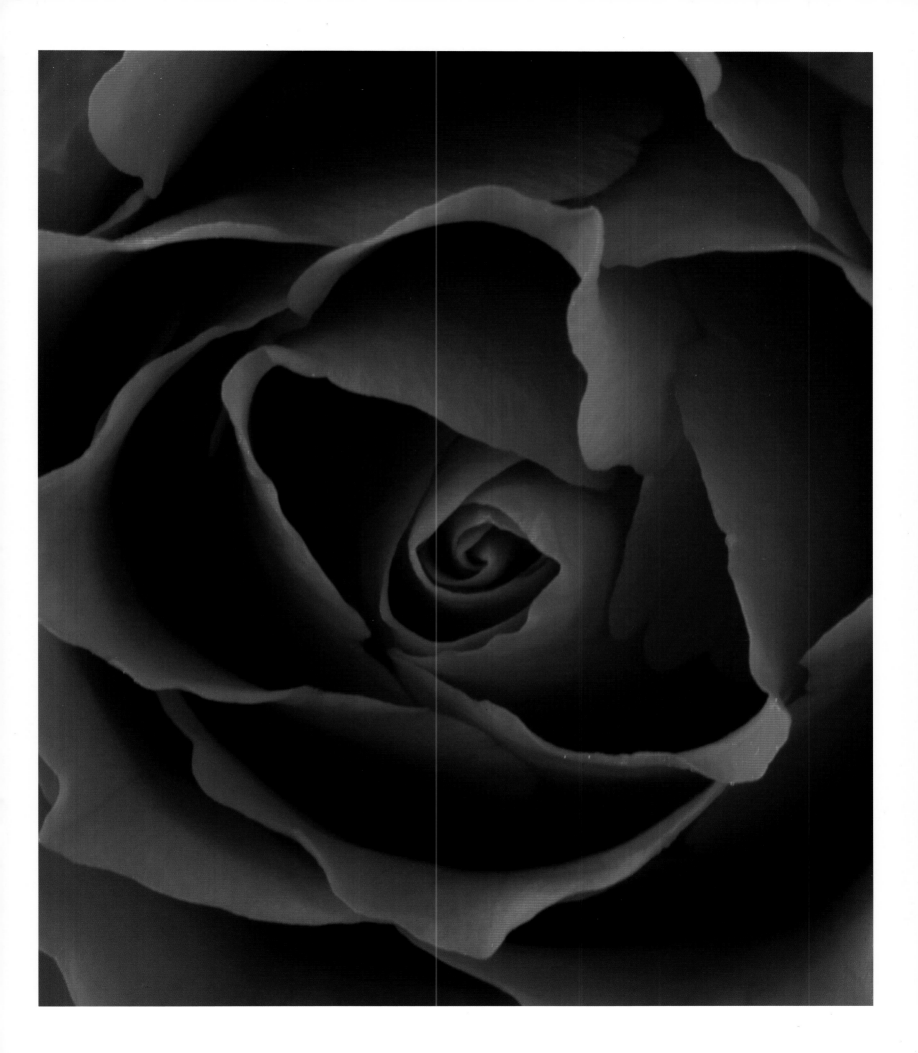

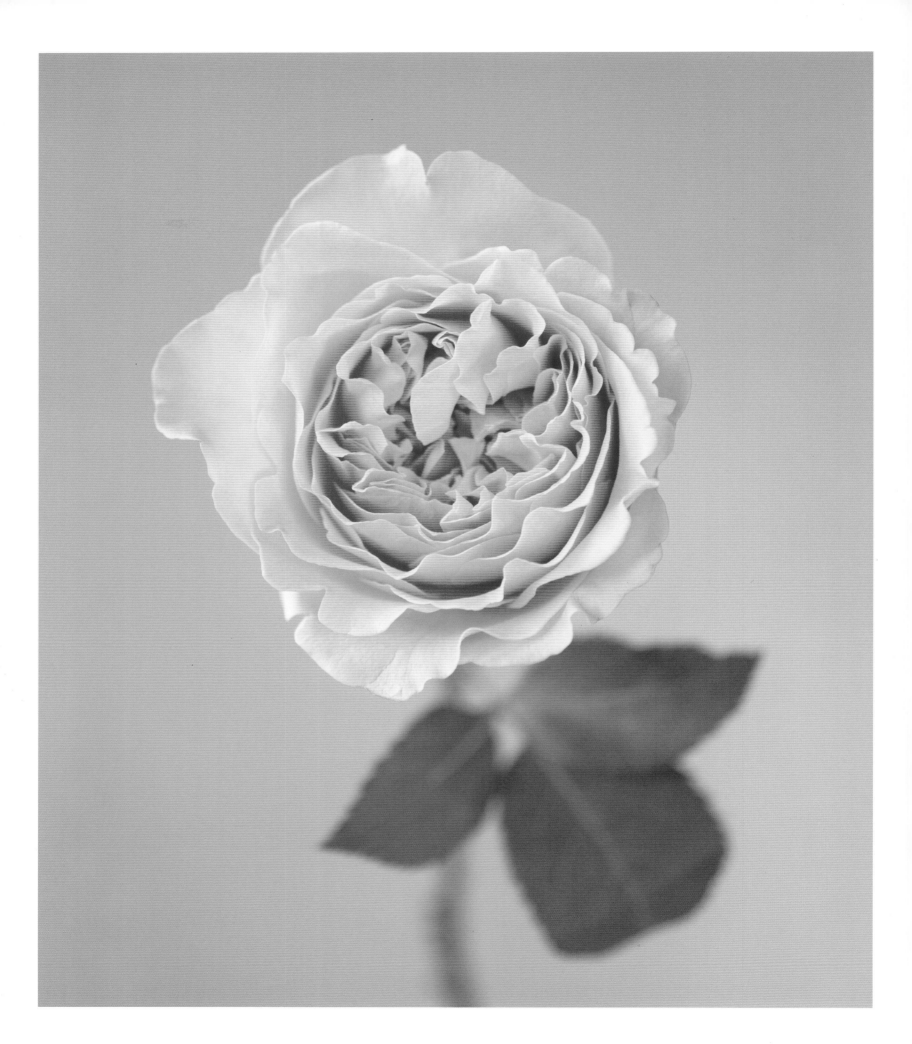

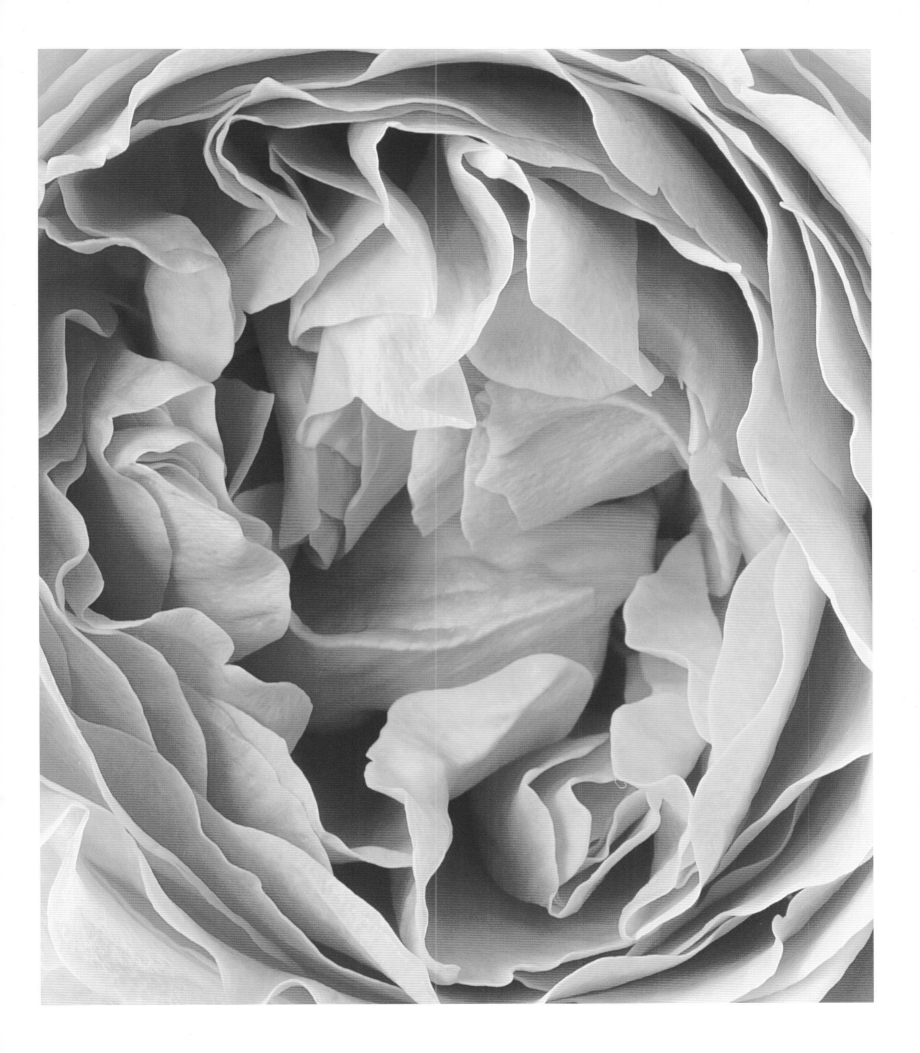

Prunus 'Kanzan'

'Kanzan' is a cherry of Japanese origin; it and
many others have been cultivated for centuries in
Japan, where they play an extremely important
cultural role. The flowering of cherry blossom
is a major occasion there, a time when family
and workplace picnics and parties take place
on mats laid out under the trees. In a culture
where the transience of life is held in particular
and very spiritual regard, the brief and beautiful
life of cherry blossom (rarely more than two
weeks) is deeply symbolic. The flowers are
portrayed again and again in both traditional
and modern art. Japanese culture has always
blended beauty and death in a way those from
other cultures find difficult to understand; the
supreme example is that of the kamikaze pilots
of the Second World War, who were known
as 'cherry blossom' and often had the flowers
painted on the sides of their aircraft.

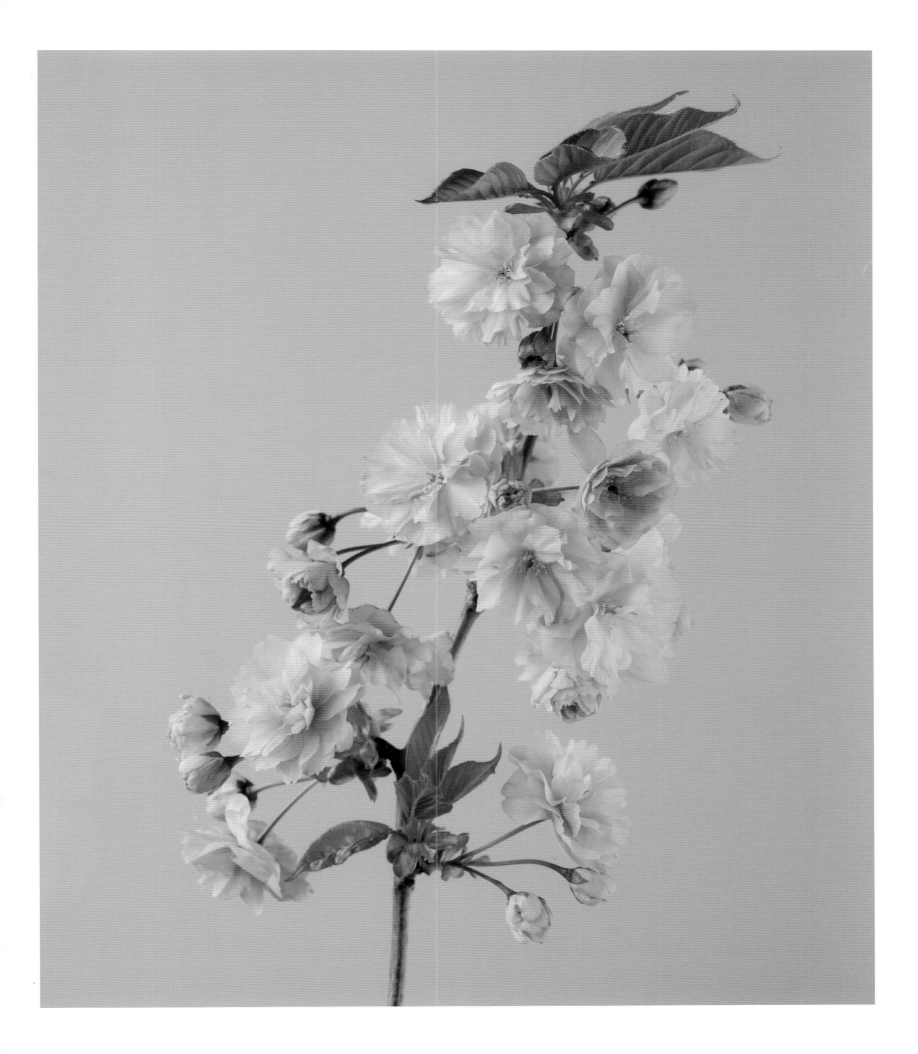

Allium sphaerocephalon

This ornamental garlic illustrates the 'typical' form of the flower head, an off-centre globe. Of the more than 700 species of allium, it is one of those chosen for inclusion in ornamental horticulture, for the deep red–purple of its flower heads, and perhaps also for its flowering season, which is in midsummer, unusually late for alliums. The colour looks superb with pink or white flowers or silver foliage, but the plants take up so little space that it is possible to scatter large quantities among other plants to get the effect of blobs of intense colour without them competing. Unfortunately, *Allium sphaerocephalon* does not seem to like the competition of other plants, and unless it has a reasonable amount of space for its narrow leaves to get good light, there is no guarantee that it will flower in subsequent years.

Hailing from a wide area of Europe and Asia, this is a variable species, with many recognized sub-species. The alliums are a complex, variable group in any case, and something of a nightmare for botanists to sort out, as well as for gardeners attempting to keep up with what the botanists decide. What unites all alliums is the distinctive scent, the result of a chemistry that produces a cocktail of sulphur-containing compounds, which give the plants their distinctive smell and may deter pests and predators. Many *Allium* species are used in cooking, and indeed nearly all are edible. The only people who regularly ate this particular species, though, were tribal communities around Lake Baikal in Siberia.

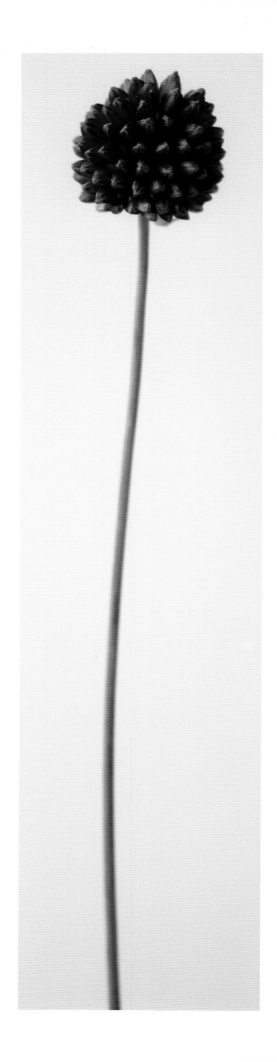

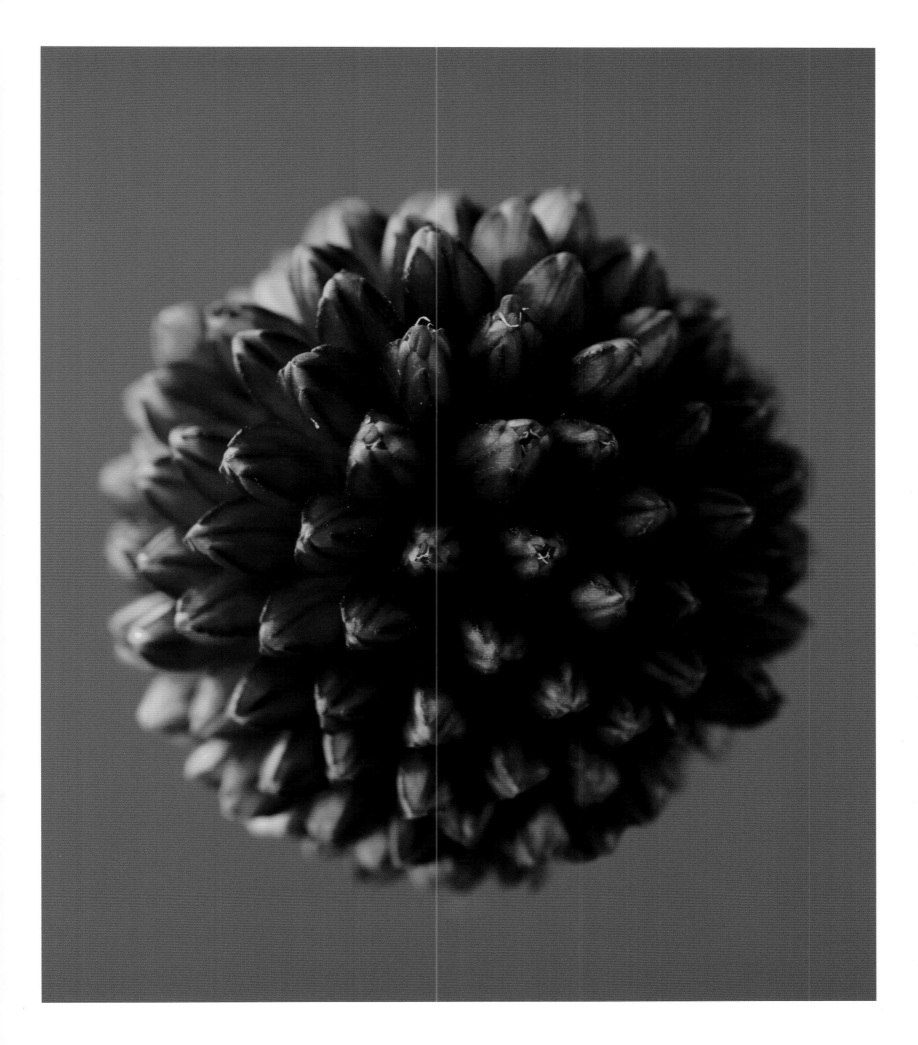

Gaillardia 'Oranges and Lemons'

Gaillardias are members of the daisy family
(*Asteraceae*), with bright flowers in a variety
of reds, oranges and yellows; cheerful colours,
if sometimes slightly matt. Their resemblance
to the bold patterns and strong colours of
traditional Native American blankets gives them
their common name, 'blanket flower', but their
main appeal surely has to be their subconscious
evocation of a child's drawing of the sun, with
its outstretched rays.

In the garden, gaillardias grow and flower
rapidly, but they do not live long; at three to
four years at the most, their lifespan is too long
to be described as annual, but not really long
enough to be truly perennial. Short-lived they
may be, but gaillardias have a plan, backed up
by plenty of easy-to-germinate seed. That we
respond so well to their sunny charms and
deliberately plant them might be seen as an
even more successful evolutionary strategy.

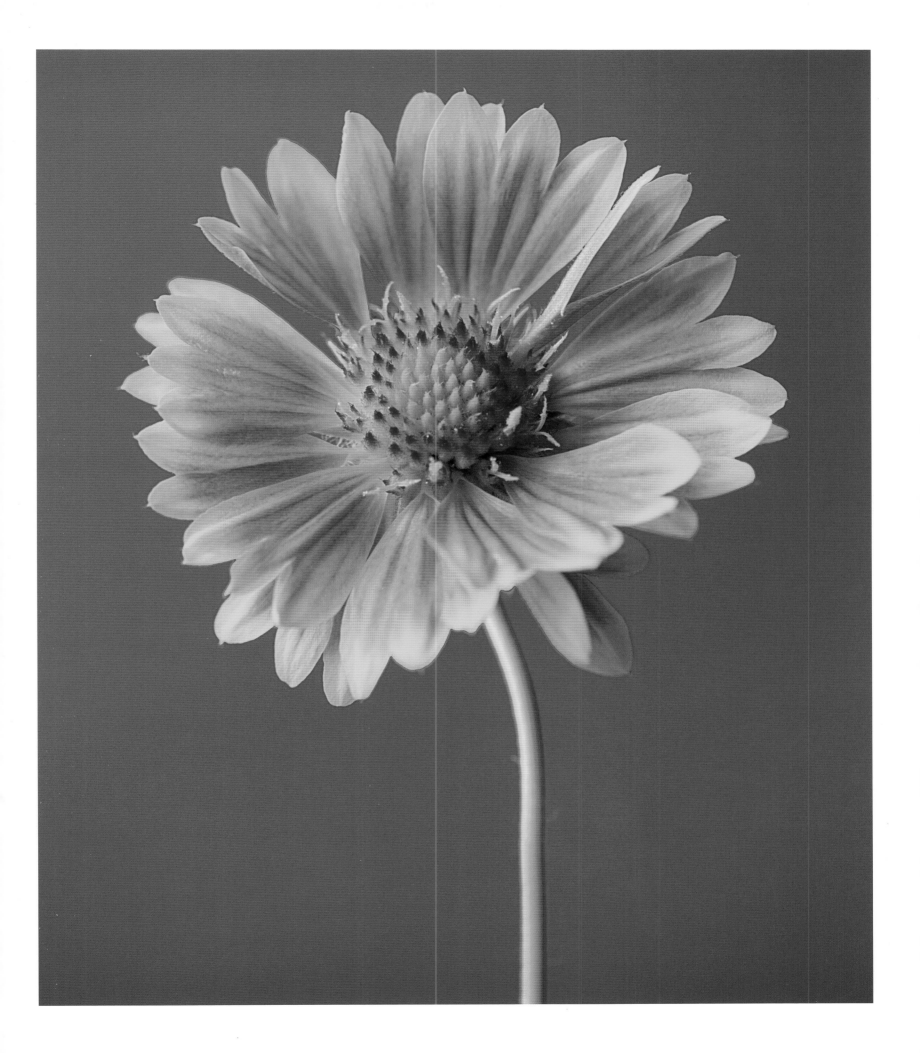

Paphiopedilum cultivar

Paphiopedilums are, not surprisingly, known as 'slipper orchids'. In some ways they are a little like the arisaemas (see pp. 90–93): they live on the forest floor (tropical, in the orchids' case) and have a similar aesthetic allure. Not colourful, but strange, and with elaborate and intricate patterning often in greens and browns, they appeal to a particular type of person. As in the case of arisaema-lovers, devotees of 'paphs' verge on the obsessive.

Paphiopedilums are found throughout South-east Asia and southern China, generally in shady locations, on the forest floor or on the wet cliffs (more or less vertical expanses of thick vegetation, constantly dripping with moisture) that are a very important habitat in many tropical regions. Lacking the fleshy pseudobulbs by which many tropical orchids store moisture and nutrients through dry seasons, paphiopedilums are limited to growing in damp, humus-rich soils.

The obvious feature of the flower is the pouch, which acts as a nectar store and trap. Insects fly in but are unable to get out without passing by the stamens, which deposit clumps of sticky pollen on their bodies. On visiting the next flower, the insects deposit these clumps (technically the pollinia) on the receptive female part of the flower, enabling fertilization. Unlike most flowers, which deposit pollen as a dust on to the bodies of visiting insects, orchids are precise, transferring the pollen to exactly the right spot, a mechanism that has tended to promote the evolution of complex and intricate flower shapes.

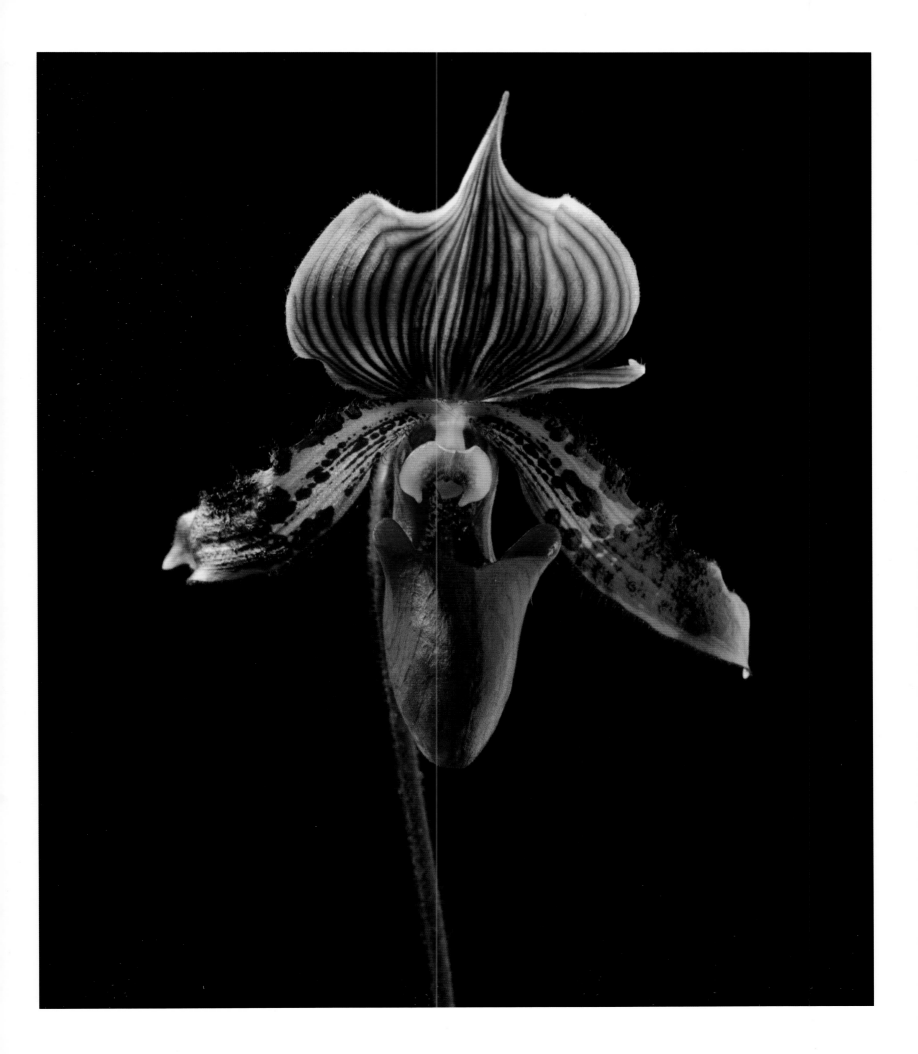

Paeonia lactiflora 'Sarah Bernhardt'

Colourful, full-blown and voluptuous, it is no wonder that in China peonies have traditionally been a symbol of wealth. The ancient Greeks and Romans held them in high esteem, too, possibly because of the very great ages to which the plants live. Peonies had herbal uses that necessitated their being harvested, but anyone doing so risked the same fate as reputedly befell those who dug up mandrakes: the plant would groan and the collector be struck dead. Such myths were probably very useful for herb collectors keen to safeguard wild plants they had found from freelance operators.

In Europe and around the Mediterranean, wild peonies were grown for medicine, often in monastic gardens. It was not until the nineteenth century that the showier Asian species were introduced to Europe, and with them the idea of the peony as an ornamental. It helped that the Chinese and Japanese had done plenty of selection over many centuries, and that they favoured different styles of bloom; the Chinese preferred the fully double and almost ball-like, while the Japanese liked singles or semi-doubles.

Peonies became established in European gardens during the nineteenth century, and French breeders, in particular, produced many good varieties, some with flowers that bring to mind the flouncy petticoats of cancan dancers at the Moulin Rouge. The French actress and occasional courtesan Sarah Bernhardt (1844–1923) was the most famous woman on the stage in her time; hers is the perfect name for a big, full-blown, very pink peony. It was bred by one of the most prolific plant-breeders of all time, Victor Lemoine of Nancy.

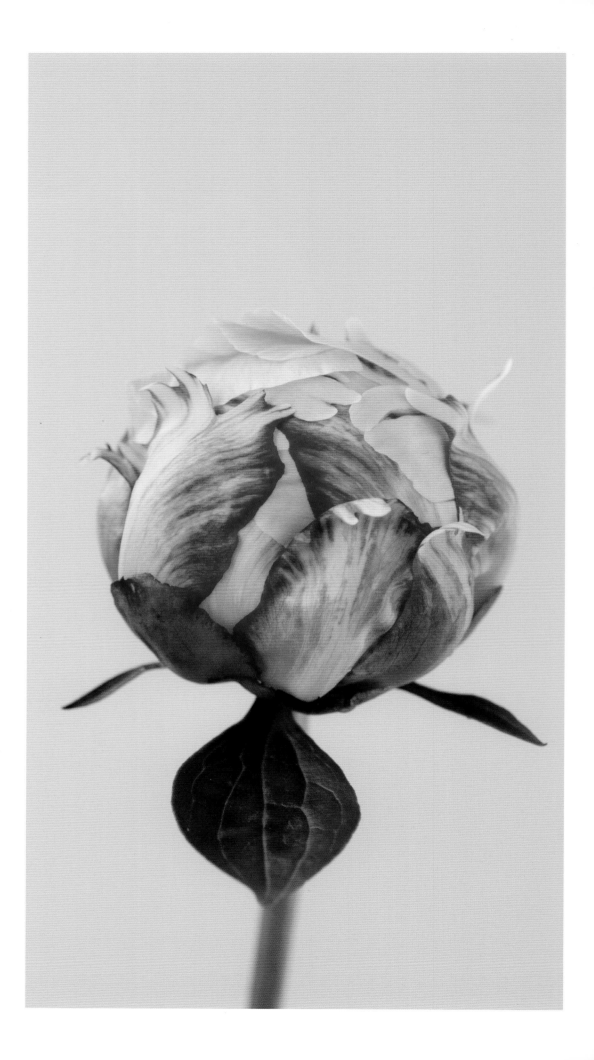

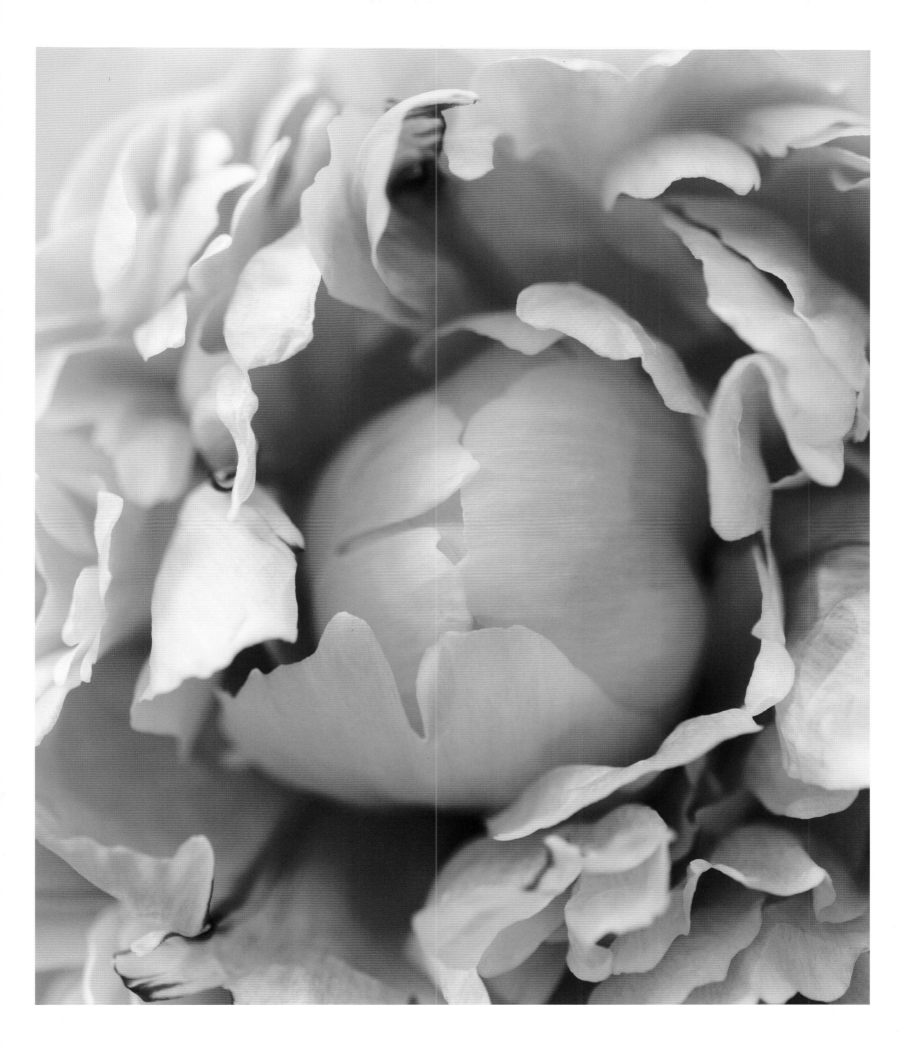

Oxalis versicolor

There are about 800 species of the small and largely prolific *Oxalis* scattered all over the globe. As might be expected from such a large genus, there is much variation. Some species have proved notoriously invasive when introduced to countries beyond their homeland. *O. versicolor*, however, is too refined for such behaviour. Hailing from South Africa, it is one of several species that survive the dry season by dying back to a small tuber. It emerges during the cool, moist winter to produce startling flowers – white with a red edge to the petals, giving a striped effect.

The plants have given their name to oxalic acid, which is found in all of them, and which gives spinach, strawberries and rhubarb their distinctive sharp taste. While of no particular culinary importance, the foliage of *Oxalis* can be pleasantly refreshing when chewed or eaten in salads.

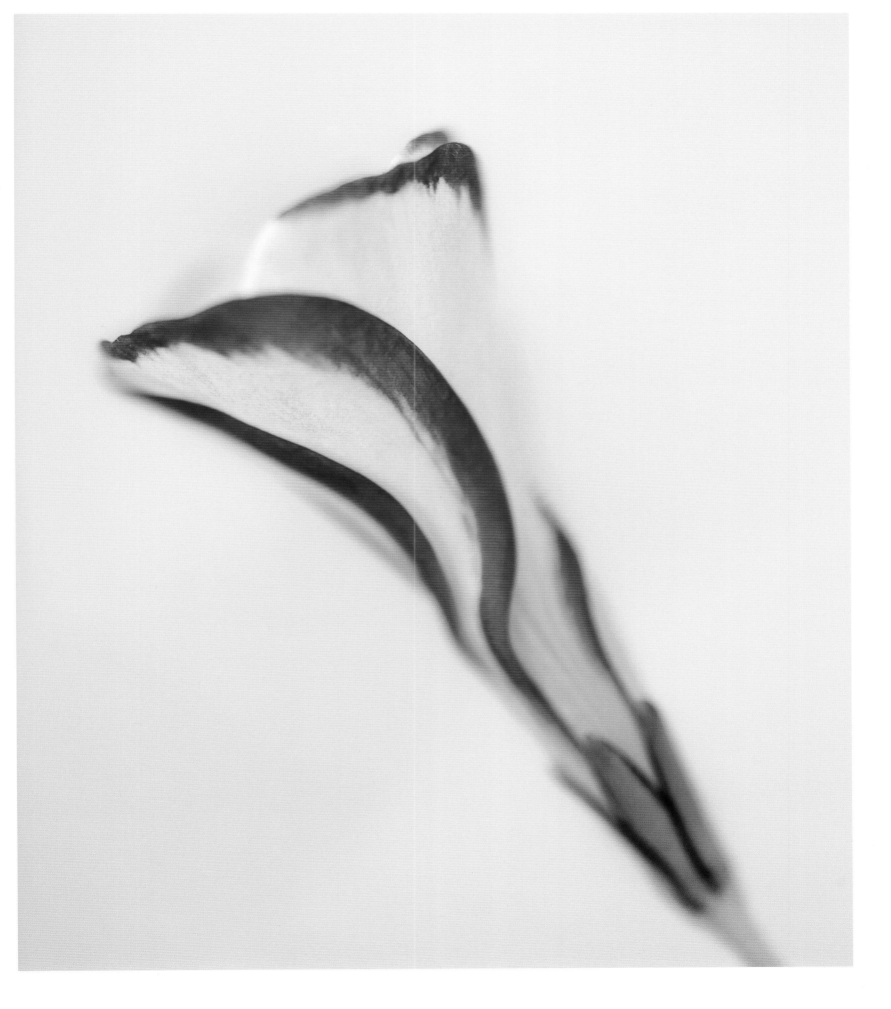

Papaver orientale 'Watermelon'

In common with its annual cousins, the perennial Oriental poppy grows readily from seed. It crosses easily, too, with the result that nurseries have raised a great many varieties, in all colours – from pure white to deepest red, with lots of pinks and oranges in between. The plant's tendency to cross has a deeper history, for it has now emerged that what we call *Papaver orientale* is not really a species at all, but what botanists would call a 'hybrid swarm' between three very similar plants: *P. orientale*, *P. pseudo-orientale* and *P. orientale* var. *bracteatum*, all from the same area (Turkey, Iran and the neighbouring countries of western Asia). Introduced into gardens in the early eighteenth century, they crossed, re-crossed and re-crossed again, giving us the rich genetic melange we have today. Every now and again a nursery picks one out and sticks a label on it, and we have another new variety. The luscious 'Watermelon' was clearly chosen for being pinker than pink.

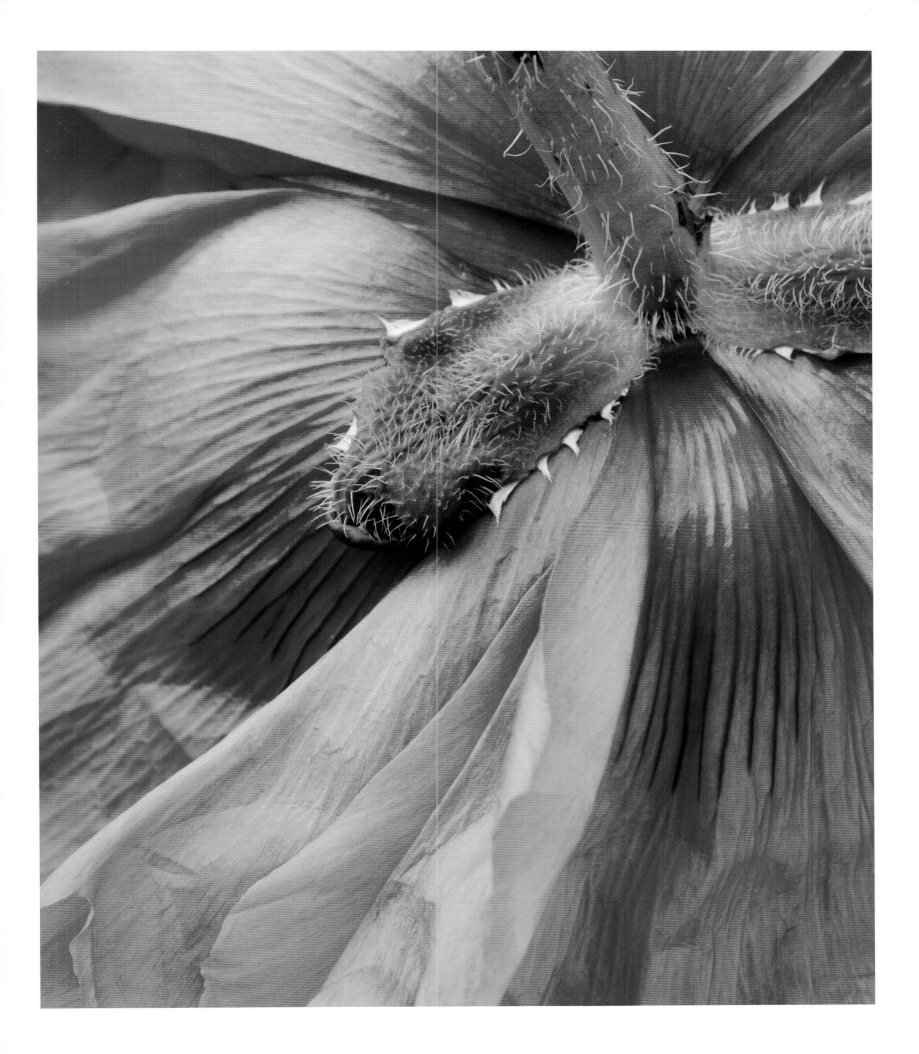

Tulipa humilis

Tulipa humilis hails from the hilly borderlands of Turkey, Iraq, Iran and Azerbaijan. This area more or less describes the Kurdish homeland, and it is no surprise to see that what appears to be *T. humilis* is the symbol of one of the region's main political parties, the Patriotic Union of Kurdistan. Flowering in early spring, this species and other wild tulips are picked for Nowruz, the ancient Zoroastrian festival of the new year, which is celebrated by several of the peoples of western Asia, including the inhabitants of the shrine city of Mazar-i-Sharif in northern Afghanistan.

The first person in the west to grow *T. humilis* was the Dean of Manchester, the Very Reverend William Herbert (1778–1847), an amateur scientist whose ideas on evolution and genetics pre-dated those of both Charles Darwin and Gregor Mendel. Herbert was a particular lover of bulbs, and used daffodils to illustrate the idea of hybridization, which, at the time, was very controversial.

Anemone pavonina (page 186)

Dahlia 'Mabel Ann' (page 187)

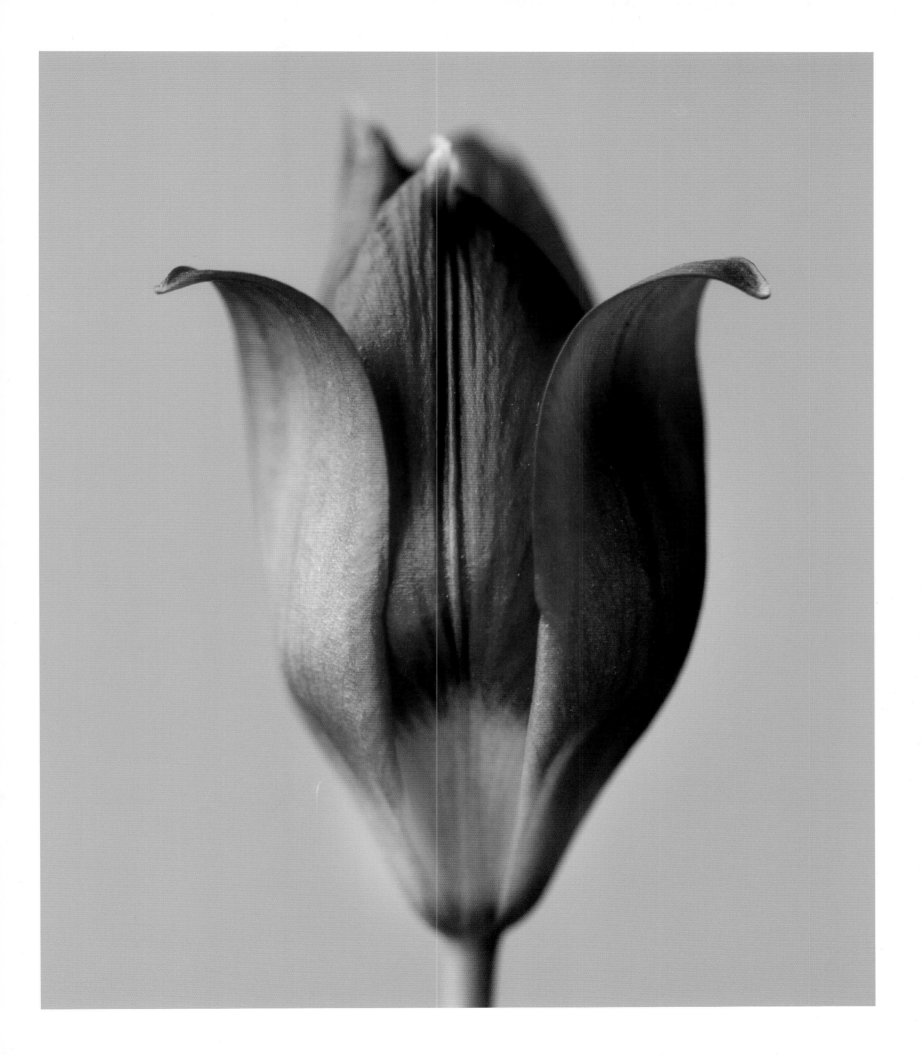

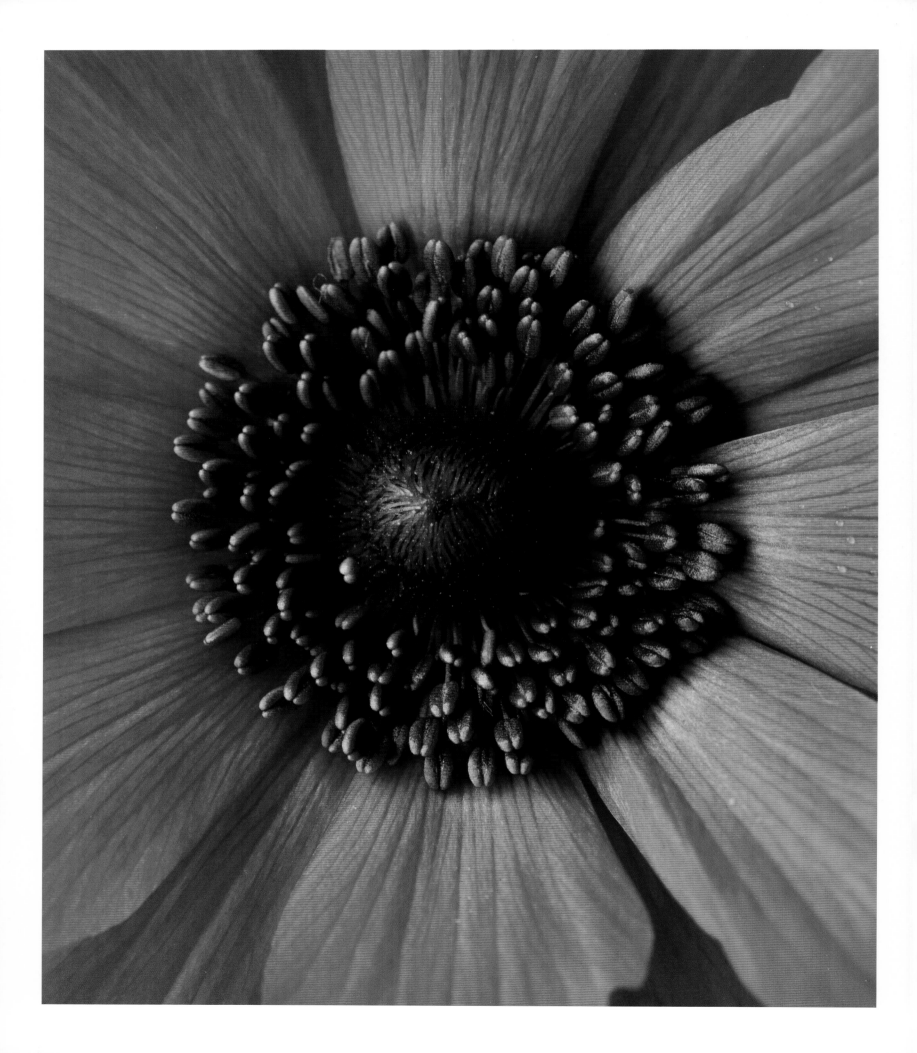

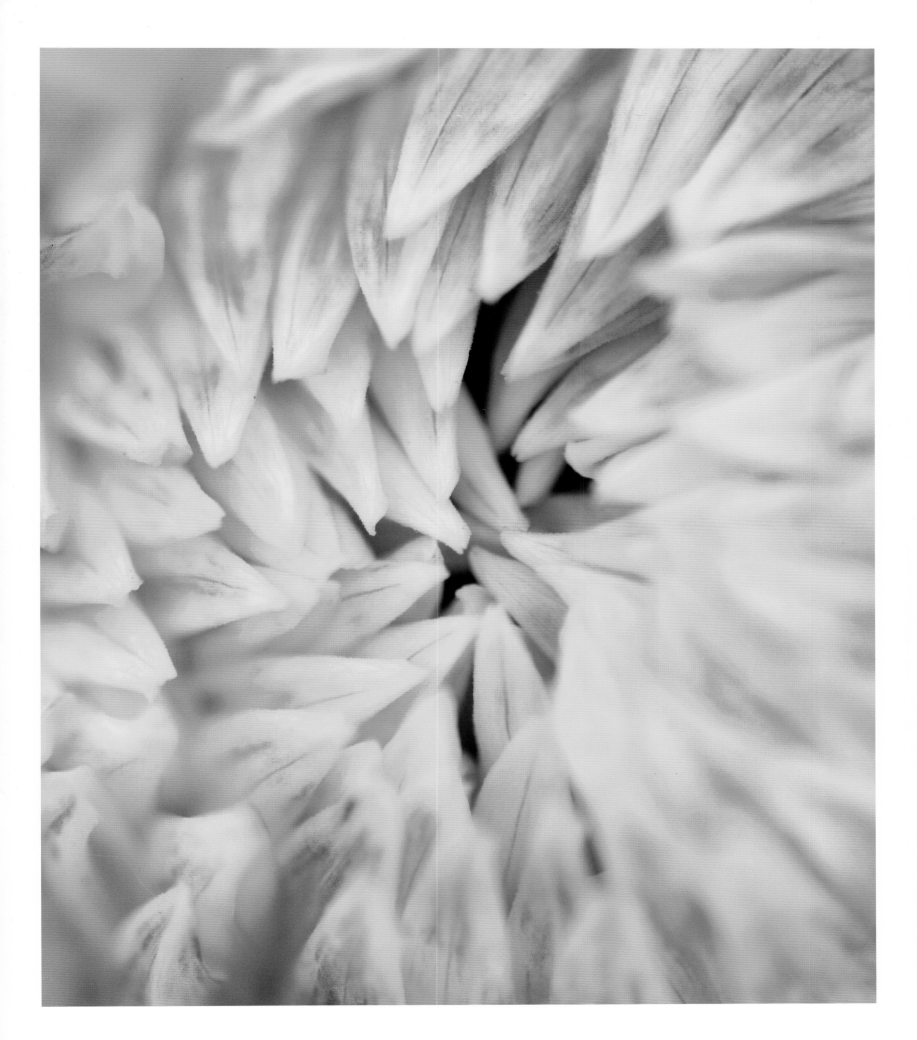

Technical note

Most of the images in this book were shot on my Canon EOS 1DS MKIII, a 21-megapixel digital camera, fitted with a 180-mm macro lens, in my small studio using soft, natural daylight, sometimes boosted by the use of reflectors. In a minority of cases, I came across a particular specimen in a garden or nursery and decided to photograph the subject *in situ*.

The main source of light in my studio is a large north-facing window to the left of where I place the flowers. It gives a gentle, soft light with low contrast. I find this best for delicate plant portraits and details, as every subtle colour, texture and form can be clearly seen without the distraction of highlights and shadows. Sometimes I use a large sheet of white card or a white reflector below or to the right of my subject, to bounce light into the shadows. For very dark subjects – a black tulip or hellebore, say – I may even use a sheet of black card or velvet on the right-hand side of the flower, to darken the subject on the shadow side.

The backgrounds are usually large sheets of coloured card, placed at least 1 metre (3 ft) behind the subject. I like to try out different colours as backgrounds and experiment with colours that clash with, contrast with or complement my sitters. If I want to darken the background while keeping the subject fully lit, I block the daylight hitting the former with a sheet of card. For black backgrounds I use a piece of velvet, which absorbs light and gives a really good matt-black surface. I like to use large apertures, such as f/3.5 and f/4, in order to focus the viewer's attention on a particular point, blurring the rest of the plant and the background. I use smaller apertures – typically f/11 or f/16 – for greater depth of field when I want to emphasize the texture or form of a specimen. I shoot in raw format, which is similar to a digital negative in that it captures the maximum amount of information possible. Using a slow ISO (film speed), typically 100 ISO, gives me the best possible quality in my pictures. I then use Adobe Camera Raw to make small adjustments to the clarity, vibrancy, colour saturation, contrast, brightness and colour temperature of each image before finally cleaning it up in Adobe Photoshop CS3. The raw files are then converted into 60-megabyte TIFF files, from which I can make A3, A4 or smaller JPGs.

Clive Nichols
March 2010

Clive Nichols photographs the arum lily, Zantedeschia sp. (see pp. 22–23), in his studio.

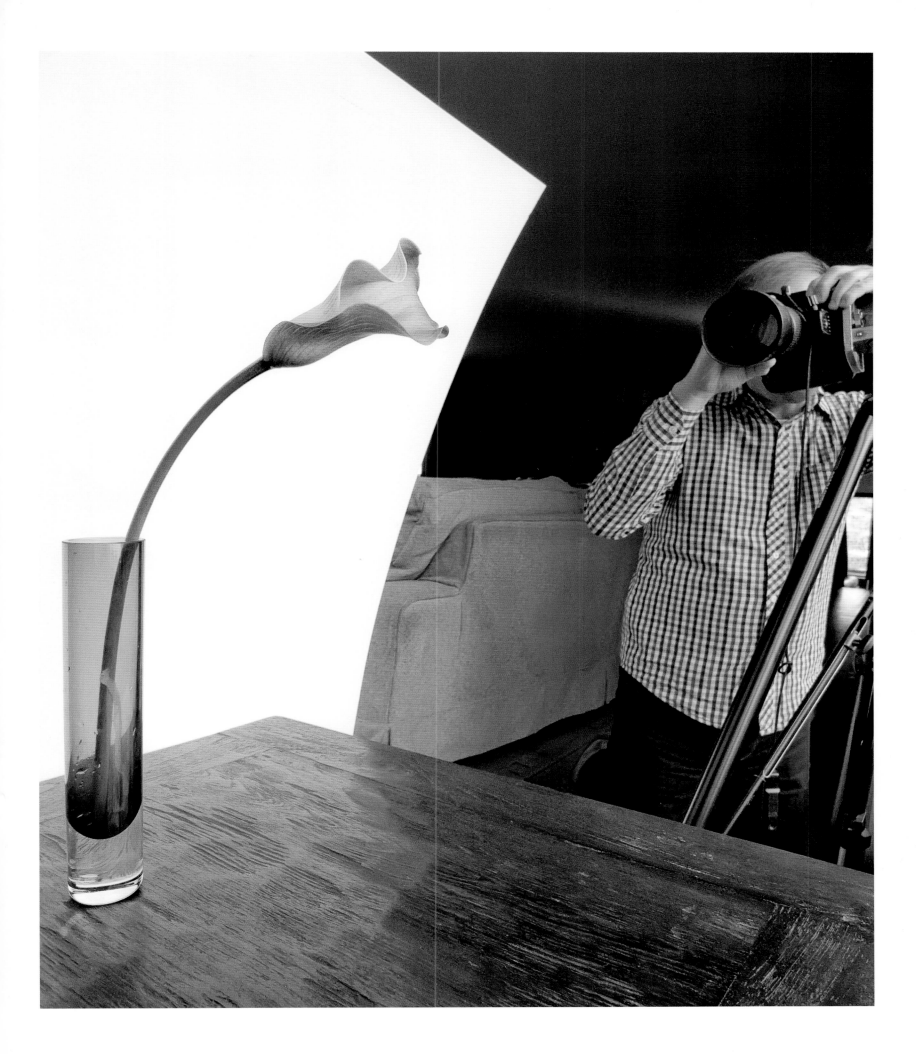

Sources

The research for this book has involved trawling through a considerable quantity of sources. Frustratingly, there is no single source for information on the history, culture and folklore of cultivated plants.

The most comprehensive source I found was the chiefly historical Heinz-Dieter Krausch, *Kaiserkron und Päonien rot …: Von der Entdeckung und Einführung unserer Gartenblumen* [Crown Imperials and Red Peonies …: On the Discovery and Introduction of our Garden Flowers], Munich, Germany (Deutscher Taschenbuch Verlag) 2007.

In English there are two very useful sources on plant history, both long out of print but easily available second-hand. Both are by Alice M. Coats: *Flowers and their Histories*, London (Hulton Press) 1956; and *Garden Shrubs and their Histories*, New York (Vista Books) 1963.

On folklore and symbolism, Claire Powell, *The Meaning of Flowers*, London (Jupiter Books) 1977, and Marianne Beuchert, *Symbolik der Pflanzen* [The Symbolism of Plants], Frankfurt, Germany (Insel Verlag) 1996, are comprehensive and thorough.

Noël Kingsbury
March 2010

Index

Photographer's acknowledgements

I am grateful to the garden and nursery owners who have provided me with some of the flowers that appear in the book: Lucas Boreel, Bob Brown, Graham Gough, Dr Ronald Mackenzie, Chris and Toby Marchant, Michael Marriott, John Massey, Hugh Nunn and Gina Price. In addition, I should like to thank the following at Merrell Publishers for making this book a reality: Hugh Merrell, Claire Chandler, Rosanna Lewis, Nicola Bailey, Alexandre Coco and Alenka Oblak.

Clive Nichols

Author's acknowledgements

Writing this book has meant trawling the recesses of my memory, my library, other people's libraries and the internet for botanical and horticultural facts and slivers of information. The staff of the marvellous Lindley Library held by the Royal Horticultural Society in London should be thanked, as should Bob Brown of Cotswold Garden Flowers, whose website (cgf.net) includes a unique encyclopaedia, which records this indefatigable plantsman's experiences of growing a vast range of (mostly herbaceous) plants. I should also like to thank Jim Archibald, whom I seem to have rung several times asking for advice; Jim is a fantastically knowledgeable plantsman, who has also travelled and seen so much of our garden in the wild. I am grateful to Dr James Compton for his botanical advice. The staff of Merrell Publishers have been as delightful to work with and as supportive as ever; if only all publishers could be like them. Finally, I thank my partner, Jo, who has listened patiently to the various moans and groans that inevitably accompany writing.

Noël Kingsbury

First published 2010 by

Merrell Publishers Limited
81 Southwark Street
London SE1 0HX

merrellpublishers.com

British Library Cataloguing-in-Publication data:
Nichols, Clive.
Florescence : the world's most beautiful flowers.
1. Flowers – Pictorial works. 2. Photography of plants.
3. Photography, Artistic.
I. Title II. Kingsbury, Noel.
779.3'43-dc22

ISBN 978-1-8589-4534-7

Produced by Merrell Publishers Limited
Designed by Alexandre Coco
Project-managed by Rosanna Lewis
Printed and bound in Dubai

Plant names have been checked against the Royal Horticultural Society's Horticultural Database, available at rhs.org.uk.

Jacket, front: *Tulipa humilis*; see pp. 184–85
Jacket, back, left to right: *Rosa* 'Darcey Bussell' (see pp. 44–45); *Clematis* 'Crystal Fountain' (see pp. 18–21); *Tulipa* 'Blumex' (see pp. 84–85).
Frontispiece: *Tulipa* 'Juliette'
Page 7: *Paeonia lactiflora* 'Sarah Bernhardt'; see pp. 178–79
Page 9: *Dicentra spectabilis*; see pp. 86–87